MIMESIS
INTERNATIONAL

LITERATURE

n. 5

ESTERINO ADAMI, FRANCESCA BELLINO
AND ALESSANDRO MENGOZZI

OTHER WORLDS AND THE NARRATIVE CONSTRUCTION OF OTHERNESS

MIMESIS
INTERNATIONAL

This book has been published with the financial contribution of the Department of Humanities, University of Turin.

© 2017 – MIMESIS INTERNATIONAL
www.mimesisinternational.com
e-mail: info@mimesisinternational.com

Isbn: 9788869770951
Book series: *Literature* n. 5

© MIM Edizioni Srl
P.I. C.F. 02419370305

TABLE OF CONTENTS

OTHER WORLDS AND THE NARRATIVE CONSTRUCTION OF OTHERNESS

ESTERINO ADAMI, FRANCESCA BELLINO
AND ALESSANDRO MENGOZZI[1]

University of Turin

The papers collected in this volume are concerned with the explorations of science fiction and, more generally, the representation of otherness through the narrative construction of fantastic, imaginary, appalling or attractive places, stories and figures. The scope of the collected papers is deliberately open-ended and broad, since they aim to traverse, tackle, compare and contrast a constellation of narrative discourses, texts, and authors in various cultures, often observed in a dialogic relationship between past and present, local and global variables, native and alien models.

This volume ambitiously gathers contributions from Italian scholars working in a variety of disciplines ranging from Indian cultures to Arabic literature and film studies, stylistics in English-language fiction and postcolonial authors to Semitic and Classical philology, and it is therefore grounded upon different methodological perspectives and theoretical frameworks. Interdisciplinarity spreads across the papers, conceived as case studies, and affects approaches and standpoints of every contributor, since the multidimensionality and complexity of the objects of investigation trigger the adoption of various methodologies and indeed compel scholars to reflect on methodology, interpretative paradigms and ideological frameworks.

1 The idea of collecting these contributions in a volume arose from a conference held at the University of Turin (May 13, 2014) and entitled "Luoghi e Creature d'Oriente: dal fantastico alla fantascienza". The editors express their gratitude to all those who attended and contributed to it, especially Carlo Pagetti, whose outstanding studies on fantasy and science fiction deeply inspired the very idea of the conference.

Many of the genres taken into account – science fiction, comic books, oral myths, folk-tales, heroic narratives – superficially appear to be simple, even naïf or marginal, representing a generic category of the so-called 'popular culture', but in reality they partake of cultural complexities in transit between tradition and (post)modernity. In challenging canons and readers, and implicitly suggesting other paths of narrative transformation and elaboration, for example with the same themes and characters across genre boundaries, from literature to cinema, from mythology to graphic novels, these narratives actually appropriate modalities and devices that undergo a process of revision to envisage thorny cultural questions.

Narratives of otherness are addressed with the whole methodological armamentarium of cultural studies and beyond, including history, philology, literature, semiotics and of course narratology. Narratives are read and presented as cultural products of, or, in reaction to specific historical contexts: the gradual formation and diffusion of complex text networks in late-antique, medieval and early modern Asian empires, the confluence of Buddhism, Marxism, Socialism and Gandhism at the beginning of the 20th century in India, the massive Chinese immigration to England and the USA, the diffusion of French colonial power in North-Africa, the reception and original re-working of science fiction in Arabic literature during the second half of the 20th century, episodes of collective panics in concomitance with political changes in early-1960's Tanzania and Zanzibar, the first crisis of Nasserism around the end of the Sixties and the arising of an oppressive and repressive regime in Egypt.

The macro-theme of East and West confrontation, in both directions, generates a series of interrelated tropes, topics and features, that cumulatively design a red thread throughout the papers. Freely moving within the ideological and cultural paradigm of postcolonial studies, going beyond or explicitly rejecting Said's *Orientalism* (1st ed. 1978), contributors examine the alleged East-West dichotomy with a critical gaze, both within and across cultures: thus not only the construction of the "Other" as a kind of clichéd bearer of otherness, exotic strangeness, and

even threat – see, e.g., the Yellow peril and its medieval Mongol forerunner, the risks of miscegenation and hybridisation, the Swahili sex-maniac monster and other deadly images associated with political power and alienation, returning dead women, hard-to-exorcize demons, the Indians as beasts in the Alexander Romance, and the time-honoured ghoulish character of Ra's al-Ghūl in modern Batman adventures – but also as the reshaping of Western symbols from what a Western-centric perspective may consider the world's peripheries.

As an alternative to the Greenwich-centred world map, Hindi science fiction by Rāhul Sāṃkrityāyan envisages a global geopolitical map centred on a small-size capital city in Brazil, temporary residence for functionaries and nomadic global politicians. An Asian rather than Graeco-Mediterranean axis is proposed to describe the territory in which inclusive works such as the Alexander Romance enjoyed immense popularity, creating a literary space for the negotiation between global and local cultural identities.

Stereotype is one of the mechanisms through which different narratives operate. The outlandish creatures, characters, and places at first sight appear to be connoted as unoriginal, frozen and even trite, but in reality they work as means for exploring a variety of discourses by speculating on other wor(l)ds, and to achieve such a goal they often rely on intertextuality and hybridity, two key paradigms that reverberate through various genres.

Intertextuality here concerns the capacity of texts and stories to link bridges with other references and domains. The linguistic, literary and cultural materials analysed in the various papers establish connections between traditions, shuttling between times and spaces, so that it is possible to imagine the irruption of fantasy as a way to obliterate history in 1960's Egypt, utopian or dystopian places in the Indian subcontinent, the menace of the East in terms of racialised figures at the beginning of the 20th century in the West, or ghostly beliefs from ancient Greece to the Raj period and contemporary Indian cinema.

Hybridity on the other hand triggers a strategy of transformation that affects both styles and contents. The expressive modalities

and languages of Asian and African science fiction and Fantasy in fact stem from and blend together a wealth of traditions, imageries and stories. Thanks to them fiends of antiquity surface from Victorian ghost literature in the works of M.R. James, or the Tanzanian demon Popobawa leaves fiction and as shared belief enters the realm of propaganda, news and eventually history. Interestingly, hybridity also turns out to be a recurring token as it thematically impacts body discourse with monstrosity as a constant feature for the beings and creatures portrayed in this type of text.

From a quasi-canonical narratological perspective, Eastern characters play the roles of villains in Western narratives, complying with a rather predictable rule of polar contraposition: the Other is a dangerous enemy. However, Ra's al-Ghūl becomes the Eastern anti-hero of American comics only after or perhaps because he has been the internal pagan enemy of Islam or the external colonial invader in Arabic popular epic. Read through the programmatically universal lens of Jungian psychoanalysis, the super-villain spirit Popobawa may be seen as an African character that embodies "the uncanny" and transposes African fears in the domains of Swahili fiction, in literature and movie production.

Contributions are arranged in four main sections that form a kind of thematic tour. The first section (*Other Spaces, New Worlds*) deals with Hindi and Arabic science fiction. A Hindi author narrates a socio-political utopian model of universal modernity, alternative to imported socialism and capitalism and Indian nationalism. Through science fiction, Arab authors create ideal or fearful cities and societies, in the desert or under the sea, and struggle to imagine an original modern future, using native traditions and foreign models. The second section (*Constructing Forms of Otherness*) analyses the narrative and psychological mechanisms that give form to a stereotype or archetypical image of the threatening Other. The third section (*(Re)Shaping Style(s), Language(s) and Discourse(s) of Otherness*) is centred on the idea of language as a tool to build up styles, genres and texts, and

literature as an escape from disappointing history and a cross-cultural wandering space of narrative ghosts. The fourth section (*Circulating Fearful Otherness*) tests the limits and heuristic potential of a philological approach in reconstructing the wide circulation of motifs and characters from antiquity to (post-) modernity.

OTHER SPACES, NEW WORLDS

CONTESTING COLONIAL ETHNOGRAPHY THROUGH AN IMAGINED GLOBAL GEOGRAPHY FOR THE 22ND CENTURY

Rāhul Sāṃkṛtyāyan's Hindi Science Fiction *Bāisvīṃ Sadī*

ALESSANDRA CONSOLARO

University of Turin

A journey to the twenty-second century

Rāhul Sāṃkṛtyāyan (1893-1963, hereafter RS) was a fiercely independent scholar, and he is one of the most interesting Indian intellectuals of modern times, as Machwe's (1998) biographical account shows. As well as other, more internationally renowned, talented public figures in South Asia prior to Independence, such as Rabindranath Tagore or Ananda K. Coomaraswamy, he was a polymath. He was a polyglot and a traveller, a communist and a Buddhist. He was provided with an amazingly vast and deep scholarship, being a historian, a novelist, a philosopher, and much more. This article introduces RS's challenge to the narrative of colonialism, capital, socialism, and to the discourse of modernity. I will focus on two texts: *Bāisvīṃ sadī* (hereafter BS), a juvenile work written in 1923; and *Ghumakkaṛ śāstra* (hereafter GS), first published in 1948, a work that marks his maturity, both in age and in thought, about which I have written elsewhere (Consolaro, 2013).

If intellectual wandering means to stake out the boundaries of established disciplines, for RS this also implied writing outside the limits of established genres, moving freely in space and time, and expressing his thoughts with no restraints. This was much praised in his collection of short stories *Volgā se Gaṅgā*, as well as in his historical novels (Fornell, 2010). A less studied but interesting text is BS, a Utopia about the 22nd century that was not inserted by Kamlā Sāṃkṛtyāyan – Rāhul's wife, who edited the edition of some of his works after his death – in the list of

fiction writings, being instead listed as a "political essay." In the introduction to the first edition, RS states that Viśvabandhu's "travelogue" (*bhramaṇ vṛttānt*) had come to his mind in 1918 and took the form an "essay" (*nibandh*) on 6th February 1924, during his reclusion in Hazaribagh jail (*Do śabd*, page not numbered). In later autobiographical accounts he explains how the text was composed, again emphasizing fuzziness regarding genre. For example, in *Merī Jīvan-yātrā* he writes:

> [...] I felt once again the desire to write that book, and to write it in Sanskrit. [...] At that time, though, I didn't have a clear knowledge of 'Bolshevism and universal peace'. I hadn't even heard of the name 'Utopia'. But in 1917 I had read on the newspaper *Pratāp* news about the Russian revolution and its aftermath, and accordingly I had formulated an idea of society, that I wanted to represent in this book. I intended to describe the path leading from the present society to that one. Therefore, I sent a young ascetic, Viśvabandhu, to the Himalaya. [...] On my second 'journey to jail' I realized the impracticability of Sanskrit [...] and I wrote it as *Bāisvīṃ sadī*. (264–265)

This is what he wrote in his autobiographical essay "Maiṃ kahānī lekhak kaise banā?":

> At the end of 1921, I was sentenced to six months. In prison, I got time to read and write, and I put pen to paper. This was the first time ever I wrote fiction. The purpose of my writing, though, was not to tell a story or narrate. Just as, being a traveller, I had begun writing about my travels, in 1918-19 I had created a socialist world in my imagination, adding some fantastic nuance to whatever true or false news were published in the Hindi press about the Russian revolution. I wanted to write down that imaginary world. At that time, I had no philosophical knowledge of Socialism, actually I hadn't even heard Marx's name, therefore my Socialism was utopian Socialism, I had no notion of practical issues. I did not know that the carriers of Socialism are workers and peasants, who have no lesser relevance than literacy. [...] Whether you define *Bāisvīṃ sadī* a novel (*upanyās*), a long story (*baṛī kahānī*), or a socialist utopia, that indeed was my first book of fiction (*kathātmak graṃth*). (596)

BS is a story about a journey in the future, straightforward to the point of appearing naïve. The narrating voice is a male character,

Viśvabandhu (literally: Universal Friend), who wakes up after a two-hundred-year slumber. He remembers he had retired in meditation in a cave in Nepal after a life of travelling and teaching, at the age of 60. He sets off and walks in a familiar, yet different landscape: he is surrounded by rich agriculture and irrigation channels, hydroelectricity and channelled drinkable water, things that did not exist there at the time when he fell asleep. On meeting some human beings, he finds out that he is in the year 100 of the global (*sārvabhaum*) era, that is in 2124. A highly technological world is united into a global state confederation, and lifestyle is worldwide homogeneous. The naked wanderer is soon recognized as the famous Master Viśvabandhu from Nalanda University, and the rest of the narration describes his wonder at this utopian society that he comes to know while travelling back to Nalanda. The main focus of the argument is that, in order to have a good social system, good education and intellectual development are needed, together with material advancement.

Challenging modernity

The process of modernization that happened in the 19th-early 20th century should not be envisioned as the result of an "influx" due to the contact with the Western colonizers; it is better understood as an epistemological paradigm shift, a ferment of ideas that are tried in an epoch of crisis and that produce an intellectual debate, forging a new framework of thought. Also in the Hindi literary field a process of "translation of modernity" took place (Srivastav, 2005: 391), and RS too is the agent of an alternative kind of modernity: a transnational one, and a very radical one, insofar for him the 'cosmology of wandering' is not an appendage to a wider world view, but *is* the *Weltanschauung*.

In the world depicted in BS, private property has been eliminated, and there is no discrimination on the basis of gender, caste, class, or religion. A global language is used for general communication. Education is compulsory for seventeen years and children leave their parents at the age of three, living in boarding

schools that are based on community life. Individual bonds, such as family, are created by free choice, and ultimately are to be cancelled in favour of a global identity: in fact, a much wider view and a universal approach to any issue can be obtained only transcending local differences. The economic system is based on intensive production: each place produces only few items according to local characteristics, and all other commodities are imported. Infrastructures are efficient and transports are fast. People's occupations are according to their abilities and inclinations. Everybody has to work four hours a day five days a week; "the remaining twenty hours can be devoted to sleep, read, dance and sing, meet people, pursue their studies, practice philanthropy, do service to literature, and all other activities" (73). After nine months work everybody gets a vacation and can travel at will for a couple of months. This allows them to share their knowledge and learn about places and people, and this way knowledge, that was once elitist and reserved to highly cultured people, has become common.

RS presents a master narrative informed of Marxism and Buddhism, a vision that today can seem both philosophically and politically naïve, as it rests on a simplistic model of bio-technological evolution and a fantasy of horizontal perfectibility. What is the use of reading this science-fictional tale today? Interpreting BS just as an example of Marxist influence on an ingenuous Indian author would be reductive and erroneous. For RS learning was never an abstract activity: it derived from practice, performance, communication, and interaction with other people. In the first quarter of the 20th century the confluence of Buddhism, Marxism, Socialism (and Gandhism) was a relevant intellectual trend, which is yet to be studied systematically in the intellectual history of modern India. The passion that animates this book is a concern for the historical situation in which the author lived: India was in an age of conflicting fears and desires, in the middle of a nationalistic struggle, and RS was seeking modes of representation and forms of accountability adequate to the complexities of the real-life world he was living in. He wanted to think about what and where he lived, not eluding the embodied

locations and the rooted positions which he happened to inhabit. Therefore, he jumps two hundred years ahead in time, but he visits the places he actually knows, he describes the intellectual world he inhabits, calling on a new form of ethical responsibility considering "life" as "subject" of research, instead of "object", anticipating a material and discursive connection between the text and its social and historical context that in Europe, for example, will be discussed much later by feminist and poststructuralist philosophy (Braidotti, 2006).

RS positions himself as transnationalist in an age of nationalism, and at the same time he is consciously localist in his imagination of a globalized world. His new world is a projection of the Buddhist monastic communal life informed by the Soviet model of economic system, advocating state ownership of productive enterprises, central planning of production and allocation of goods and services at state determined prices, a subsidiary role for money, banking and public finance, freedom of workers to choose their jobs, and state monopoly over foreign trade and transactions. In an epoch when the nationalist fantasy of modernization was based on an East/West dichotomy, he proposes alternative creative links and zigzagging interconnections between discursive communities which are generally kept apart from each other, prompting the reader to reflect on them. He focuses on literacy and scholarly work as the pivotal elements for a critique of tradition that aims at identifying forces, aspirations, and conditions that propel individuals out of the inert repetition of established habits of thought and self-representation, through an investigation based on Buddhist philosophy, that he had already started studying at the time of writing BS. He claims that habit is a sort of addiction, but it is socially enforced and thereby "legal", and generates forms of behaviour that are accepted as "normal" or "natural." Past experiences are given disproportionate authority just because accumulation of habits is granted unreasonable credit. In order to stop this process, a transformation of schemes of thought and of consolidated ways of inhabiting the world is needed, able to promote a change of culture. It is a radical change, happening in the immanent structure of the subject, which can

be fostered only by a clear understanding of maps and relations of the interconnections that link individuals to their social and organic environment.

Global villages

Let us turn to the way RS envisions living conditions and planning in his Utopia. The system of government, based on representational democracy and universal adult suffrage, is organized on a series of levels, beginning with local or village government, and ascending through the districts and provinces to the national and finally global level. Full-scale industrialization, scientific agriculture, and modern infrastructure are a constant feature all over the world. Densely populated, crowded cities do not exist any longer.

In the colonial view India's poverty economic underdevelopment, urban congestion, and deficiency of transportation reflected the nation's shortcomings and were a symptom of backwardness. In an era when industrialized civilization was already well-established in the West, India was just beginning to industrialize. While the nationalist fantasy of modernization found its expression in the dream image of a planned industrial metropolis, RS suggested the possibility of an alternative both to it and to the refusal of it – Gandhi's "traditional" village. Modernist urban planning favoured by progressive architects, such as Bombay's MARG group, aimed to achieve a more efficient and rational urban space, but failed to address social desires and needs (Prakash, 2010: 251–88). RS did not endorse the liberal state's ideal to promote the public good through capitalism: in his vision private interests would necessarily hinder the state's ability to express general interests. At the same time, he did not accept anti-modern positions: for him national traditions and industrial and technological modernity were compatible, and were to be embodied in the future free Indian nation, that was to be concurrently modern and different. He fosters a nation-based cosmopolitanism, challenging the colonial discourse that iden-

tified colonized as bearing an ontological and anthropological deficiency. Rather than articulating a supposed cultural essence of the nation, he viewed himself as an intellectual participating in a universal discourse that rejected single thought, where there was an interconnection of discourse communities.

RS's village has nothing to do with the 'traditional' Indian village. It shares with Gandhi's village the definition of a place where people can live simple, dignified lives in meaningful communities. Both emphasize local autonomy and employment, the village and the villager. But Gandhi's apotheosis of village republic – constructed as representative, deliberative, and harmonious – rested on the moral basis of *dharma*, and represented a hierarchical and ordered "freedom," even somehow reflecting suspicion of mass democratic action. Order was granted by existing sanctified custom, in which rank and distance, privilege and obligation, rights and duties, were legitimized by religion. Seeing industrialization as a force that brutalized human beings, alienating them from self and society and depriving them of the capacity to govern themselves, Gandhi proposed an economically and morally revitalized village community as a viable and attractive alternative to urban and machine civilization. Many among India's intellectual and professional classes, though, dissented about the notion that the village was the virtuous solution. RS's position is similar to Ambedkar's: the village – a social unit consisting of castes divided into Touchables and Untouchables – was the very site of social evil, where no room for democracy, equality or fraternity was left.

RS's modernism balanced nationalism with universalism, thus avoiding the East/West binary trap. For him the claimed purity of cultures was simply a nationalist myth fabricated in the 19th century, and it was a mistake to think of "premodern" and "modern" in a dichotomized way, equating them with East and West. His cosmopolitanism assumed India's national sovereignty and equality in a world of nations, but at the same time postulated a transnational level. In his view the village is not self-sufficient, as it is a cell of a complex structure where circulation of goods

and people is necessary. Yet, it is equipped with all necessary items for a simple and healthy life. This village is the core of a nomadic society and economy, in the sense that it allows and promotes the fluid circulation of capital, commodities, and people at a global level. It differs from the capitalistic vision in that the latter favours the proliferation of differences, but only within the strictly commercial logic of profit. RS's nomadic vision is strictly no-profit, and aims to the development of intellectual subjectivities permitted by a collectively organized society taking care of all bodily needs that generally distract from intellectual activity. Rejecting universals, whether from a unifying "capitalist" or from a "nationalist" perspective, he reinterprets national selves as fluid cultural spaces devoid of the oppressive potential of collective nationalist identities. Even if centralization is viewed as inevitable in the modern age, RS's ideal is a set of small, heterogeneous and independent communities, that restore human intimate connection with the soil, albeit scientific and technocratic methodology are viewed as supposedly thoroughly applicable. Indigenous nations can persist and contribute to the world society: being transnational does not coincide with the disintegration of any sense of collective polity. There are all the norms of metropolitan modernity that were supposed to compose the modernizing national order – industrialization, self-realizing individualism, innovation, science, medicine, rationality, the bureaucratic state relations of mobility, empire, agency and citizenship. But they are devoid of the hegemony of masculinity and of imperialistic aims, thanks to the substitution of a centralized state control to capitalism. For RS an idealization of labour such as the one proposed by Gandhi is not acceptable: technology and commodities are not to be rejected; on the contrary, they are welcomed as possibilities for a better quality of life, allowing time to entertainment, art and culture, in a radical quest for an alternative to materialism.

Transnational subjectivity and a global nomadic world

RS's argument is grounded on an ethics of sustainability, based on interconnections. I have used the term "subject", yet

this should be understood not as a coherent and unified character, but rather as a changing, mobile and heterogeneous self, that can be expressed only in parts and fragments. If the subject is not one, whole, unified and in control, but rather fluid, in process and hybrid – if it "in transit" – then travel becomes a privileged position to express it. This has been observed also with reference to other relevant public intellectuals of that period, such as Nehru, Gandhi, and Iqbal (Majeed, 2007). Notwithstanding the differences among them, transnationalism is a common feature of their work.

The grand unifying concept whereby a nation defines the identity of its people has been challenged and criticized by postcolonial theories on the subnational, including people from various diverse regions within the same nation (Mitra, 2012); the subaltern, including people who are generally classified as the minority groups determined through race, religion, caste, class, etcetera (Ludden, 2001); and the transnational, including people belonging to a certain nationality, but living in other countries (Appadurai, 2000). In BS, RS construes a global world where identity cannot be simply subsumed within a group identity, or conflated with a pre-existing nationality. He relocates the notion of identity beyond the discourses of "symbol" and the "local" into a larger cultural space, that is the interconnection of relations where the subject positions itself, performing production and consuming practices that comply to the transformations that may affect the space system (Lefebvre, 1991). Different forms of cultural construction are central to the production of space, principally in terms of class, but also gender, ethnicity, sexuality, family relations and age. Identity, being produced by a culture space, is further used to manipulate such a space, and becomes an agent to reproduce it.

The protagonist of BS is a well-travelled 260 years old man, who happens to put together the ability to travel in space as well as in time. When he first meets local people, he appears as a naked caveman and he is self-conscious of their gaze: "Everybody is staring at me, wondering whether I am a beast [...] Well, that man is coming in my direction, I'll ask and find out [...] They are

probably considering me a 20th century savage and they even saw me wearing just leaves! Moreover, here nobody wears a beard, not to mention my bear-like hair!" (6–7). He is confused, yet he is not restraint by any sense of self-lack, but rather actively starts asking questions in order to understand his new situation. Soon he is recognized as the famous Master Viśvabandhu from Nalanda, who contributed to the revivification of the ancient Buddhist monastic university, establishing an educational centre that has become a worldwide beacon for the study of philosophy, history, antiquities, and linguistics. He sets forth to Nalanda, and the rest of the story is a travelogue, presenting the wonder of places and people he meets on the way. Far from "settling back home," he visits the educational institutions there, and then, together with his new friend and travel mate, the historian Viśvamitra (Universal Friend, he too!), leaves again for a new journey all over India.

The text closes with a short description of the "happy globalized welfare" in the republic confederation of India. Interestingly enough, the emphasis on educational institutions and the spread of literacy does not point to a celebration of the modern technocrats engaged in building a range of institutions for the new nation-state, but is rather a counter-discourse, arguing that traditional forms of learning have the same importance as modern science. In fact, there is a constant effort to stress that, although all nations are on an equal status, India has a leading role, which ultimately derives from its great culture and learning.

The space constructed in BS is an alternative both to conventional and imperial notions of travel, as well as to the late eighteenth and early 19th centuries travel writing by Indians who looked at Britain as an example of the power of a stable modernity and express a sense of incompleteness and inadequacy (Puri). RS challenges the colonialist discourse that immobilizes the "native", objectifying non-white persons as "travelees" (Pratt, 2008: 258). He also overturns historicism – the European "way of saying "not yet" to somebody else" (Chakrabarty, 2008: 8) – drawing on a long tradition of mobility in order to reclaim for India a place in a global narrative of modernity, qualifying it as a travelling culture and claiming that not only India is ready to

play a role in a modern world, but actually has always been on the forefront. In GS he traces a long genealogy of wandering Indians, ranking them as "first-class *ghumakkaṛs*" (7–12); in *Volgā se Gaṅgā* he shows the nomadic roots of Indian culture, and in his travelogues and autobiographical accounts he defines himself against European ethnographic representations of the "native". RS's texts are autoethnographies, texts constructed by the other in response to or in dialogue with those ethnographic representations by which European colonizers represented to themselves their others (Pratt, 2009: 9). Ethnological encounters through travel are not erased, as it happens in imperial representations of the other, but rather are emphasized and expressed through a non-unitary, nomadic or rhizomatic view. Here the ethnographer's gaze is situated and embodied; knowledge is always partial, it is produced in itinerary, through encounters in specific locations. There is no trace of Haraway's (1991: 189) "god-trick of seeing everything from nowhere," distancing the knowing subject from everybody and everything in the interests of unfettered power.

Strategies of positioning and embodiment

Strategies of positioning and embodiment are evident in Viśvabandhu's account of his journey. Even if faster technologies are available, he insists on travelling by train, possibly a slow train, in order to be able to see changes in the places he used to know. This is not resistance to modernity, as in Gandhi's case (Majeed, 2007: 80–96), but rather a way of emphasizing that the location RS is interested in is not a fixed place or a bounded site, but an itinerary of travel that implies a shifting positioning. A slow journey is also a strategy that abolishes distance, allows deeper human interactions and perhaps, per extension, "rambling". This is not envisioned in contrast to the utilization of the modern technology of transport. Slow travelling does not necessarily imply the peripatetic, or the renounce the comfort of technological development: RS conceptualizes a globalized welfare, where comfort and commodities are at everybody's disposal, with no

class, caste, gender or whatsoever discrimination. While sitting on the train to Nalanda, Viśvabandhu is shown recalling the old times, when to travel for poor people meant being packed like sheep into a wagon, standing, and with no place to sleep; forget reading, one had to be alert and beware of pickpockets. Now, comfortably sitting in a train provided even with a library wagon, he can converse at ease with his travel mates, getting a better idea of a global geography where multiple sites of self-differentiation are present. For example, he meets a woman professor of Andhra University, coming back from a long study journey to Madras, Sri Lanka, Bali, Australia, Borneo, Nanjing, Beijing, Siberia, Mongolia, and Tibet. This multi-centred geography, as shown in figure 1, is in contrast to the Eurocentric global geography that puts London – *the* modern metropolis – in the centre and describes the rest as a declining periphery.

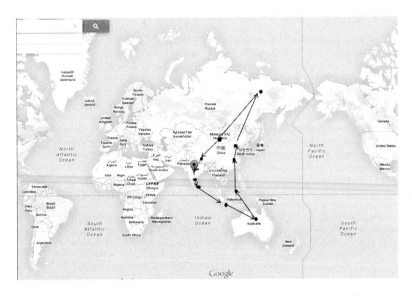

Fig. 1 The research journey of the Andhra University woman professor
(adapted from Google Maps).

The map coming out of this text traces fluid geographies, that are simultaneously local, transregional and global. It redefines

both Europe and India's place in a global geography, drawing a map of India in alternative to the image constructed by colonial ethnography, which positioned London at the centre of the world. In the new world there is no metropolitan centre, but a rhizomatic structure of interdependent villages. There is a capital, called Global city, having a population of 50.000 people, which is situated in Brazil on the equator (see figure 2). This is the residence place of the President, functionaries, and secretaries, but it is described as just a place of temporary permanence, with the members of the global assembly constantly flying in and out.

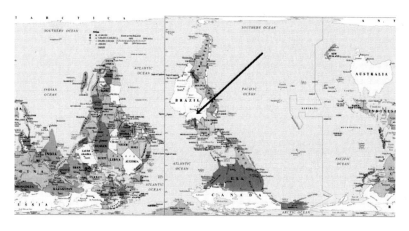

Fig 2. Map of the world in BS (adapted south-north Hobo-Dyer Equal Area Projection Map). The arrow marks the world capital.

An important strategy for space production in RS's works is embodiment. One strategy of embodiment is privileging the oral word, which always exists in a total existential situation which engages the body. In BS food and diet, hygiene, clothing, and sleep are described over and over, with a redundancy that shows how they are not simply an ingenuous account of needs, but must be interpreted as fostering insights into the complexities and difficulties of embodiment. The lifestyle of a traveller must be such as to secure one's mobility as an itinerant. As shown in GS, divesting one's self of possessions and adopting a rigorous and controlled behaviour are required conditions for those who

embrace wandering as their dharma (62–63). In contrast to the process of disembodiment that can be observed in Indian travelogues of the 19th century, he proposes what Majeed defines as "re-corporealisation" of space and movement (95), insofar he stresses the reality of the body and the embodied experience of living. Physical work is exalted as positive and rewarding. While travelling, one can experience body-reflexive practices such as fasting and *brahmācārya*, which he treats not as tools for religious or spiritual enhancement, but as a means for exploring of the nature of embodiment. Body is an on-going situation, it is connected to the mind and in order to have intelligent people one should create a healthy body and environment: in BS Viśvabandhu describes extensively the nutritional and educational policies of the 21st century, emphasizing how children in the utopian future are more intelligent not only because they receive better schooling, but also because they live in a healthier environment and have a healthier diet (79–83; 87). He is also interested in sartorial politics and the text presents redundant appreciations of the good shape of people and of the comfortable clothes they wear, pointing out the connection between good look and health, but also the democratizing, gender and class balancing effect of a more comfortable and less glamorous fashion (35).

When dwelling in travel is the norm, discipline and management of one's own embodiment and corporeality are necessary in order to maintain freedom from any kind of bonds. For example, while RS recognizes the intensity of sexual desire as a natural phenomenon, he also exhorts *ghumakkaṛs* to control and overcome sexual drives, or else they will end up sedentarizing, insofar pleasure is addictive and habits are the first bondage in human life (GS: 62–66). The choice for a celibate life is concerned not just with the body, but also with the mind and the interactions between body and mind. If a male and a female *ghumakkaṛ* decide that they want to have an intercourse and/or a relationship, they can keep on living on the road, but if they set up a family, the process of sedentarization becomes inevitable. In any case, wanderers should always behave so that they do not get ashamed

nor make others feel shameful. This is a strategy for developing at the same time self-respect and equality: if wandering individuals are free, they nevertheless must avoid doing things that might injure of cause embarrassment to people living in sedentary contexts, as their duty is to keep high the status of *ghumakkaṛs*. At the same time, when shame is associated with formal systems based on inequalities of power and status, they should not feel ashamed in performing works that are considered lower in those societies, as they have gone beyond the notion of higher or lower rank (26–31). In the envisaged 22nd century perfect society all manual works have been replaced by technology and workers do not have to toil. There is no division between intellectual and manual work, as erudition is not reserved to an elite, but is rather the basis of civil life.

RS's wandering, as well as the wandering of his *ghumakkaṛ* fictional characters, is an activity in which rigorous philosophical and scientific inquiry is always accompanied by reverence and restraint. Wandering is what keeps humans in touch with an ethical or aesthetic wondering. The utopian 22nd century globalized society envisioned by RS proposes an alternative modernity to the one imagined by the socialist Russia, the capitalistic Europe, and also to the visions offered by Indian nationalists. In the closing of the text, the 260 years old traveller Viśvabandhu and his travel mate Viśvamitra continue their journey in a world where universal equality is guaranteed by both material and intellectual equal opportunity and freedom of movement for goods and people. They embody a nomadic model for a positive globalization, thus constituting not only a local modernity, but even anticipating theories of becoming and philosophical nomadism that are now labelled as postmodernist.

Works Cited

Appadurai, Arjun, 'Grassroots Globalization and the Research Imagination', *Public Culture* 12.1 (2000), 1–19.

Braidotti, Rosi, *Transpositions: On Nomadic Ethics* (Cambridge UK: Polity Press, 2006).

Chakrabarty, Dipesh, *Provincializing Europe: Postcolonial Thought and Historical Difference* (Princeton, N.J.: Princeton University Press, 2008).

Consolaro, Alessandra, 'The Errant Philosopher: Rahul Sankrityayan's Journeys in Time and Space', *W_ndering. Exploring InFluxes and Cultures in Motion, Communication and Culture Online* special issue, edited by Consolaro, Alessandra, and Jolanda Guardi, 1 (2013), 15–28. Available from: http://www.komunikacijaikultura.org/KKSpec1.html [Last Accessed: 2nd May 2014].

Fornell, Ines, ,Von der Wolga bis zum Ganges: Die Rekonstruktion der Vergangenheit im Erzählschaffen des Hindi-Autors Rāhul Sāṃkṛtyāyan', *Studien zur Indologie und Iranistik*, 27 (2010), 29–53.

Haraway, Donna, *Simians, Cyborgs, and Women: The Reinvention of Nature* (New York: Routledge, 1991).

Lefebvre, Henry, *The Production of Space* (Oxford: Basil Blackwell, 1991).

Ludden, David (ed.), *Reading Subaltern Studies: Critical History, Contested Meaning, and the Globalisation of South Asia* (New Delhi: Permanent Black, 2001).

Machwe, Prabhakar, *Rahul Sankrityayan* (New Delhi: Sahitya Akademi, 1998).

Majeed, Javed, *Autobiography, Travel and Postnational Identity: Gandhi, Nehru and Iqbal* (New York: Palgrave Macmillan, 2007).

Mitra, Subrata, 'Sub-National Movements, Cultural Flow, the Modern State, and the Malleability of Political Space: From Rational Choice to Transcultural Perspective and Back Again', *Transcultural Studies*, 2 (2012), 8–47.

Prakash, Gyan, *Mumbai Fables* (Noida: Harper Collins Publishers, 2010).

Pratt, Marie Louise, *Imperial Eyes: Travel Writing and Transculturation* (New York: Routledge, 2008).

Puri, Bharati, 'Traveller on the Silk Road: Rites and routes of passage in Rahul Sankrityayan's Himalayan wanderlust', *China Report*, 47.1 (2011), 37–58.

Sāṃkṛtyāyan, Rāhul, 'Maiṃ kahānī lekhak kaise banā?', *Rāhul Vāṅmay*, khaṇḍ 2, *Jīvanī Aur Saṃsmāraṇ*, edited by Sāṃkṛtyāyan, Kamlā. Nayī Dillī: Rādhākṛṣṇa (1994), 595–7.

—, *Ghumakkaṛ Śāstra* (Ilāhābād: Kitāb mahal, 1994).

—, *Bāisvīṃ Sadī* (Ilāhābād: Kitāb mahal, 2011).

—, *Volgā Se Gaṅgā* (Ilāhābād: Kitāb mahal, 2011).

—. *Merī Jīvan-yātrā-1* (Nayī Dillī: Rādhākṛṣṇa, 2010).

Srivastava, Sanjay. 'Ghummakkads. A Woman's Place, and the LTC-walas: Towards a Critical History of "Home", "Belonging" And "Attachment"', *Contributions to Indian Sociology*, 39.3 (2005), 375–405.

WHERE SCIENCE FICTION
AND *AL-KHAYĀL AL-'ILMĪ* MEET

ADA BARBARO

University of Rome

In the bottom of my soul I felt madness
And deep yearning like a deep sea
I want the strange road to lead
To that coveted faraway land
To the eternal horizon
Where tender Apollo lives
I walked and walked and nothing appeared
Before me, save the road stretching out
............
With a crying thirst, I finally
Woke up and saw no Utopia.

[Nāzik al-Malā'ika, *The Lost Utopia*[1]]

Imaginary places or those presumed as such, projections of real cities on this or another planet, have always tickled the artistic whims of writers, more or less willing to create forms of otherness and alternatives to the present time. The following brief analysis aims to describe the places of encounter between science fiction and the production of *al-khayāl al-'ilmī* (Arabic for science fiction) through a structured approach that goes from a material to a conceptual setting.

Bookshops and libraries in translation

One of the most debated questions concerning the production of science fiction in Arabic lies both in its periodisation and in

1 Quoted in Khairallah (1997: 49).

the reconstruction of its emergence as a genre, including the
process of hybridisation between original and culture-specific
traits and models and conventions deriving from the much
more robust production in English and French. Without giving
in to the temptation to revive conventional monolithic views of
West dominating East, it seems nonetheless right to accept that
narrative in English influenced vocabulary as well as themes of
Arabic SF.

The first places of encounter are bookshops, where we see
the reception mechanisms between translations and adaptations
of foreign works, in the circulation dynamics of works that are
available in their original language and in translation. It is there
that the first encounter is enacted and carried out; only apparently
is such an encounter physical and material, but in reality it hints
at much wider issues. In this connection, a preliminary distinction
should be made concerning the reception of science fiction by
the Arab intellectual elite and by the more popular readership.
Although a descriptive analysis of translations may be interesting
(see, below, the works listed in the Appendix), it is equally
important to bear in mind that several science fiction writers are
and were perfectly able to read works in their original languages.

The famous Egyptian playwright Tawfīq al-Ḥakīm (b. 1898-
d. 1987) authored at least two science fiction works that could
be considered the forerunners of this literary genre in the Arab
world. Ivan, one of the main characters of his novel '*Uṣfūr min
al-Sharq* (*Bird from the East*, 1938), represents a particular type
of West that looks with disenchanted eyes at the transformation
and alienation of the European city: "What did the masses gain in
learning the dumb signs of the alphabet? Their heads have been
filled with vacuity and rubbish, as Huxley says. The level of their
taste has lowered without developing a will or a personality and
you can see them led like sheep by anyone who starts bleating in
front of a microphone: masses will always be masses" (al-Ḥakīm,
1988: 168–9, my translation). Through Ivan, Tawfīq al-Ḥakīm
mentions the author of *Brave New World* (1932) with a decidedly
reactionary slant. What matters here is that he manages to show his
knowledge of Huxley's novel. A preliminary survey of available

translations shows that the first Arabic version of this work dates back to 1947. It is therefore legitimate to suppose that Tawfīq al-Ḥakīm had already had the opportunity to read Huxley's novel, maybe in its original version or in French, while staying in Paris.[2] Huxley's influence is not isolated. In the play *Riḥla ilā al-Ghād* (*Voyage to Tomorrow*, 1958) Tawfīq al-Ḥakīm weaves a plot that is dense with reflections that recall themes retraceable in Orwell's *1984*, such as the sphere of the senses and the emergence of its alterations in a seemingly perfect society. In this case too, the author might have read the original or a French version,[3] as the first translation of Orwell's novel into Arabic was published in 1949 in Beirut.

The penetration of English science fiction works into the Arab world is explicitly thematised in the work of Egyptian author Nihād Sharīf (b. 1930 – d. 2011), who may be considered the father of Arab science fiction. In one of his most famous novels, *Qāhir al-Zaman* (*The Conqueror of Time*, 1972) through one of his characters, he openly describes the fascination of science fiction for an Arab reader:

> Egyptian literature is undoubtedly a noble, grandiose and eternal literature [...] but, as far as I am concerned, it is a realistic, traditional literature. [...] At one point, I got tired of everyday reality, [...] and thus I discarded novels based on realistic descriptions, contemporary literature which is so concrete, and I committed myself to the narrative of the future. [...] I turned to that kind of literature that follows the method of science and has allowed me to orientate my much pre-ordained life towards visions, images and feelings possessing clearly wider horizons. I read Jules Verne, Wells, Huxley and other writers, and with them I live in those mysterious worlds of theirs, travel in a world that no longer exists, witness the war of planets and rediscover the continent of Atlantis; then, I plunge into the centre of the Earth, taste godly foods, look for the invisible man, look out from Huxley's new world. (Sharīf, 1972: 136, my translation)

2 In the same year (1932), Jules Castier translated *Brave New World* into French and the publisher Plon published it with the title *Le Meilleur des mondes*.

3 Gallimard published the first French version of *1984* translated by Amélie Audiberti in 1950.

Unsurprisingly the author mentions the most authoritative examples of worldwide science fiction, at least of its first wave: Huxley, Jules Verne and Herbert G. Wells. Sharīf dedicated an essay to Jules Verne who is unquestionably among the most translated writers in the Arab world. An Arabic translation of Verne's *De la Terre à la Lune* (*From the Earth to the Moon*, 1865) was first published in 1958. *The Invisible Man* by Wells (1897) was already available in translation in 1940, whereas *The Food of the Gods* (1904) appeared in 1947, and *The New World Order* (1940) in 1947. These classics are just a few examples of worldwide science fiction works that are available in Arabic translation. Arabs can read in their language many other recent authors and, more interestingly, critical essays on science fiction, for instance those authored by Veronica Hollinger, Patrick Parrinder and Darko Suvin (see Appendix).

Encounters in writing

In his "The Medieval West and the Indian Ocean: An Oneiric Horizon", Le Goff (1970) claims that back in the Middle Ages along the routes of the great explorations, the West preferred to ignore the reality of the worlds that bordered the Indian Ocean. The lands that were located in a yet unexplored otherness became a receptacle of "dreams, myths and legends of the closed world of dreamlike exoticism, *hortus conclusus* of a mixed Paradise of ecstasy and nightmares" (Squarcini, 2006: 83, my transl.). From the Middle Ages on, the unexplored Otherness in fact has become the background of several literary works belonging to hybridised genres, thus producing a number of writings that could be described as belonging to some kind of "proto-science fiction". Science fiction lovers do not miss the fascinating details that emerge from within this world because, over the centuries, they have been progressively seduced by the existence of ever more attractive places hiding modern wonders, as Brian Stableford indicates in his *Dictionary of Science Fiction Places* (1999).

What is unknown or poorly known thus becomes exotic in the imagination of many science fiction authors. Exoticism, as a

category of taste that witnessed its greatest diffusion in the 19th century,[4] was born within a complex network of emotions that are generated by the evocation of and relationship with foreign countries. This feeling, which underpinned the works of many literary authors of the age, dwindled in the 20th century with the onset of the scientific approach to cultures but has continued to nourish the creative vein of numerous authors of science fiction worldwide.

In the *Greenwood Encyclopedia of Science Fiction and Fantasy*, Gary Westfall writes the "Islam" entry in which the scholar reflects on the influence of the Muslim world on Western science fiction, identifying a sequence of three categories subdivided as follows: works set in the Arab-Muslim world; texts focusing on characters coming from the Arab-Muslim world; writings inspired by Arab culture. A few examples of novels are mentioned for each of these three categories. Jon Courtnay Grimwood's trilogy, *Pashazade* (2001), *Effendi* (2002) and *Felaheen* (2003), belongs to the genre of allohistory; or, again, Kim Stanley Robinson's *The Years of Rice and Salt* (2002) whose events, starting from 1348, the year of the Black Plague, stretch to 2019, when only two superpowers survive in an apocalyptic scenario: the Chinese world and the Muslim one. As far as texts on Arab-Muslim characters are concerned, Westfall mentions, among others, *Stranger in a Strange World* (1961) by Robert Heinlein and *Red Mars* (1992) by Kim Stanley Robinson. The final category is dominated by the well-known case of Herbert's cycle of Dune. Other literary examples show how science fiction has welcomed the Arab-Muslim world on paper, so to speak: in the *hortus conclusus* of the Arab-Muslim world, where deplorable aspects of exoticism persist, science fiction authors like to entertain themselves by

4 Segalen (2002) presents the emergence of exoticism during the age of imperialism. Especially in the 19th century, exoticism spread as an aesthetic and ontological category, covering a significant portion of the concept of "otherness". The idea of exoticism as a cultural and political attitude is subsumed into Said's *Orientalism* (1978), with a focus on the relationship between the West and the Arab world.

suggesting settings and characters that clearly refer to the Arab world.[5]

The phenomenon is not confined to English-language literature, as shown by novels such as Luca Masali's *La perla*

5 For example, in 1986 George Alec Effinger published a cyberpunk novel, *When Gravity Fails*, set in a futuristic Middle East, exploiting the consolidated Western paranoia of a declining West faced with pressing Muslim progress. The book cover represents the main character wearing a *kefiah*. His name is Marid Audran, he is from the Maghreb and a prostitute's son, who is involved in petty criminal activities in his neighbourhood, Budayeen, a criminal area located in an unmentioned place in the Middle East. If we move now from books to television, the Bajorans, the people depicted in the famous *Star Trek* series as alien humanoids from the planet Bajor, are another example of the penetration of the Arab Muslim world into science fiction. The series' authors conceived these humanoids as an oppressed people forced to live the life of refugees and, for this reason, they have been compared to Palestinians. The *Star Trek* franchise hosts actor Alexander Sidding, known by the pseudonym of Sidding el Fadil, of a Sudanese father, in Dr. Julian Bashir's role. Still elaborating on an exclusively Muslim context, another humanoid species represented in the series is that of the Ferengi, from the Farsi word *farangi*, erroneously considered the corruption of the English word 'foreigner'. In this case, the series' authors risked falling into a stereotype, as they caricatured this society and showed its patriarchal and sexist organisation. *Babylon 5* is another TV series apt to focus on the Arab Muslim context, especially as concerns the description of the Minbari, an alien race whose name is easily decodified. These are only a few examples of place construction in science fiction in which the Arab Muslim imaginary is at work, sometimes with stereotypical traits. If we now explore the evolution of fantapolitics, Ṭālib 'Umrān's (b. 1948) *al-Azmān al-Muẓlima* (*Dark Times*, 2003) portrays the anatomy of Islamophobic and xenophobic politics, nourished by the war of terror following 9/11, without ever acquitting the perpetrators of the attack on the Twin Towers. Matt Ruff's recent novel *The Mirage*, published in 2012, is set in another universe in which the Arab world is the leader, becoming a modern and tolerant society with the passing of time, while Christian countries are fundamentalist and backward. On September 11, 2001, Christian fundamentalists hijack a number of planes and make them crash into the Tigris & Euphrates World Trade Towers in Baghdad. As a reaction to the attack, the War on Terror is started and the Arab-Persians attack the US. The plot reveals lack of knowledge of the Muslim world, as well as lingering Islamophobia. I would like to thank Dr. Salvatore Proietti, researcher in Anglo-American Literature at the University of Calabria, for offering suggestions about these cross-cultural contaminations.

alla fine del mondo (*The Pearl at the End of the World*, 1999). The exotic trend in literature fully inserts itself between the lines of this text. André Citroën, tycoon of the rising car industry, disappears during a trans-Sahara crossing he has organized. In the meantime, a harsh struggle for power takes place in a remote future between the second Ottoman Sultanate, which has become a hegemonic superpower, and its opponents: the Tetrads, Shiite female terrorists who replace the Persian chador with negative light projectors that make them look like cones of darkness, and the Cyber Dervishes, warrior monks that manage to combine the teaching of the Qur'ān with state-of the-art computer science technology. The many references to the Arab Muslim world sound slightly contrived at some times, more genuine at others.

Masali clearly echoes the adventure that actually took place on December 17th 1922, when a convoy of five Citroën Halftrack vehicles left the city of Touggourt, in the north of the Sahara, and entered the desert. The expedition was led by Georges-Marie Haardt and Louis Ardouin-Dubreuil, whose memories and impressions were later collected in *Le raid Citroën; la première traversée du Sahara en automobile; de Touggourt à Tombouctou par l'Atlantide* (1923).[6] Their travelogue well illustrates the taste of the exotic, the voice of mystery that surrounds the desert and the tone of romantic heroism that enwraps the expedition, all features that will provide the subsequent literature with several suggestions, especially when the Sahara, the Atlantis of the Tuaregs, is represented according to Western taste in science fiction, as in the works of the Libyan writer Ibrāhīm al-Kawnī (b. 1948).

Doris Lessing's creative vein and her strong relationship with the Sufi world belong to this context of fusion between two worlds far apart, along the path of the science fiction imaginary.

6 As Van Leeuwen (1997: 67) observes: "The authors sustain the spirit of adventure by descriptions of the scenery, skeletons found on the way, and inconveniences met on the road, such as technical defects, sleepy drivers, steppe fires, impregnable mountain ranges, fata morganas, storms, etcetera. Moreover, they repeatedly refer to the ferocious Tuaregs, who in the past would have a slaughtered them without mercy, but who are now pacified under French rule".

As Galin (1997: 4) argues: "Lessing has made use of Sufi ideas to enhance her own perception on human beings on earth and on other planets, in life and in afterlife". The late Nobel Prize winner deals with Sufism as a vital energy that, despite its "oriental" origins, is an intrinsic part of contemporary Western society and culture. Lessing, who had read Idries Shah's *The Sufis* (1964), was heavily influenced by Sufism and wrote several essays about it, later collected in *Time Bites* (2004).

Moreover, she authored a cycle of science fiction novels entitled *Canopus in Argos*, written between 1979 and 1983. In this case, exoticism gives way to the more mature reworking of Sufi themes while Lessing coins a new form of energy called SOWF, an acronym standing for "Substance-Of-We-Feeling". The acronym indicates a kind of energy that the declining planet Shikasta receives in order to get light in the Canopus, the universe created by Lessing. The SOWF acronym would seem to derive from the Arab root *ṣwf*, from which the world *taṣawwuf*, purity, supposedly derives, not to mention the word *ṣūf* itself, whose original meaning is wool. The cultural exchange between the two cultures here reveals a peculiar logic, modeled on a scheme, which is fully profitable and rich in meanings.

Lost cities, non-places, ideal and imaginary cities: the desert and under the sea as places of encounter

Western science fiction is sometimes influenced by the little-known and therefore mysterious Arab Muslim imaginary. In 1999, Brian Stableford published his above mentioned *Dictionary of Science Fiction Places* where he retraces the most important settings in science fiction novels, both on Earth and elsewhere, with plenty of details concerning the history, geography and inhabitants invented in over 250 years of science fiction. The scholar describes islands of wisdom, wonderful cities and dystopian realisations of utopian planning that occupy so much space in the production of science fiction and of *al-khayāl al-'ilmī*.

The quest for the ideal city is a recurrent theme in Arabic literary production and in science fiction worldwide, which best stigmatises the mistakes made by mankind, victim of its own thirst for power. It sets the two productions on a seemingly common route. Here narrative expresses an artistic value that overcomes the merely literary level. For example, the theme of the lost city and the search for Atlantis survives both in science fiction and in *al-khayāl al-ʻilmī*: the work *Rajul min al-Qāra al-Mafqūda* (*A Man from the Lost Continent*, 1997) by Syrian writer Ṭālib ʻUmrān revives this myth, as it occurred in Nautilus' prodigious adventures in *Vingt mille lieues sous les mers* (*Twenty Thousand Leagues Under the Sea*, 1870) by Verne, as well as in the enterprises of the Atlantis survivors in Alexei Tolstoy's *Aelita*, also translated into Arabic. Coping with a displaced city is always heart-rending and veiled by such a pessimistic tone as to turn utopia into nostalgia for what is lost, as the Italian novel by Adonella Corsetti *Voi cosa avreste fatto?* (*What Would You Have Done?*, 1977) also suggests.

In both science fiction productions, imaginary cities are set in the desert.[7] In Classical and non-Classical Arabic literature, the desert has always been a privileged setting of poetry and narrative. Besides the desert settings of the emerging literature at the beginnings of Islam, desert settings play a crucial role in the modern and contemporary era, with their suggestions of microcosms reminiscent of a lost Atlantis. The idyllic tones of the classical literature that science fiction often imitates come to an end, while gentrification and displacement, with their accompanying feelings, are denounced.

The *tamaddun* (civilization) theme is revived in the works of some of the best-known contemporary Arab writers, for example Ibrāhīm al-Kawnī and ʻAbd al-Raḥmān Munīf, whereas the construction of a feeling of displacement, leading up to the *ghurba*, is characteristic of Palestinian narrative. Like the sea

7 A possible synthesis between the two worlds might be retraced in Pierre Benoît's *L'Atlantide* (1919) where the descendants of the lost continent are imagined as living in the Sahara desert.

sometimes, the desert is a metaphor of marginality and of being nationless:

> The evocative similarities between the sea and the desert – their seamless borders, perils and enthralling romantic inspirations – have always been noted in Arabic literature, classical and modern. Travelling across the desert is often compared to seafaring, and rewards ahead are often enticing enough that the dangers encountered during the journey on a landscape where directions can hardly be discerned are worthwhile. The desert, however, has always been a more pervasive metaphor of exile, but necessarily of exilic wanderings, perhaps because it is the more prevalent motif in Arabic literature, especially the pre-Islamic *qaṣīda*. The Palestinian novel appropriates, internalises and problematizes the desert motif of the *qaṣīda* to make a statement about the Palestinian statelessness, exile and diaspora (2012: 76; see also Hafez, 2002: 55–83).

Inspired by Plato's *Republic* and functioning as a vital part of Classical Arabic culture, al-Fārābī (d. 950)'s *al-Madīna al- Faḍīla* (*The Ideal City*) is revived in the works of Arab science fiction writers with settings that range from sky to desert and even the deep sea (Barbaro, 2013: 164). In the production of *al- khayāl al-'ilmī* as in science fiction, the non-place acquires an urban connotation that reveals dissent against existing political systems in ways that are not too heavily disguised. The culture of narrativity condenses in the creation of non-places that are alternative to the present, as in *The Missing Man* (1968-71) by Katherine MacLean, which well connects the two traditions. The background of this American novel is explicitly a politically independent kingdom, Arab-Jordan, born in New York City in the 21st century. Its society lives in a sort of detachment from other nearby communities, considered breeding grounds of potential enemies. The narrative becomes literature of commitment, accusing the real home and foreign policies implemented by the US government in thinly disguised ways.[8]

8 According to Stableford (1999: 22): "The community of Arab Jordan closed itself off because its bitterly anti-Semitic founders considered the USA to be a Jewish country. Imitating policies and procedures

The city of the abyss is yet another imaginary location shared by science fiction and *al-khayāl al-'ilmī*, this time on sea routes. The urban nucleus may be associated here with the conception of the city as a "mental space", according to the distinction made by Henri Lefebvre in *La production de l'espace* (*The Production of Space*, 1974). For the French urbanist and philosopher who invented urban sociology, this mental space is a construction of our own mind by means of the combination of linguistic processes and perceptions. Though forged by our impressions, the result always takes place in real places, made up of a physical dimension, nature, a mental one, i.e. logical and formal abstraction, and a social one. In the Arab world two examples are *Sukkān al-'Ālam al-Thānī* (*The Inhabitants of the Second World*, 1977) by Nihād Sharīf and *Faḍā' Wāsi' bi-l-Ḥulm* (*A Wide Space to Dream*, 1997) by Ṭālib 'Umrān. In both works the features of the *Madīnat al-qā'* (the City of the Abyss) (Barbaro, 2013: 164) are portrayed along with Lefebvre's physical component – the tangible space, in other words – and the mental one, which can be led back to the logical and mental abstractions that arise in the reader's minds. The social component is made manifest in the two works when the authors introduce the elite of young scientists intent on preventing the construction of nuclear weapons.

Something, however, jars with science fiction from the start: the submarine settings, endowed with a Western flavour, so to speak, turn out to be constrained places of collision, thus strengthening the hypothesis of their possible definition as "mischievous places". In fact, the Arabic works here quoted seem to meet in a famous city of the abyss, the *Undersea City* (1958) by Frederick Pohl and Jack Williamson. It is a kind of "false friend", a delusive opportunity for relationship between the two cultures that soon

already instituted by Black Harlem, they built a wall around a four-block-square area and declared it to be an Arabian Cultural Preservation Club. In the hope of making themselves feel more at home they filled a central plaza with desert sand and planted date-palms, as well as building a mosque and a minaret".

betrays its deception.[9] In Pohl and Williamson's case, whose fruitful friendship led to the publication of a trilogy commonly categorised as juvenilia – where *Undersea Quest* (1954) and *Undersea Fleet* (1956) are the two other titles – there is no real encounter between science fiction and *al-khayāl al-'ilmī*. The two English-language authors imagine a capitalist project of colonisation of the underwater world that is not consonant with the redemptive and utopian aim that underscores the construction of the Arab cities of the Abyss.

The undersea settings in Robert Ellis Dudgeon's *Colymbia* (1873) are also dissonant "mischievous places". After getting lost, a group of English people take shelter in the city of the abyss and give rise to a new society by mixing with its native dwellers. Some kind of pacifism, instead, underlines another undersea setting in James White's *The Watch Below* (1965), translated into Italian by Piero Anselmi as *Incontro nell'abisso* and published by the SF series Urania on December 8th 1985.

In the Arabic works, the prevailing theme is the onset of a society led by young scientists and willing to improve the destiny of humanity. Yet the undersea world is far from being a safe place from the Arab Muslim viewpoint, when one considers the uneasy relationship with the sea in the Muslim tradition, with the exception of the South Seas, undoubtedly more favourable to Islam's peaceful expansion across the sea.

Hourani's *Arab Seafaring in the Indian Ocean in Ancient and Early Medieval Times* (1951) helps explain the contacts through sea routes as integrated into the Muslim cosmography that regards the seas as favourable to Islam's expansion in the world. The volume focuses on the phenomenon of Islam's expansion by sea with the description of routes and vessels heading for the Indian Ocean and the East, which neglects the Mediterranean as a fruitful and not only physical contact zone between neighbouring

9 Worth mentioning among recent films is James Cameron's *Aliens of the Deep* (2005), whose director had already shown his predilection for undersea locations in the final scenes of *The Abyss* (1989).

peoples.[10] Besides the lines of conquest, there is an uninterrupted link between the Arab world and the sea, along routes enabling contacts that are not solely physical or dependent on political reasons. The creation of utopian societies set in undersea spaces revives what Xavier de Planhol (2000: ii-iii) defines the contact of "l'*homo islamicus* avec la mer",[11] though he may occasionally be subject to "sea sickness" in several expeditions.[12]

While the authors of *al-khayāl al-'ilmī* thus privilege the setting of their perfect societies in the deep sea, their preferences seem to jar with the general tendency of Arab writers to set their works on the land. How the land is conceived has set the standards of identity narratives, as the land is an essential factor to establish the conditions of social life and the political system. Yet, the tradition of sea explorations within Islam is a long one, which also arose from writing travel guides that supported European expeditions over time (Allen, 1988: 14).

> Arabs, or perhaps we should say Arab *literati*, retained an uneasy relationship to the sea. Of course Arab literature produced such a quintessential seafarer as Sindbad the Sailor, who cannot resist the lure of the sea and stubbornly plunges from one adventure into another. Indeed Sindbad has become the symbol of man challenging the waves and addicted to sailing and maritime trade (van Leeuwen 2009: 13–14).

10 See Hourani (1971: xv): "[...] I have limited myself to Eastern writers, with only a brief excursion into the Mediterranean, where Arabs have been sailing since the beginning of Islam. Such a division can be justified by the many contrasts between the two seas and the land bordering them in past times: geographical conditions, contacts with other nations, types of ships, methods of navigation were all different."

11 De Planhol's (2000) writing is an extensive, excellent overview of authors and works dealing with the relationship between Islam and the sea. Mollat (1993) is a collection of thought-provoking lessons given by the author at the Sorbonne in 1972.

12 According to de Planhol (2000: iii), while Christians were unlikely to boast of the perception of the sea as dangerous and managed to become less prone to fear, Muslim travelogues expanded on the risks of the sea almost with complacence. This resulted from the fact that Christians were better seamen than Muslims were.

When they play with marine representations, Anglophone writers describe the underwater world as a territory dominated by the presence of Fate, the perceived danger of monsters, storms, shipwrecks and so on. Arab science fiction writers, instead, seem to rehabilitate this constrained territory, creating a redeeming image that counterbalances the Western perceptions of science fiction writers. We may find a few parallels as concerns the sea route when we compare Verne's *Vingt mille lieues sous les mers* with Sharīf's *Sukkān al-'Ālam al-Thānī*. A noticeable time gap exists between the two texts. The former is set in the last quarter of the 19th century while the latter is set at the end of the 20th century. Nevertheless, the two texts turn out to be linked to each other. The Egyptian writer does not create any prominent personality like Verne's Captain Nemo, but

each of the scientists in the city of the abyss is Captain Nemo: they all ran away from the land, coming from different countries to realise that the ideal of global peace will last only a few months, if not just weeks. The reason why both Captain Nemo and the scientists in the city of the abyss were obliged to run away from the mainland is the same; and the fatal progress that awaits them is the same, even when a double game takes place letting both leaders and scientists escape from the city of the abyss. From that moment they will decide to give life to new institutions in Australia. (Qāsim, 1993: 224–225, my transl.)

The ocean abyss, the remote dwelling of marine beings, becomes the place in which almost perfect urban models are realised in Arab science fiction.

Drawing inspiration from some of the best-known themes in fantasy, in science fiction sea cities become a refuge for scientists who try to escape from the boring life on their planet. The sea depths host the foundations of urban centres alternative to the real ones, safe microcosms ruled by science and good governance. (Barbaro 2013: 164)

The imagined communities that arise in the Arabic-language imaginary represent the mother country or, at least, the ideal one that waits to be founded. Utopia thus becomes the ideal of a different nation, circulated by novels and newspapers (Anderson,

2006: 25).[13] These imaginary places are slowly peopled by animated creatures that make them meaningful: bodies come to life and "produce space by creating directions and boundaries and by imposing a spatial organization on their surroundings. Places are incorporated into systems of organization, based on the difference between various directions, dualities, oppositions and symmetries" (van Leeuwen, 2009: 61).

In both worlds – the Anglophone and the Arabic – the culture of narrativity thus finds multiple versions, reworking *topoi* that are ascribable to different epochs and cultures which find mutual harmony and compete to dignify a genre too often neglected as merely popular. In these writings a tradition belonging to both the Western and Arab worlds is revived: the heritage of a glorious past is set in a new frame that is supported by new forms of knowledge and taste built on the pillars of modernity and scientific and technological development.

The directions here outlined reveal the constant and actual cross-fertilisation between different science fiction traditions and invite one to consider *al-khayāl al-'ilmī* with the attention it deserves. Ultimately Arab science fiction lends itself to critical investigations and reflections that are far from banal and would seem to provide the disenchanted West with new interpreting paradigms for the still misunderstood Arab Muslim world.

13 Anderson (2006: 25) argues that "Why this transformation should be so important for the birth of the imagined national community of the nation can be seen if we consider the basing structure of two forms of imagining which first flowered in Europe in the Eighteenth century: the novel and the newspaper. For these forms provided the technical means for "representing" the *kind* of imagined community that is the nation."

Appendix: Arabic translations of works of/on science fiction

Asimov, Isaac, *al-Baḥth 'an al-'Anāṣir (The Search for the Elements)*, Trans. by Ismā'īl Ḥaqqī (Cairo: al-Maktaba al-Anjlū al-Miṣriyya, 1968).
—, *al-Ḥaqīqa wa-l-Khayāl (Fact and Fancy)*, Trans. by Jābir 'Abd al-Ḥamīd Jābir (Cairo: Dār al-Ma'ārif, 1965).
—, *al-'Ilm wa-Āfāq al-Mustaqbal*, Trans. by 'Aṭṭā al-Sayyid (Cairo: al-Hay'a al-Miṣriyya al-'Āmma li-l-Kitāb, 1995).
—, *Isti'rād al-Rūbūṭ (The Complete Robot)*, Trans. by Fidā' Dakrūb (Beirut: Dār al-Ḥadātha, 1994).
—, *Manābi' al-Ḥayā (The Wellspring of Life)*, Trans. by 'Abd al-Ḥamīd Ibrāhīm Zakī (Alexandria: Dār al-Ma'ārif, 1970).
Booker, M. Keith, and Thomas, Anne-Marie, *al-Murji' fī Riwāyāt al-Khayāl al-'Ilmī (The Science Fiction Handbook)*, Trans. by 'Āṭif Yūsuf Maḥmūd (Cairo: al-Markaz al-Qawmī li-l-Tarjama, n.d.).
Bradbury, Ray, *Fahrenheit 451*, Trans. by Mājida Manṣūr (Cairo: Dār al-Shurūq, 2008).
—, *al-Mirrīkh Janna: Qiṣaṣ min al-Khayāl al-'Ilmī*, Trans. by Nāẓim Mazhar (Cairo: Dār al-Shu'ūn al-Thaqāfiyya al-'Āmma, 1999).
Clarke, Arthur et al., *2001 wa-Ba'dahā: Khayāl 'Ilmī (2001 an Beyond: Science Fiction Stories)*, Trans. by Samīr 'Izzat Naṣṣār (Amman: al-Ahliyya li-l-Nashr, 2006).
—, *Luqaṭāt min al-Mustaqbal: Baḥth fī Ḥudūd al-Mumkin (Profiles of the Future: an Inquiry into the Limits of the Possible)* (Cairo: al-Majlis al-A'lā li-l-Thaqāfa, 2002).
Collins, Michael, *Ḥamalū al-Nār min al-Qamar: Riḥlat Rā'id al-Faḍā' (Carrying the Fire: An Astronaut's Journey)*, Trans. by Mīshīl Taklā (Cairo: al-Maktaba al-Anjlū al-Miṣriyya, 1978).
Csicsery-Ronay, Istivan Jr., *'Adab al-Khayāl al-'Ilmī wa-l-Ittijāhāt al-Naqdiyya' (Science Fiction/Criticism)*, Trans. by Aḥmad Hilāl Yass, *Majallat al-Naqd al-'Adabī al-Fuṣūl*, 71 (2007), 107–130.
Gattegno, Jean, *Adab al-Khayāl al-'Ilmī (La Science-Fiction)*, Trans. by Mīshīl Khūrī (Damascus: Dār Ṭalās, 1990).
Golding, William, *Ālhat al-Dhubāb (Lord of the Flies)*, Trans. by Qāsim Maḥmūd (Cairo: Riwāyāt al-Hilāl, 1984).
Griffiths, John, *Thalāth Ru'à li-l-Mustaqbal: Adab al-Khayāl al-'Ilmī al-Amrīkī wa-l-Brīṭānī wa-l-Rūssī al-Sūfītī (Three Tomorrows: American, British and Russian Science Fiction)*, Trans. by Ra'ūf Waṣfī (Cairo: al-Majlis al-al-A'lā li-l-Thaqāfa, 2005).
Ḥakīm, Tawfīq al-, *Arinī Allāh* (Cairo: Dār al-Shurūq, 2007).
—, *Masraḥ al-Mujtama'* (Cairo: Maktabat al-Ādāb, 1950).
—, *'Uṣfūr min al-Sharq* (Cairo: Maktabat Miṣr, 1988).
Hassler, Donald M., *'Tajaddud al-Khayāl al-'Ilmī' (The Renewal of "Hard" Science Fiction)*, Trans. by Muḥammad Bihansī, *Majallat al-Naqd al-'Adabī al-Fuṣūl*, 71 (2007), 146–55.

Hirsch, Lester, *al-Insān wa-l-Faḍā'* (*Man and Space*), Trans. by Ṣalāḥ Jalāl (Cairo: 1972).

Hollinger, Veronica, 'al-Khayāl al-'Ilmī wa-Mā Ba'da al-Ḥadātha' (*Science Fiction and Postmodernism*), Trans. by 'Illā' al-Dīn Maḥmūd, *Majallat al-Naqd al-'Adabī al-Fuṣūl*, 71 (2007), 131–45.

Huxley, Aldous, *al-'Ālam al-Ṭarīf* (*Brave New World*), Trans. by Maḥmūd Maḥmūd (Cairo: Dār al-Kātib al-Miṣrī, 1947).

James, Edward, and Mendlesohn, Farah, *Dalīl Kambrīdj li-l-Khayāl al-'Ilmī* (*The Cambridge Companion to Science Fiction*), Trans. by Ayman Ḥulmī et al. (Cairo: al-Markaz al-Qawmī li-l-Tarjama, 2014).

Lem, Stanislaw, *Cyberiada*, Trans. by Hidā' 'Abd al-Fattāḥ (Cairo: Maktabat al-Usra, 2000).

—, *Masraḥ al-Khayāl al-'Ilmī* (Cairo: Maktabat al-Usra, 2000).

—, *Solaris*, Trans. by Muḥammad Bidarkhān (Damascus: Dār al-Ḥiṣād li-l-Nashr wa-l-Tawzī', 1990).

Martinson, Harry, *Anyārā: Qaṣīda Malḥamiyya min al-Khayāl al-'Ilmī* (*Aniara: an Epic Science Fiction Poem*), Trans. by 'Ābid Ismā'īl (Damascus: Dār al-Madā li-l-Thaqāfa, 2006).

Orwell, George, *1984*, Trans. by Anwar al-Shāmī (Beirut: al-Markaz al-Thaqāfī al-'Arabī, 1949).

Parrinder, Patrick, *Ẓilāl al-Mustaqbal. H. J. Wīlz wa-l-Qiṣaṣ al-'Ilmiyya wa-l-Nubū'a* (*Shadows of the Future: H.G. Wells, Science Fiction and Prophecy*), Trans. by Bakar 'Abbās (Cairo: al-Majlis al-A'lā li-l-Thaqāfa, 1997).

Shneider, Susan, *al-Khayāl al-'Ilmī wa-l-Falsafa* (*Science Fiction and Philosophy: From Time Travel to Superintelligence*), Trans. by 'Izzat 'Āmir (Cairo: al-Markaz al-Qawmī li-l-Tarjama, n. d.).

Scholes, Robert, and Rabkin, Eric R., *Āfāq Adab al-Khayāl al-'Ilmī* (*Science Fiction: History/Science/Vision*), Trans. by Ḥusn Ḥusayn Shukrī (Cairo: al-Hay'a al-Miṣriyya al-'Āmma li-l-Kitāb, 1996).

Sharīf, Nihād, *Qāhir al-Zaman* (Cairo: Dār al-Hilāl, 1972).

—, *Sukkān al-'Ālam al-Thānī* (Cairo: Maṭba'at al-Amāna, 1977).

Silverberg, Robert, *Qiṣaṣ... min al-Khayāl al-'Ilmī* (*The Nebula Award Stories Number Eighteen*), Trans. by Fatḥī 'Abd al-Fattāḥ (1986).

—, *Qiṣaṣ min al-Khayāl al-'Ilmī* (*Science Fiction Short Stories*), Trans. by Fatḥī 'Abd al-Fattāḥ (Cairo: 1983).

'Umrān, Ṭālib, *al-Azmān al-Muẓlima* (Damascus: Dār al-Fikr, 2003).

—, *Faḍā' Wāsi' bi-l-Ḥulm* (Damascus: Dār al-Fikr, 1997).

—, *Rajul min al-Qāra al-Mafqūda* (Damascus: Dār al-Fikr, 1997).

Verne, Jules, *'Ishrūn Alf Farsakh^in taḥta Saṭḥ al-Mā'* (*Vingt mille lieues sous les mers*), Trans. by Ḥusayn Muḥammad al-Qabbānī (Cairo: al-Hay'a al-Miṣriyya al-'Āmma li-l-Kitāb, 2005).

—, *Min al-Arḍ ilā al-Qamar* (*De la Terre à la Lune*), (Cairo: Maṭba'at al-Ma'mūn, 1958).

—, *al-Rihān al-'Ajib ḥawla al-'Ālam fī 80 Yawm^an* (*Le Tour du monde en quatre-vingts jours*), (Cairo: Riwāyāt al-Hilāl, 1970).

Wells, Herbert George, *Ālat al-Zaman* (*The Time Machine*), Trans. by Samīr

'Izzat Naṣṣār (Cairo: al-Ahliyya li-l-Nashr wa-l-Tawzī', 2005). *Riḥla fī Dunyā al-Mustaqbal* (*The Time Machine*), with an introduction by André Maurois, Trans. by Niẓmā Lūqā (Cairo: Dār al-Hilāl, 1962).

—, *Ālat al-Zaman wa Bilād al-'Imyān* (*The Time Machine and The Country of the Blind*) (Amman: Dār al-Nasr, 2005).

—, *al-Ghadhā' al-Siḥrī* (Cairo: Dār al-Hilāl, 1964).

—, *Awwal Man Waṣala al-Qamar* (*The First Men in the Moon*), Trans. by Mīshīl 'Abd al-Aḥad (Cairo: Wizārat al-Ta'līm al-'Ālī, 1979).

—, *Ḥarb al-'Awālim* (*The War of the Worlds*), Trans. by Samīr 'Izzat Naṣār (Amman: Dār al-Nasr, 1997).

—, *Jazīrat al-Duktūr Mūrū* (*The Isle of the Doctor Moreau*), Trans. by Amīra 'Alī 'Abd al-Ṣādiq (Cairo: Āfāq li-l-Nashr wa-l-Tawzī', 2013).

—, *Ma'ālim Tārīkh al-Insāniyya* (*The Outline of History*) (Cairo: Lajnat al-Ta'līf wa-l-Tarjama wa-l-Nashr, 1948-1956).

—, *Mughāmara fawqa al-Qamar* (*A Trip to the Moon*), (Cairo: Riwāyat al-Hilāl, Dār al-Hilāl, 1961).

—, *Mūjaz Tārīkh al-'Ālam* (*A Short History of the World*), Trans. by 'Abd al-'Azīz Tawfīq Jāwid (Cairo: al-Hay'a al-Miṣriyya al-'Āmma li-l-Kitāb, 1999).

—, *al-Rajul al-Khafī* (*The Invisible Man*), Trans. by 'Izzat al-Sayyid Ibrāhīm (Cairo: Riwāyāt Jadīda, 1940).

—, *Ta'ām al-Āliha wa Kayfa Jā'a ilā al-Arḍ* (*The Food of the Gods and How It Came to Earth*), Trans. by Muḥammad Badrān (Cairo: Dār al-Kātib al-Miṣrī, 1947).

—, *Tārīkh al-Sayyid Būllī* (*The History of Mr Polly*) (Baghdah: Maktab al-Shams li-l-Nashr, 1990).

Works Cited

Allen, Roger, *The Arabic Literary Heritage: The Development of Its Genres and Criticism* (Cambridge: Cambridge University Press, 1998).

Anderson, Benedict, *Imagined Communities: Reflections on the Origin and Spread of Nationalism* (London: Verso, 2006).

Barbaro, Ada, *La fantascienza nella letteratura araba* (Roma: Carocci, 2013).

de Planhol, Xavier, *L'Islam et la mer: la mosquée et le matelot, VIIème-XXème siècle* (Paris: Perrin, 2000).

Galin, Müge, *Between East and West: Sufism in the Novels of Doris Lessing* (Albany: State University of New York Press, 1997).

Hafez, Sabry, 'The Novel of the Desert: Poetics of Space and Dialectics of Freedom', in *La Poétique de l'espace dans la littérature arabe moderne*, Edited by, Hallaq, Boutrus, Ostle, Robin, and Wild, Stephen (Paris: Presses Sorbonne Nouvelles, 2002), pp. 55–83.

Hourani, George F., *Arab Seafaring in The Indian Ocean in Ancient and Early Medieval Times* (Princeton, N.J.: Princeton University Press, 1971).

Khairallah, Asʿad E., 'The Greek Cultural Heritage and the Odissey of Modern Arab Poets', in *Tradition and Modernity in Arabic Literature*, Edited by, Issa J., Boullata, and Terry, De Young (Fayetteville: University of Arkansas Press, 1997), pp. 43–61.

Le Goff, Jacques, 'L'Occidente medievale e l'Oceano indiano: un orizzonte onirico' (1970), in *Tempo della Chiesa e tempo del mercante, e altri saggi sul lavoro e la cultura nel Medioevo* (Torino: Einaudi, 1977), pp. 257–77.

Mollat, Michel, *L'Europe et la mer* (Paris: Seuil, 1993).

Ouyang, When-chin, *Poetics of Love in the Arabic Novel: Nation-State, Modernity, and Tradition* (Edimburgh: Edimburgh University Press, 2012).

Qāsim, Maḥmūd, *al-Khayāl al-ʿIlmī, Adab al-Qarn al-ʿIshrīn* (Cairo: al-Haya al-Miṣriyya al-ʿĀmma li-l-Kitāb, 1993).

Segalen, Victor, *Essay on Exoticism: An Aesthetics of Diversity* (Durham: Duke University Press, 2002).

Squarcini, Federico, *Ex Oriente lux, luxus, luxuria: storia e sociologia delle tradizioni religiose sudasiatiche in Occidente* (Firenze: Società editrice fiorentina, 2006).

Stableford, Brian, *The Dictionary of Science Fiction Places* (New York: The Wonderland Press, 1999).

Van Leeuwen, Richard, 'Cars in the Desert: Ibrāhīm al-Kawnī, ʿAbd al-Raḥmān Munīf and Andrè Citroën', *The Arabic Literatures of the Maghreb: Tradition Revisited or Response to Cultural Hegemony?*, Edited by Isabella, Camera d'Afflitto, *Oriente Moderno*, special issue, 16 (77), 2–3 (1997), pp. 59–72.

—, 'The Narrative of the Ship: al-Muʾaqqit, Maḥfūẓ and Jabrā', in *Intertextuality in Modern Arabic Literature since 1967*, Edited by Luc Willy, Deheuvels, Barbara, Michalak-Pikulska, and Paul, Starkey (Manchester: Manchester University Press, 2009), pp. 13–32.

CONSTRUCTING FORMS OF OTHERNESS

DR. FU MANCHU AND SHANG CHI
From *Yellow Peril* to *Yellow Power* in Western Imaginary

CRISTINA COLET

University of Turin

During the 1910s-1920s, Dr. Fu Manchu embodied the evil icon of the *Yellow Peril* in Western imaginary, both in literature and cinema. In Western Countries, in particular the United States and England, Chinese immigrants represented a threat. On the one hand, the massive presence of Chinese immigrants was a hard problem there. In the United States, they arrived during the so-called period of the "Gold Fever", when many of them worked as coolies for the building of railway lines. The Chinese Exclusion Act (1882) prohibited the migration of Chinese laborers to the US (Fig. 1). On the other hand, the Chinese community represented a peril because of its increasing and uncontrollable economic power. Moreover, the Chinese seemed to refuse Western social life as shown by the proliferation of Chinatowns in Europe and America and their tendency to live in closed societies. From the beginning of the 20th century, many writers started to create "unsavory" characters that embodied Western concerns about the Chinese presence and, in particular, the possibility that their power would increase and crush Western economic power. One of the most prolific authors in this field, Sax Rohmer (1883-1959), affirmed that "the Chinese still believe that the yellow race can dominate the world, and the Oriental mind spells out the means in a manner altogether opposite to Western ideas" (Rohmer, 1922: 26).

Undoubtedly, Dr. Fu Manchu emerges as the most representative figure of this kind of literature, an embodiment of the Yellow Peril. First described by Sax Rohmer, Dr. Fu Manchu personified the Western vision of the Orient: "Imagine a person, tall, lean, and feline, high shouldered with a brow like Shakespeare and

a face like Satan, a close-shaven skull, and long, magnetic eyes of the true cat-green."[1] He represents a threat against Western powers and personifies all Western fears: "the cruel cunning of an entire Eastern race, accumulated in one giant intellect with all the resources of science past and present [...] the *Yellow Peril* incarnate in one man", a perfect product of orientalist thought.[2]

During the 1910s and 1920s, first literature – with authors such as Sax Rohmer, Jack London, Emile Driant, Philip F. Nowlan, Arthur J. Burks, and Howard Ph. Lovecraft – and then cinema and comics dealt extensively with the *Yellow Peril*. The characters of Long Sin, Pearl White's rival in the film *The Exploits of Elaine* (1914) and Wu Fan in *The Perils of Pauline* (1919) transposed some of Fu Manchu's features onto the silver screen.

For twenty years and more, literature and the movie industry created stereotypes and legends about the Chinese, described as dangerous and evil figures. In the 1930s, a new kind of representation of the yellow terror emerged, not in the form of dreadful figures who threatened Western countries, but quiet characters who gave their contribution to Western societies, being part of them. Another kind of stereotype, that of not too manly males, served to represent Chinese characters as not perceived as a danger by Western readers and audiences. It is the case of Charlie Chan, a corpulent and not very masculine investigator, or Mr. Wong.

Only many years later, Western countries, the United States in particular, start looking at Chinese migrants no longer as strangers but as part of their societies. During the 1960s-1970s, heroic Asian characters spread across Western imaginary. They are martial arts heroes in films directed by Chang Cheh and King Hu and played by actors like Bruce Lee, who for the first time have positive roles in USA productions, in contrast with the minor or negative roles assigned before to Asian actors.

1 *This incipit is present at the beginning of each book of Dr. Fu Manchu's series.*

2 "Yet the Orientalist makes it his work to be always converting the Orient from something into something else; he does this for himself, for the sake of his culture, in some cases for what believes is the sake of the Oriental" (Said, 1979: 67).

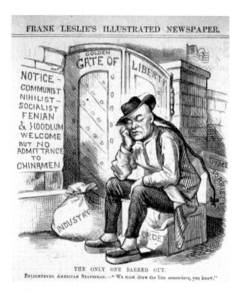

Fig. 1 – "The only one barred out", caricature of Chinese man seated outside "Golden Gate of Liberty" (source: Library of Congress); in the caption, at the bottom: "Enlightened American Statesman. – We must draw the line *somewhere, you know.*"

Marvel created a comic strip character, Shang Chi, who embodied the naturalization of the Chinese character in the United States imaginary by killing his father, Dr. Fu Manchu. The circle is closed. Evil Fu Manchu, who for many years threatened American people with the idea of repressing Western culture and creating a hybrid race, is finally defeated by his own son, the only hero capable of rescuing and protecting America, becoming himself an American icon.

The Yellow Peril: A historic introduction

To understand the emergence and meaning of the Yellow Peril we need to consider the two Opium Wars (1839-1842 and 1856-1860), when China was defeated by the English army. The Qing

Dynasty lost power and was at the mercy of Western nations. It eventually came to its end with the foundation of the first republic in 1911. In this period, the image of the *Dongya bingfu* (*Sick man of East Asia*) began to spread all over the world. Western countries began to mock Chinese people because of their loss of territories by the mid-19th century: "Although probably coined by a Chinese intellectual, in the nationalist discourse, *dongya bingfu* became a label imposed on China and the Chinese body politic by Japan and the West. Curing the 'sick man', a savagely self-critical image, has thus long been a central goal of China in order to gain international respect and status" (Ashew, 2009: 108).

From the mid-19th century Chinese people left their poor country and migrated to the United States and Europe, especially England. They created their communities, then called "Chinatowns" by Western people, modeled on the *tong*, a kind of Chinese community which offered support to fellow countrymen, but was inaccessible to non-Chinese:

> [They] live in the cheapest possible residential areas; most have a natural desire to live among "their own kind", where they can use their native language, find foods to which they are accustomed. And recreate familiar, if modified, social organizations. In addition, the pressure of the larger host community usually encouraged and sometimes forced, ethnically distinct groups to live in rather strictly defined areas (Daniels, 1988: 18).

Westerners organized a business of guided tours for white men willing to visit Chinatowns and try the thrill of their sinister atmosphere, crossing the doorstep of transgression and ambiguity (Haenni, 2002: 21).

A *tong* often created a sort of parallel and controlled society where Chinese people did business without contributing to the local economy and sending back to China, instead, all their income. For this reason, American and English people looked at them with suspicion. Moreover, the massive immigration consisted of men, while women remained in China to take care of the family, which raised a great concern about possible

threatening affairs between Chinese men and Western women. The affirmation of a mixed race was a dreadful idea. It is from this atmosphere of suspicion and fear of "the Other" that many authors created evil literary characters of Chinese origin.

Dr. Fu Manchu's literary and cultural precursors

In *The Yellow Danger*, M.P. Shiel (1899) theorized the idea that the Chinese that we find in Sax Rohmer's *Fu Manchu* might invade Europe. Asian people (not only Chinese) in that period were perceived as a threat to Western countries. It was the time when Western armies were engaged in Asian campaigns such as the Boxer Rebellion (1899-1900) and the Russo-Japanese War (1904-1905). The fear of a "yellow man" invasion and the consequent diffusion of the idea of a yellow peril were endemic. The derogatory term "yellow face" had been introduced because of the color of the skin that was neither 'white nor black' to European eyes, but something different, something else. By that time, it began to assume negative connotations. The philosopher Hegel (1928) thought that once the Orient had been the cradle of civilization, whereas the West had taken over this role in modern times. From the Western intellectual's point of view, Chinese civilization represented humanity in its infancy, and *Rotteck-Welckersches Staatslexikon* (1848: 155–191) stated that China lacked history and the "yellow face" lived on the margin of civilization.

The yellow peril may be traced further back in European culture:

> rooted in medieval fears of Genghis Khan and the Mongolian invasions of Europe, the Yellow Peril combines racist terror of alien cultures, sexual anxieties and the belief that the West will be overpowered and enveloped by the irresistible, dark, occult forces of the East (Marchetti, 1993: 2).

Arguably, there was a sort of revival of this fear around the turn of the 19th century, when Chinese people migrated in large

numbers to the West. Because of their different habits, they were perceived as "aliens" to Western cultures, and consequently not accepted: "Culturally biased perceptions of the Chinese as uniquely non-Western in dress, language, religion, customs, and eating habits determined that the Chinese were inferior" (Wong, 1978: xx).

Sax Rohmer significantly contributed to the cause of xenophobia and the yellow menace. He imagined the meeting of Dr. Fu Manchu with an ambiguous Chinese man, Mr. King, in the Limehouse district of London. Rohmer did not know much about Chinese culture. His work is characterized by stereotypes, such as the yellow face, the description of a Chinese character as not very manly, the long nails, the long mustache and queue, etc. Nevertheless, thanks to a couple of publications on the Middle East, Rohmer gained fame as an expert about the East and he was commissioned to write an article about Limehouse, where a large Chinese community had settled. Middle and Far East were rather confused and almost interchangeable components of "the Orient" for Western intellectuals. Indeed, "the Orient was almost a European invention" (Said, 1979: 73).

Rohmer's character resumed features of previous supervillains. However, he was to conquer the West not by means of modern powerful technologies, but employing the guerrilla and bandit techniques of Eastern dacoits and thuggees, an evident criticism against the archaic and retrograde East, still very far from Western modernity.

The success of this book series depended on the way the author emphasized current stereotypes about the Chinese:

> The role of stereotypes is to make visible the invisible, so that there is no danger of it creeping up on us unawares; and to make fast, firm and separate what is in reality fluid and much closer to the norm than the dominant value system cares to admit (Dyer, 1999: 245–251).

Previous works influence the evil atmosphere that permeated Dr. Fu Manchu's publications. A London opium den was a crucial location in Dickens' *The Mystery of Edwin Drood* (1870), whereas Dr. Fu Manchu's duplicity is reminiscent of the ambiguous and

sinister Professor Moriarty of the Sherlock Holmes stories, described in Vanity Fair as: "the most diabolic and contemporary villains in the annals of crime" (1930: 56).

The representation of the Yellow Peril in cinema

Other authors fostered the "Yellow Peril" cause. In *The Unparalleled Invasion* (1914), London imagined genocide to prevent a Chinese invasion of Western countries. In *Armageddon 2419 A.D.* (1928), Nowlan futurized a Chinese invasion of the US. The hero Antony Rogers, renamed Buck Rogers in comic strips, defeated the invaders. From 1916 to 1917, H. Irving Hancock published a book series with the sinister Li Shoon as main character. However, Rohmer's contribution was the most trenchant.

The movie industry was equally active in exploiting the Yellow Peril threat to sell movies and earn money. Literary and cultural stereotypes offered the cinema new alien characters that combined something monstrous and ambiguous and perfectly matched the audience's fears.

As pointed out by Sabine Haenni (2002: 22–23), quite a number of early movies focused on Chinese matters: from real life reportages like *Chinese Procession no. 12* (1898), *Parade of Chinese* (1898), *Scene in a Chinese Restaurant* (1903), *Chinese Shaving Scene* (1902), *Scene in Chinatown* (1903) to popular fantasy movies about Chinatown like *The Heathen Chinese and the Sunday School Teachers* (1904), *Rube in an Opium Joint* (1905, preceded in 1894 by the lost American short black-and-white silent film *Chinese Opium Den*), and *The Yellow Peril* (1908).

The Yellow Peril could be ascribed to the slapstick genre. A Chinese servant causes a lot of trouble in a rich house. The yellow peril in the title, therefore, sarcastically alludes to the turning upside down of the house by a clumsy Chinese rather than to the fear of a Chinese political and economic invasion.

The tours across the seediest parts of towns inspired films like *Lifting the Lid* (1905) and *The Deceived Slumming Party* (1908). They are characterized by a horrific impulse:

The film's sensational impulse, its longing not only to exhibit and display Chinatown but its insistence on the unimaginable horrors hidden within Chinatown, emphasizes the exotic difference of the Chinese, their inability to assimilate (Haenni, 2002: 26).

Film series like *The Exploits of Elaine* (1916), with Pearl White as the female heroine, or *The Perils of Pauline* (1919) introduced the Dr. Fu Manchu-inspired Chinese villain onto the silver screen. The Chinese villain Long Sin, Pearl White's antagonist, is described as "the prototype of the Chinese villain, that is, the monstrous Mandarin, Long Sin's only conspicuously Asian characteristic, excluding his peculiar name, was a drooping mustache, later to be known as the Fu Manchu mustache" (Wong, 2002: 56). His substitute Wu Fang in *The Perils of Pauline* is depicted as follows:

> besides Wu, the inscrutable, Long Sin, astute though he was, was a mere pigmy – his slave, his advance agent, as it were, a tentacle sent out to discover the most promising outlet for the nefarious talents of his master (Stedman, 1971: 39).

As Western countries did not assign Chinese people a place in their societies, at the beginning of the 20th century, main roles were precluded to Chinese characters, in both literature and cinema, not even as villains. Dr. Fu Manchu marked a turning point in this connection. Nevertheless, the role was played by a Western actor in disguise and with Chinese make up. Western performers also played positive roles of Chinese men and women. In *Broken Blossoms* (1919), Richard Barthelmess played Chen Huan, a Buddhist monk who falls in love with the beautiful and virgin Lucy (Lillian Gish) and tries in vain to save her from her father's violence. In *Red Lantern* (1919), the Russian dancer and actress Alla Nazimova played the role of a mixed race girl, rejected by both communities (Chinese and Western). This practice contributed to the affirmation of the term "yellow face", used to stigmatize white people who played Chinese roles in disguise and needed a special yellow cream on their face to look like "real" Chinese.

Fig. 2 – Boris Karloff as Dr. Fu Manchu in *The Mask of Fu Manchu* (1932)

However, it is with the representation of Dr. Fu Manchu (Fig. 2) that the Chinese villain takes on diabolic traits and occupies a central position in the narration. From Warner Oland, to Boris Karloff and Christopher Lee the image of the diabolic Dr. Fu Manchu remains impressed in the audience's minds. In particular, Boris Karloff and Christopher Lee who came from horror productions, contributed to permeating Dr. Fu Manchu's image of horrific traits. In comparison with the literary works by American and English authors, these actors intensified the stereotyped features of Chinese characters:

> Throughout the first four decades of the twentieth century, the Asian serials (many of which were thematically anchored in Hollywood's creation of Asian racism, the goal of which was "the destruction of the white race") constituted a significant aspect of the American motion picture industry's stock in trade. Nonetheless, the fact remained that although the industry was conspicuous in its efforts to encourage the belief that the whites were being victimized by the Chinese, the "white star system" and the general profitability of the serials excluded the Asian artists from both stardom and profit, while accounting for a simultaneous increase in cinematic and social anti-Sinicism. Because all major Asian characters "were played by white men in yellow face" the industry had a free hand in racially portraying Asian characters (Wong, 2002: 58–59).

Anna Mae Wong and Sessue Hayakawa are an exception. Anna Mae Wong was chosen to represent the female villain on the screen and obtained many important roles. She played, for example, with Marlene Dietrich in *Shanghai Express* (1932). In *Piccadilly* (1927), she plays a positive role against main-stream Chinaphobia and represents the woman threatened by white men. She anticipates the character of the dragon lady in the Fu Manchu series, embodied by his daughter Lin Moy in *Daughter of the Dragon* (1931).

Dr. Fu Manchu, both in literature and in the movies, is described as a diabolic man prepared to wage war against Western powers by all possible means, including the initiation of his sons to his hatred for the West. On the other hand, he is not a manly dark hero, although endowed with evil power. This is a form of control that Western authors employed to avoid miscegenation and prevent the creation of a new hybrid race, that Dr. Fu Manchu intended to achieve as his goal. In a certain way in literature, and even more in movies and comics, Dr. Fu Manchu is presented with a deadly aspect. He must not be capable of generating life, but rather of repressing Western culture and civilization.

The issue of miscegenation is not overcome with the positive character of Charlie Chan that moves on the line of yellow peril but with different connotations. Stereotyped Chinese characters in literature, cinema and in media in general probably stirred the attention of and irritated Chinese public opinion. As part of a cultural campaign aiming at avoiding an international crisis and a possible diplomatic incident with the Chinese government, from the mid-1920s magazines like *Collier's, Sunset, Saturday Evening Post* proposed a new kind of Chinese man. Charlie Chan, created by Earl Derr Biggers, combined traditional Chinese Confucian values and attitudes, but was respectful of American laws and rules. Like his evil predecessors, however, he was neither manly nor sexy, being portrayed as very fat and with some female manners in his way of moving. He had 14 sons but was not attractive for Western women. Risks of miscegenation were thus controlled and neutralized, answering to another, maybe even more subtle, kind of racism:

He was very fat indeed, yet he walked with the light dainty step of a woman. His cheeks were as chubby as a baby's, his skin ivory tinted, his black hair close-cropped, his amber eyes slanting. As he passed... he bowed with a courtesy encountered all too rarely in a work-a-day world, then moved on (Biggers, 1925).

A traditional Chinese male model, the *caizi jiaren* of Chinese literature, inspired this description. He is not a virile hero, but the intellectual and literate man who did not have visible muscles because he worked only with his mind and intelligence, without using his body.

Despite his unattractive appearance, Charlie Chan plays the important role of an investigator whose task is to discover crime and deliver criminals to justice.[3] Using his intelligence to serve the American government, he is thus comparable with the Chinese *caizi jiaren*. American readers and spectators appreciated him as a Chinese servant of the American. His inquiries are carried out in China and in the US so as to create a bridge between the two states and legitimize the rehabilitation of a Chinese as a positive character. However, his peculiar and unusual way of speaking English, as well as his mispronunciation, are indicators of a stereotype, which still hang on:

[He] was remotely threatening to white Americans as the continuing fear of an Asian immigration deluge was at last superfluous. [...] Chan became symbolic of the harmless and comical cultural and racial characteristics of a people barred from American shores because of their race (Wong, 2002: 60).

Western actors played Charlie Chan. Warren Oland left Dr. Fu Manchu in favor of this kind of half hero. The yellow peril was far from being overcome.

James Lee Wong is yet another investigator who inherited the baton of justice from Charlie Chan. The step to American naturalization is accomplished, since he is "the thoroughly

3 This character was inspired by Chang Apana, a real investigator who lived on the Isle of Hawaii and captured many criminals, he was of Chinese origin but he was well introduced in American society.

Americanized, Yale-educated Chinese-American secret agent".[4]
The American audience identified with him as a naturalized
American who defended American people. He became a
popular hero, a step further in comparison with Charlie Chan.
His character is delineated in twelve stories authored by Hugh
Wiley and published in *Collier's* during the 1940s and then in
book format, *Murder by the Dozen* (1951). Many movies were
dedicated to James Lee Wong (5 played by Boris Karloff). As
a kind of photo story drawn from Boris Karloff's movies, Dell
created a comic strip.

*Rehabilitating the Chinese image in contrasting the Yellow
Perils: Shang Chi and Bruce Lee*

Shang Chi is the Marvell comics' hero who had the task of killing
Dr. Fu Manchu, his father, and thus completed the rehabilitation
circle of the yellow peril. Created by Steve Englehart and Jim
Starlin for the comic series "Master of Kung- Fu" and published
by Marvel, Shang Chi is a typical example of intermedia product
that takes inspiration from Rohmer's series, to create a comic
strip where the main character, Shang Chi (Dr. Fu Manchu's son)
has to kill Dr. Petrie (Dr. Fu Manchu's rival) following Dr. Fu
Manchu's orders, but when he discovers his father's evil nature
and his aim to conquer the world and obliterate Western culture,
he decides to defeat his own father as an ally of the West. This
cruel defeat, with a sad fight between father and son, allows
Westerners to defeat Dr. Fu Manchu definitively. For Shang Chi
it is the only way to be rehabilitated to Westerners' eyes.

Shang Chi became popular in the 1970s when another "real"
Chinese, Bruce Lee, became an idol for many Westerners,
converting the idea of the Chinese man as a sick man of Asia
into that of a powerful and vigorous man. Bruce Lee became

4 Wiley, Hugh, "In Chinatown", *Collier's* 93:26 (June 30, 1934), 12–13;
"The Thirty Thousand Dollar Bomb", *Collier's* 94:4 (July 28, 1934), p.
17; "No Witnesses," *Collier's* 97:7 (February 15, 1936) pp. 10–11.

an icon who, through his body and martial art performances, expressed the idea of an invincible body that defeated enemies, even Westerners. He embodied the idea of Yellow Power, but in a positive way.

> The Yellow Power translates a sort of recovered pride, a claim of identity to overturn negative stereotypes that for many years have bombarded the Asiatic community in North America and the overseas popular culture of whom that community is referent (Gomarasca, 2001: 10).

Shang Chi and Bruce Lee's (Fig. 3) loyalty and integrity in fighting against corruption and evil rehabilitate the Chinese image to the Western audience's eyes. Bruce Lee's manhood and force inspire Shang Chi's character. The great appreciation of Bruce Lee's movies and the increasing interest in martial arts in Western countries convinced American producers and editors to create a new character, Shang Chi, to defeat the symbol of Yellow Peril, Dr. Fu Manchu, and subvert the stereotypes against Chinese culture.

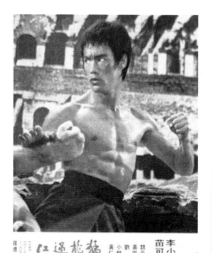 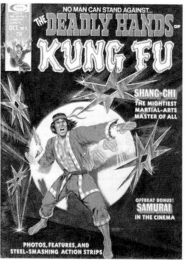

Fig. 3 – Left: Bruce Lee in The Way of the Dragon (1972); Right: Shang-Chi (October 1974).

Works Cited

Ashew, David, 'Sport and Politics. The 2008 Beijing Olympic Games', in *The European Union and China: Interest and Dilemmas*, Edited by Georg Wiessala, John Wilson, and Pradeep Taneja (Amsterdam: Rodopi, 2009), pp. 103–20.

Bergfelder, Tim, 'Negotiating Exoticism: Hollywood, Film Europe, and the Cultural Reception of Ann May Wong', in *Stars: The Film Reader*, Edited by Lucy Fischer, and Marcia Landy (London–New York: Routledge, 2003), pp. 59–75.

Biggers, Earl Derr, *The House without a Key* (Indianapolis: Bobbs-Merrill, 1925).

Bowman, Paul, *Theorizing Bruce Lee. Film-Fantasy-Fighting-Philosophy* (Amsterdam-New York: Rodopi, 2010).

Chan, Jackinson, *Chinese American Masculinities. From Fu Manchu to Bruce Lee* (New York–London: Routledge, 2001).

Choy, Christine, 'Cinema as a Tool of Assimilation: Asian Americans, Women and Hollywood', in *Color: 60 Years of Images of Minority Women in Film: 1921-1981*, Edited by Pearl Bowser (Santa Cruz: UC Santa Cruz Library, 1993), pp. 23–5.

Chung, Sue Fawn, 'From Fu Manchu, Evil Genius, to James Lee Wong, Popular Hero: A Study of the Chinese-American in Popular Periodical Fiction from 1920 to 1940', *The Journal of Popular Culture*, 10, 3 (1976), 534–47.

Colet, Cristina, 'Pericolo Giallo. "Musi gialli" nel mirino della letteratura e cinematografia angloamericana', *Orientalismi*, Edited by Marco Dalla Gassa, *Cinergie*, 3 (2013), 70–9.

Daniels, Roger, *Asian America: Chinese and Japanese in the United States since 1850* (Seattle: University of Washington Press, 1988).

Demel, Walter, *Come i cinesi divennero gialli. Alle origini delle teorie razziali* (Milano: Vita e Pensiero, 1997).

Dyer, Richard, 'The Role of Stereotypes', in *Media Studies: A Reader*, Edited by Paul Marris, and Sue Thornham (Edinburgh: Edinburgh University Press, 1999), pp. 245–51.

Frayling, Christopher, *The Yellow Peril. Dr. Fu Manchu and the Rise of Chinaphobia* (New York: Thames and Hudson, 2014).

Gomarasca, Alessandro, *La Bambola e il robottone. Culture pop nel Giappone contemporaneo* (Torino: Einaudi, 2001).

Haenni, Sabine, 'Filming "Chinatown": Fake Visions, Bodily Transformation', in *Screening Asian Americans*, Edited by Peter X. Feng (New Brunswick: Rutgers University Press, 2002), pp. 21–52.

Hegel, Georg Wilhelm Friedrich, 'Vorlesungen über die Philosophie der Geschichte', in *Sämtliche Werke*, Ed. by Hermann Glöckner (Stuttgart: Frommann, 1928).

Kashiwabara, Amy, *Vanishing Son: The Appearance, Disappearance, and Assimilation of the Asian-American Man in American Mainstream Media* (1996), http://www.lib.berkeley.edu/MRC/Amydoc.html.

Marchetti, Gina, *Romance and the "Yellow Peril": Race, Sex, and Discursive Strategies in Hollywood Fiction* (Berkeley–Los Angeles: University of California Press, 1993).

Musser, Charles, 'Ethnicity, Roleplaying, and American Film Comedy: From Chinese Laundry Scene to Whoopee 1894-1930', in *Unspeakable Images: Ethnicity and the American Cinema*, Ed. by Lester Friedman (Urbana: Illinois University Press, 1991), pp. 39–81.

Rohmer, Sax, 'The Black Mandarin', *Collier's*, 70.19 (November 4, 1922).

Said, Edward, *Orientalism* (New York: Vintage Books, 1979).

Shiel, Matthew Phipps, *The Yellow Danger* (London: Grant Richards–New York: R. F. Fenno, 1899).

Stedman, Raymond William, *The Serials: Suspense and Drama by Installment* (Norman: University of Oklahoma Press, 1971).

Studlar, Gaylyn, 'Out-Salomeing Salomè: Sance, the New Woman, and Fan Magazine Orientalism', in *Visions of the East: Orientalism in Film*, Ed. by Matthew Bernstein, and Gaylyn Studlar (New Brunswick: Rutgers University Press, 1997), pp. 99–129.

Tchen, John Kuo Wen, Yeats Dylan, *Yellow Peril! An Archive of Anti-Asian Fear* (London–New York: Verso, 2014).

Wiley, Hugh, 'In Chinatown', *Collier's*, 93.26 (June 30, 1934), 12–13.

—, 'The Thirty Thousand Dollar Bomb', *Collier's*, 94.4 (July 28, 1934), 17.

—, 'No Witnesses', *Collier's*, 97.7 (February 15, 1936), 12–13.

—, *On Visual Media Racism: Asians in the American Motion Pictures* (Denver: University of Denver, 1978).

Wong, Eugene F., 'The Early Years: Asians in the American Film Prior to World War II', in *Screening Asian Americans*, Ed. by Peter X. Feng (New Brunswick: Rutgers University Press, 2002), pp. 53–70.

Von Rotteck, Carl, Welcker, Carl, *Das Staat-Lexikon oder Encyklopädie der Staatswissenschaften*. XII (Altona: Hammerich, 1848), pp. 155–91.

Xiao, Zhiwei, 'Anti-Imperialism and Film Censorship During the Nanjing Decade 1927-1937', *Transnational Chinese Cinemas. Identity, Nationhood, Gender*, Ed. by Sheldon Hsiao-Peng Lu (Honolulu: University of Hawaii Press, 1997), p. 35.

'Specialists in Crime', *Vanity Fair* (September 1930), 56.

POPOBAWA'S IMAGE AS REPRESENTATION OF "THE UNCANNY" IN SWAHILI COLLECTIVE IMAGERY

GRAZIELLA ACQUAVIVA

University of Turin

Popobawa – Swahili for "bat-wing" – is known as a shape-shifting spirit that appeared on Zanzibar Island at the end of the 1960s and in 1995. Reports were rife that adults of both sexes had been sodomized by this spiritual entity, or *jini*, giving rise to a real mass psychosis (Walsh, 2009: 2). Strangely, these incidents coincided with elections marked by violence in the streets. Further Popobawa's outbreaks were publicized worldwide in 2000, 2001 and 2007 when the reports once again spread from Zanzibar Island to mainland Tanzania[1] (Newton, 2009: 179). Zanzibar's history, cosmology and social customs have helped to make Popobawa very interesting in the study of Swahili culture.

The aim of this contribution is to provide an examination of Popobawa narratives, including insights from psychoanalytic theories. In particular, I consider Popobawa as an uncanny and archetypal image connected with images of evil[2] and death. The "Uncanny" as a feeling of something strangely familiar is concerned with the 'supernatural' and involves feelings

1 It seems that in Kenya similar events occurred: the port of Mombasa has also been famous for its troublemaking spirits. *The Standard* of Nairobi published a report in June 2008. The article was prompted by a rash of apparent *jinn* sightings several weeks earlier in Mombasa's Old Town. The sightings seemed connected to a number of abandoned houses in the old quarter, said to be haunted by *jinn*. The newspaper reported strange goings-on beneath nearby bridges, includes sodomies and rapes by invisible persons (Mango, 2008).

2 In Sub-Saharian Africa, evil is often associated with wildness, deviance, chaos, sexual lust and predatory forces and when in such psychoses chaos erupts from the unconscious, it is clear that it is seeking new symbolic ideas which will embrace and express not only the previous order but also the essential contents of disorder.

of uncertainty regarding the reality of who one is and what is being experienced (Royle 2013: 1–8). It is also characterized by a particular "take" on things more ancient, archaic. The human imagination embraces the dark side of cosmology for understanding certain lived events and experiences and creates the evil image along the line of its own culture. If for Freud the uncanny denotes an awareness of a repressed psychic content that has been projected onto an object and experienced as something strangely familiar, in Jungian terms it describes an encounter with the so-called "archetypal shadow" or shadow archetype[3] (Huskinson, 2015: 82).

Popobawa as a psychic image

Jung's explanation for the archetypes, or primordial images, that surface in cultural and religious literature is that they are the products of what he calls "the collective unconsciousness".[4] Popobawa, which has been referred to as a "sodomizing homosexual bat spirit", is variously thought of as *jin* or spirit, demon, monster or an embodied form of witchcraft (Crozier 2011: 36). It is described as a black, one-eyed, bat-like creature with big wings, which looms large and casts a shadow on the ground or as a Dracula who loved to sodomize people – usually men, rarely women and children – when they are asleep (Böhme, 2013: 338; Parkin, 2004: 114; Mohamed, 2000: 21).

From these descriptions, I will try to extrapolate certain elements connected with psychic images. As we can see, the Popobawa's distinctiveness is that of a basic instinct creature. From a

3 In Jungian perspective, an archetype is a psychosomatic concept that links the body and the psyche as well instinct and image. It is recognizable through its outer behaviours (Wamitila, 2001: 99).

4 Jung created the concept of "collective unconscious" which enables an empirical psychology to investigate more closely the intermediate realm of a single reality or *unus mundus*. It appears to be the sum of archetypal structures that manifest themselves in typical mythological motifs in all human beings (von Franz, 1995: 75, 84).

psychoanalytic perspective, the form and the meaning of instincts are psychologic archetypes that become narrative archetypes. In this case, I think, it is possible to associate Popobawa with the archetypal figure of Dionysus, a mythical character associated with the dark elemental forces of nature, excitement and terror. The blind forces of ferocity associated with Dionysus' energies are responsible for irrational actions that may have far-reaching effects (Wamitila, 2001: 109–10).

The *popo* or *bat* is the only mammalian species which rejected the common paths of mammalian life and took to the air. Because of its nature, it seems to be an uncanny creature that has departed from the ordinary conditions of mammalian existence and whose queer habit of hanging head downwards is like a self-imposed penance for reversing the order of nature.[5] This could be an image/symbol that expresses an essential unconscious factor and therefore refers to something essentially unconscious, unknown, indeed to something that is never quite knowable. It is the perceptible expression of inner experience as, for instance, could be the death sense perception. According to Knappert, spirits often take the shape of birds, especially those species that are associated with death and the *nafsi* or human soul is sometimes pictured as a bat, *popo*, or as *popo wa mzimu* ("bat of the spirit"), a kind of nightly butterfly (Knappert, 1971: 74, 77). The bat figure is also present in Swahili traditional poetry connected with the suffering of a dying person and his anxiety after death is announced by the messenger of God, as we can read in the following verses:

Roho yako itokapo
When your soul comes out
Wahudhuri kama popo

5 There is an event that happened to Jung in Kenya and is narrated by Baynes (2015: 98), which makes clear the identification of the bat with the ghostly effects: when the natives of Mount Elgon were trying to explain to Jung the character of Ayik – the Elgonyi equivalent of Set – they dramatized a man alone in a cave at night, whose blood suddenly becomes congealed with terror as a bat's wing strikes his face. In describing this moment of panic the fear of ghosts was present in the mind of the narratives.

it will be present like a bat
Wake waume walipo
where there are women and men
Mauti mekuzingia
death has already surrounded you (Knappert, 1971: 35)

According to Knappert, dying is described by the traditional writers as a very painful process. Once the soul is delivered from the body, it hovers about like a bat, but stays in the vicinity of its last abode, yet forever separated from its beloved relatives (Knappert, 1971: 35).

Popobawa was also described as a vampire, another uncanny image whose myth – following Freudian psychoanalysis – was grounded in archaic images of repressed fears. From a Jungian perspective, vampire images reflect significant experiences and issues that are universal in human lives around the world. In fact, Jung believed that the vampire image could be understood as an expression of what he termed the "shadow", those aspects of the Self[6] that the conscious "ego" was unable to recognize. From a Jungian point of view, "shadow" or "shadow archetype" is a term that Jung used to refer to the negative side of personality seen as that which a person has no wish to project. For Jung, the theory of the shadow was a metaphorical means of conveying the prominent role played by the unconscious in both psychopathology and the perennial problem of evil (Wamitila, 2001: 117). Usually, the shadow contained repressed wishes, anti-social impulses, morally questionable motives and childish fantasies of a grandiose nature. The vampire could be seen as a projection of those aspects of the personality, which according to the conscious mind should be dead but nevertheless live. In this way, Jung interpreted the vampire as an unconscious complex that could gain control over the psyche, taking over the conscious mind like an enchantment. The image of the vampire in popular culture serves as a useful scapegoat since – through the mechanism of projection – the

6 The Self-archetype is an archetype of supreme authority and is both the circumference of the psyche and the objective centre. It is the centre of the conscious mind (Wamitila, 2001: 101).

vampire allows disowning the negative aspects of human personality (Melton, 2011: 556).

Living with demons or daimones[7]

Zanzibar and mainland Tanzania are known as places where many types of spirits live. They are called *pepo* on mainland, *shetani* or *jini* on the coastal area (Erdtsieck, 2001:4). According to Giles, many spirit types belong to the symbolic world of "up-country" or *bara* which is portrayed as pagan, wild and uncivilized, the opposite of the coastal Arab spirit realm. Arab spirits not only symbolize the long history of Middle Eastern and Islamic influences on the Swahili coastal society but more specifically the Arab cultural hegemony that replaced a more syncretic Swahili tradition as a result of the rise of power of the Omani Sultanate in Zanzibar during the 19th century. In contrast to the Arab spirit world, that of Pemban spirits or "*kipemba* spirits" is non-Islamic and more African and rural in character. They can be powerful protective spirits associated with family and village but they can also be very dangerous sorceries associated with the enemies of the society (Giles, 1995: 95–8).

Walsh reported that during a spiritual assault on a married couple one of the neighbors went into a possession trance and her possessory spirits struggled violently with the phantom intruder until it fled. The spirit then called for a local *mganga*, a Swahili term referred to a healer's figure, and explained to him what the cause of the island's current miseries really was. A couple of years before a whale had been found beached on the shore and people came from far and wide to cut out portion of its flesh and blubber. At the same time, a woman had gone in trance and her possessory spirit declared that this whale was the child of a greater spirit, warning people not to eat or else they would suffer

7 The word *daimon* comes from *daiomai* which means "divide", "distribute", "assign" and originally referred to a momentarily perceptible divine activity (von Franz, 1995: 109).

the consequences (Walsh, 2009: 27). In Jungian terms, the whale – as well as many other water creatures – is the Great Mother archetypal representation. In depth psychology, the term *Great Mother* is used in a metaphorical sense. As Mother Nature this is the goddess of fertility and one who dispenses nourishment. As water or sea, she represents the source of all life as well as symbolizing the unconscious.

Popobawa as image of "evil" in the context of political challenges

Zanzibar – consisting of Unguja, the main island, Pemba and a number of isles – is a semi-autonomous state within United Republic of Tanzania. Its strategic location in the Indian Ocean, the trade from Africa, Asia and the Middle East and intermarriage between various ethnic groups helped to create a cosmopolitan society and complicated demographic identities. Until the introduction of Omani Arab rule in the course of the 17th century, which turned Zanzibar into an epicenter of the East African slave trade, the islands' African and Arab populations are said to have lived in peaceful co-existence (Mbogoni, 2005: 198), and the "indigenous" people of the islands adopted the name of Shirazi (Lofchie, 1965: 24–6).

The new system of Arab rule and African slavery left a legacy on Zanzibari perception and identity: those who classified themselves as Arabs or associated to them were called *mabwana*, a Swahili term meaning "privileged masters", and those who were classified *Africans* identified themselves as victims of the old slave society. When, in 1890, Zanzibar became a British protectorate, British rule kept this kind of prejudice by grouping people into ethnic compartments, preserving a social structure that favored Omani Arabs over Africans (Mohammed, 1991: 7–8).

The formation of ethnic identity on Pemba Island evolved in a different manner: greater intermarriage between Africans and Arabs and a common acceptance of Shirazi identity decreased racial tension. It was during the Second World War that the

economy of the two islands picked up. The period between 1945 and the end of 1963 was one of stability and progress. The British aimed at independence for the Zanzibar Protectorate in December 1963. On January 12th 1964, the Afro-Shirazi Youth League's members and their leaders headed by John Okello, a man from Uganda who had lived on Pemba Island for some time, forced their way into the police arsenal and defeated the sultan's guards. In a few days between five and ten thousand people were killed, Zanzibar became a quasi-socialist state ruled by Abeid A. Karume and his Afro-Shirazi Party. The government of Zanzibar and Tanganyika merged to form the United Republic of Tanzania with Julius K. Nyerere as President and Karume as first vice-president. It seems that the merger was not a political reality. In fact Unguja and Pemba remain divided between supporters of CCM (*Chama cha Mapinduzi* or "Revolutionary Party"), that is still ruling in Tanzania and the CUF (Civic United Front) which dominates Pemban politics (Knappert, 1992: 35–6).

Stories about the Popobawa surfaced on Pemba in 1965, a year after the 1964 revolutionary massacres. The most common tale claims that a tribal elder angered by his neighbors conjured up a brutal genie to wreak vengeance upon them. The legend says that he lost control of his creation which became the night-prowling Popobawa (Newton, 2009: 179). According to Parkin (2004: 114), at the time of the first registrations of political parties in anticipation of the 1995 multiparty elections there, arose a witch-finding movement led by a man named Tokelo from Tanga on Tanzanian coast. Since Tokelo came to be regarded by the people of Pemba as a fake, some argued that Popobawa movement was his revenge for not having been paid for his services there.

Similar events recurred in 1995, lasting from just before Ramadhan in Pemba but continuing in Zanzibar town on Unguja island where Popobawa's victims referred of being attacked by an amorphous intruder that "pressed" or "crushed" their chest and ribs.[8] Without doubt, the victims experienced extreme terror

8 The Popobawa's victims seem to show the typical symptoms of sleep-paralysis: persons wake up paralyzed, sense a presence in the room, feel

and were often frozen speechless when they were assaulted (Parkin, 2004: 114; Walsh, 2009: 3, 25). On Unguja there were extensive preparations in the run-up to the first national multiparty elections: promise by the new party in power of the continuation of the stability and steady progress that they claimed to have achieved since independence.[9] The old Revolutionary party or CCM retained its control by winning twenty-six parliamentary seats against Civic Union Front party or CUF's twenty-four. Members of ethnic minorities and those with property expressed considerable fear that the elections would erupt in fighting and massacre on the scale of 1964 Zanzibar's unrest (Parkin, 2004: 118–20). Thus Popobawa's image has been associated with fear.

Attack of the "grotesque" is not uncommon in the African landscape.[10] In 1990s another shape-shifting entity forcing sexual intercourse on its victims and named Njombo-bla appeared in Sierra Leone. This time victims were only women which reported that a "dark mist" appeared in the middle of the night and seemed to put them into an immobilized swoon. Njombo-bla attacks correspond with the rise to prominence of the Kamajors, a Mende hunter-militia. They were not simply a militia, their local support and authority arose from their association with a much older traditional Mende society of magical and heroic hunters[11] (Henry, 2015: 243–44). According to Ellis and ter Haar (2013: 37), a notable feature of politics in many parts of Africa is the

fear or even terror, and may hear buzzing and humming noises or see strange lights. A visible or invisible entity may even sit on their chest, shaking, strangling, or prodding them (Blackmore, 1998).

9 In 1995 Zanzibar elections two political parties competed: CCM or Chama cha Mapinduzi – Revolutionary Party and CUF or Civic Union Party (Parkin, 2004: 120).

10 Other African monsters looking like Popobawa are Kangamoto and Impundulu. The first one is a flying monster living in the legends of Angola and Congo and described as a flying reptile, a sort of pterosaur; the second one is a supernatural bird from Zulu and Xhosa folklore. This bird is sometimes a shape shifter, that can appear as a human and sometimes said to be a supernatural familiar that guards a witch or witch doctor. It will attack people and drink their blood.

11 In the magic world of the unconscious, the figures of the hunter and the witch correspond to the negative parental *imagos* (Jung, 1959: 235).

importance attributed to spiritual beings that are perceived to be a source that is at stake in political environments.

Both Zanzibar and Sierra Leone events are clear examples of how a religious mechanism is involved in a political context and used as methods to reorder power maintaining fighting discipline or intimidating the opposition.

Popobawa as a fantastic character

With the liberalization of Tanzanian economy in the 1990s, transnational flows of video film horror reached the country. It seems that horror film makers highlight social taboo by visualizing the suppressed. In this period, Popobawa was the subject of several newspaper and internet articles and blogs (Böhme 2013: 331). The spiritual entity became part of popular cultural products such as novels, blogs and films. In 1996, an anthology of four stories was published by East African Educational Publishers. Among them, *Mazishi ya Popo* (*Bat's Burial*) which was turned into a big event despite the fact that bat was unknown to other animals.

In 2002, John P. Oscar and E. Soko, two cartoonists from Dar es-Salaam, recalled the theme of the shadow in their serialized story *Kisiki cha Mpingo* (*The Stump of the Ebony Tree*). The story is part of the wonder-comic branch *Katuni za Miujiza* (*Fantastic Comics*). The main character is the sorcerer Kisiki cha Mpingo whose own kingdom, which he rules from his residence in an old hollow tree, is the "evil". Sometimes he uses oversize bat-wings to fly wherever he wants. His opponent is the witch Bibi Chonjoluchonya. They use *runinga za kiasili* ("traditional television set"). This is a description for magic mirrors which magicians use to observe events just like on surveillance cameras. The word for mirror-image in Kiswahili is *kivuli* ("shadow"). Thus it is possible to see a shadow in the mirror. As spirits and dead persons also appear as shadows and they are visible in the mirrors. According to Beez, this concept emerged long before mirrors were in common use in East Africa, but earlier at water ponds and pools (Beez, 2004: 83–5).

In 2007, Oscar published *Usiku wa machungu:Mikononi mwa Popobawa* ("Night of bitterness: In the hands of Popobawa"), a Gothic novel whose title is very similar to another novel, *Joram Kiango. Mikononi mwa Nunda* ("Joram Kiango. In the hands of the beast", 1986) written by Ben R. Mtobwa. In the following years, Oscar's novel was adapted for the screen. According to Thompson (2014: 84–85), the horror film *Popobawa* directed by Haji Dilunga in 2009 is the first Tanzanian film to visualize homosexuality. The film revolves around a woman who uses witchcraft to create the *jini*, ordering him to sodomize members of her family as revenge for their wronging her. Thompson stresses the fact that the film both reflects and perpetuates fears that homosexuality is becoming more common in Tanzania, and dramatizes anxiety about women's power that exceeds the lesbian menace communicated via analogy.

Actually, homosexuality is not uncommon in Tanzania and several reports have highlighted a societal acceptance of sex between men in Zanzibar where homosexual practices were tolerated during Ramadhan when heterosexual intercourse is prohibited (Middleton, 1991: 120). The pre-revolutionary period has been described as a time when the orthodox Muslim majority cohabitated in harmony with homosexuals. After the 1964 Zanzibar revolution, something changed as a consequence of the expatriation of many religious scholars in the wake of revolution, followed by an importation of foreign scholars (Saleh, 2009: 199–200). According to Arnold (2002: 148) in the post-revolutionary era the past tacit understanding that guaranteed the rights of minorities and those of homosexuals started to be changed: Zanzibari government, for instance, monitored *taarab* musical troupes after a virulent exchange of *taarab* songs concerning homosexuality and in 1984, a formal censorship was established to review these songs before they could be performed and broadcasted on the government radio. On the mainland homosexuality played a considerable role in Dar es-Salaam political circles during German colonization and a number of court cases pertaining to same-sex sexual violation were tried in this German period that came to an end in 1919,

after which Tanganyika became a British colonial protectorate. The film and consequently the Popobawa's figure seem to be a mere representation of the Freudian uncanny. It is thus conceived as a terrifying feeling that comes from something experienced, previously repressed and then subsequently and suddenly emerging into consciousness.

Popobawa's popularity has gone beyond the Tanzanian borders, and in 2008 it was the subject for the popular TV series "Destination Truth" (Season 2, Episode 4) by Neil and Michael Mandt. The team travels to Zanzibar to find the Popobawa. Furthermore, in Episode 6 of the first season of "The Secret Saturdays", a Cartoon Network original animated series created by J. Stephens, a pink, one eyed, bat-like creature identified as a Popobawa is featured in the opening scenes. The series revolves around a family of cryptozoologists who travel the world seeking out mythical monsters in part to study and in part to protect them from those who might wish to do these creatures harm. In the episode mentioned above, the creature is shown dive bombing the Saturday family, apparently guarding its nest. Though the Popobawa is only featured for few minutes, its presence on a children's cartoon show is very intriguing.

Concluding remarks

Analyzing the political history of Zanzibar, the power inherent in an ancient system was mobilized to create chaos in a modern political mainstream by the re-enactment of an old narrative about hidden devils or *daimons* symbolizing true events of historical suffering. For some time it was said that mythological images of primitive cultures derive from external factors such as the given presence of the sun, moon, and vegetation and so on. Jung pointed out that when one links images or other imaginary elements to an outer object, this is a psyche-made response to something external and never an exact reproduction. In individual consciousness, "ego" is a layer of unconscious psychic contents that have been acquired as a result of the individual's biographical experience:

repressed and forgotten material. It seems that when in such mass psychosis chaos erupts from the unconscious, it is seeking new symbolic ideas which will embrace and express not only the previous order but also the essential contents of disorder – a creative achievement has become a necessity. When there is mass psychosis, only a new creative archetypal conception, brought up from the depths, can stop the development towards a catastrophe.

Works Cited

Arnold, N., 'Placing the shameless: Approaching poetry and the politics of Pemba-ness in Zanzibar, 1995-2001', *Research in African Literatures*, 33 (2002), 140–66.

Baynes, H.G., *Mythology of the Soul (Psychology Revivals): A Research of the Unconscious from Schizophrenic Dreams and Drawings* (New York: Routledge, 2015).

Beez, J., '*Katuni za Miujiza*. Fantastic Comics from East Africa', *International Journal of Comic Art*, 6, 1 (2004), 77–95.

—, and Kolbusa, S., '*Kibiriti ngoma*. Gender Relations in Swahili Comics and Taarab Music, Stichproben', *Wiener Zeitschrift für Kritische Afrikastudien*, 3 (2003), 49–71.

Blackmore, S., 'Abduction by Aliens or Sleep Paralysis?', *Skeptical Inquirer*, 22.3 (1998) [Available on line http://www.csicop.org/si/show/abduction_by_aliens_or_sleep_paralysis].

Böhme, C., 'Bloody Bricolages: Traces of Nollywood in Tanzanian Video Films', in *Global Nollywood. The Transnational Dimension of an African Video Film Industry*, Ed. by M. Krings, and O. Okome (Bloomington & Indianapolis: Indiana University Press, 2013), 327–344.

Crapanzano, V., 'Half-disciplined chaos: thoughts on contingency and trauma', in *Genocide and Mass Violence. Memory, Symptom, and Recovery*, Ed. by D.E. Hinton, and A.L. Hinton (Cambridge: Cambridge University Press, 2013), pp. 157–72.

Crozier, I., 'Making up Koro: multiplicity, psychiatry, culture, and penis striking anxieties', *Journal of the History of Medicine and Allied Sciences*, 67 (2011), 36–70.

Ellis, S., G. ter Haar, 'Spirits in Politics: Some Theoretical Reflections', in *Spirits in Politics. Uncertainties of Power and Healing in African Societies*, Ed. by B. Meier, and A.S. Steinforth (Frankfurt am Main: Campus Verlag, 2013), pp. 37–48.

Erdtsieck, J., *Nambela Mganga wa Pepo. Mambo Afanyayo Mganga wa Tiba ya Asili kwa Uwezo wa Pepo Nchini Tanzania* (Dar es-Salaam: Dar es-Salaam University Press, 2001).

Franz, M.-L. von., *Projection and Re-collection in Jungian Psychology: Reflections of the Soul* (Chicago and La Salle: Open Court, 1995).

Freud, Sigmund, *The Uncanny* (London: Penguin Books, 2003) [1919].

Giles, L.L., 'Sociocultural Change and Spirit Possession on the Swahili Coast of East Africa', *Anthropological Quarterly*, 68.2 (1995), 89–106.

—, 'Possession Cults on the Swahili Coast: a Re-Examination of Theories of Marginality', *Africa*, 57.2 (1987), 234–58.

Henry, D., 'Attack of the Grotesque: suffering, sleep, paralysis, and distress during the Sierra Leone War', in *Genocide and Mass Violence. Memory, Symptom, and Recovery*, Ed. by D.E. Hinton, and A.L. Hinton (Cambridge: Cambridge University Press, 2015), pp. 242–60.

Huskinson, L., 'Psychodynamics of the Sublime, the Numinous and the Uncanny. A dialogue between architecture and eco-psychology', in *Analytical Psychology in a Changing World. The Search of Self, Identity and Community*, Ed. by L. Huskinson, and M. Stein (London and New York: Routledge, 2015), pp. 72–88.

Jung, C.G., *The Archetypes and the Collective Unconscious*, in *Collective Works of C.G. Jung*, Vol. 9, Part 1 (Princeton, N.J.: Princeton University Press, 1981) [1959].

Knappert, J., 'A Short History of Zanzibar', *Annales Aequatoria*, 13 (1992), 15 – 37.

—, *Epic Poetry in Swahili and Other African Languages* (Leiden: Brill, 1983).

—, *Swahili Islamic Poetry: Introduction, the Celebration of Mohammed Birthday* (Leiden: Brill, 1971).

Lofchie, M.F., *Zanzibar: Background to Revolution* (Princeton, N.J.: Princeton University Press, 1965).

Mango, C., 'Evil Exploits of the Invisible People', in *The Standard* (Nairobi, Kenya: 30 June 2008).

Mbogoni, L.E.Y., 'Censoring the Press in Colonial Zanzibar: An Account of Seditions Case against Al-Falaq', in *In Search of a Nation: Histories of Authority and Dissidence from Tanzania: Essays in Honor of I.M. Kimambo*, Ed. by G. Maddox, J. Giblin and Y.Q. Lawi (London: James Currey, 2005), pp. 198–215.

Melton, J.G., *The Vampire Book. The Encyclopedia of the Undead* (Canton: Visible Ink Press, 2011).

Middleton, J., *The World of the Swahili. An African Mercantile Civilization* (New Haven: Yale University Press, 1992).

Mohammed, A.A., *Zanzibar Ghost Stories* (Zanzibar: Good Luck Publishers, 2000).

—, *A Guide to a History of Zanzibar* (Zanzibar: Good Luck Publishers, 1991).

Mtobwa, B.R., *Joram Kiango. Mikononi mwa Nunda* (Dar es-Salaam: Heko Publishers, 1986).

Newton, M., *Hidden Animals. A field Guide to Batsquatch, Chupacabra and Other Elusive Creatures* (Santa Barbara, Denver: Greenwood Press, 2009).

Oscar, J., and Soko, E., *Kisiki cha Mpingo* (Dar es-Salaam: Dream Team Entertainment, 2002).

Pearson, K.A., 'Spectropoiesis and rhizomatics: learning to live with death and demons', in *Nihilism and the Fate of Modernity*, Ed. by G. Banham, and C. Blake (Manchester: Manchester University Press, 2009), 124–45.

Pels, P., 'The Magic of Africa: Reflection on a Western Commonplace', *African Studies Review*, 41.3 (1998), 193–209.

Royle, N., *The Uncanny* (Manchester: Manchester University Press, 2003).

Saleh, M.A., 'The impact of religious knowledge and the concept of *dini wal duniya* in urban Zanzibari life-style', in *Knowledge, Renewal and Religion*, Ed. by Larsen, K. (Uppsala: Nordiska Afrikainstitutet, 2009).

Schmidt, T.H., 'Colonial intimacy: the Rehenberg scandal and homosexuality in German East Africa', *Journal of the History of Sexuality*, 17 (2008), 25–59.

Stoliznow, W.K., *Language Myths, Mysteries and Magic* (Palgrave: McMillan, 2014).

Thompson, K. Daly, 'Swahili Talk about Supernatural Sodomy. Intertextuality, the obligation to tell, and the transgression of norms in coastal Tanzania', *Critical Discourse Studies*, 11.1 (2014), 71–94.

Walsh, M., 'The Politicization of Popobawa: Changing Explanations of a Collective Panic in Zanzibar', *Journal of Humanities*, 1.1 (2009), 23–33.

Wamitila, K.W., *Archetypal Criticism of Kiswahili Poetry* (Bayreuth: Eckhard Breitinger, 2001).

(RE)SHAPING STYLE(S), LANGUAGE(S) AND DISCOURSE(S) OF OTHERNESS

THE SHAPES OF THINGS TO COME
IN INDIAN SCIENCE FICTION
Narrative and Style in Manjula Padmanabhan and Vandana Singh

Esterino Adami

University of Turin

The aim of this article is to provide a preliminary investigation of some examples of linguistic rendition and textual patterning of a particular genre, i.e. science fiction, with a focus on the postcolonial English-language context of India. Since language constitutes the very first building block that allows the construction and articulation of narratives both at micro and macro levels (Mandala, 2010; Stockwell, 2000), I will consider the stylistic power of English in informing stories, disrupting expectations and creating innovative meaning through a variety of rhetorical devices. Specifically, I will look at some extracts from the short fiction written by two Indian authors, Manjula Padmanabhan and Vandana Singh, but I will also broaden the category of postcolonial so as to include reference to an Anglophone writer like Ian McDonald, who, despite not being from the Indian subcontinent, somehow belongs to and succeeds in representing the postcolonial Indian world, with its forces and contradictions.

My argument therefore lies in the manifestation of language for literary purposes in science fiction as appropriated and abrogated by writers to reinvent, adapt and manipulate storytelling traditions. Given the complexities of the science fictional domain, the postcolonial sector in India and the peculiarities of literary texts in English, my analysis will follow an interdisciplinary orientation by exploiting various analytical tools and theories, such as postcolonial studies, stylistics and narratology (e.g. Adami, 2010, 2015; Black, 2006; Langer, 2011; Mandala, 2010; Stockwell, 2000, 2003). In this light, the science fictional genre will be observed as a form of architext (Stockwell, 2000), or megatext (Pak, 2011), namely a structural set of compositional

and thematic features capable of triggering narrative discourse, perspectives and implications, ultimately establishing a dialogic relationship between author, text and reader.

Language, style and postcolonial science fiction narratives

It is vital to put forward some methodological premises as well as to reflect on a series of critical labels utilised to identify disciplinary fields, approaches and notions that constitute the framework I adopt in my analysis. My starting point concerns the interconnection between language and narrative, considering the former as an expressive code to communicate and represent the world we live in, or its possible and imaginable alternatives, and the latter as a cognitive, socially rooted modality to conceptualise reality and make sense of human experience at large. In this light, language endorses and supports the storytelling process, which from a cognitive angle represents a strategy to decipher and extract meaning from life, and in fact Stockwell highlights the representational power of literature as a form of parable and also affirms that "narratives are one of the fundamental aspects of understanding" (2000: 122). Consequently, the notions of storytelling and narrative construction function as tools to mediate our perception of the surrounding context and of our identities. The hopes, expectations and many other values and feelings that we process are then translated into words, phrases, sentences and higher-level structures via careful selection and connotative projection.

My investigation also takes into account the connection between language studies and science fiction on the one hand, and between science fiction and postcolonialism on the other. In the former case, it is worth considering that both disciplines pertain to and seek to explain the mechanics and the paradigms of complex systems, or metaphorical worlds, and their articulations. As Stockwell (2003: 195) holds, "there is an obvious mirroring similarity between the phrases 'science fiction' and 'literary linguistics'. The words in each pair orbit around a meaning that

takes in the analytical and the aesthetic. Both are fusions that arise out of interdisciplinary connections that have become customary and familiar. Both claim a special relationship with rationality and the scientific method". Linguistics and science fiction thus appear to share some traits or at least to evoke some resemblance, which is not merely some suggestive echo but rather concerns the workings of the mind in elaborating thoughts and notions (i.e. structuring systems or envisaging the future), and thus producing meaning and categorising reality. As such, language and science fiction operate on both a micro level (working on the various linguistic levels) and a macro level (e.g. in the formation of discourse), and they exhibit a high degree of creativity, which is realised via a range of resources such as neologism, metaphor, metonymy or hyperbole (Stockwell, 2000: 115–138).

A similar position emerges from Mandala's (2010) study of science fiction, as she regards language in its multiple dimensions as the very first indicator of style, capable of generating provoking speculations and attracting the readers' attention. Alongside particular devices and means, however, even standard or common language, i.e. the use of language that superficially does not present striking features, can effectively contribute to the defamiliarisation of narrative elements and ultimately constructs "extraordinary worlds in plain language" (Mandala, 2010: 95). As a matter of fact, in science fiction the verbal material is crucial, as it depicts and encodes alternate worlds in textual format: "style extrapolates future Englishes, suggests spoken past Englishes, presents the impossible as real and creates characters" (148). The skilful elaboration of language therefore aims to activate narrative patterns that, in the case of science fiction, contemplate possible or alternative visions, and to intermingle the real with the imaginary, with the effect of changing and revising our mental schemata, i.e. those mental structures that we employ to approach and understand surrounding reality (Black, 2006: 32; Stockwell, 2000: 75–89).

It is also necessary to consider the relation between science fiction and postcolonialism as the two are characterised by some similar key aspects, such as the sense of otherness, the idea of

geographical and cultural distance, the approach towards science and its impact on the environment (Adami, 2015). Indeed, according to Raja and Nandi (2011: 9), "the connection between science fiction and postcolonial studies is almost natural: both these fields are deeply concerned with questions of temporality, space, and existence. Central also to both these fields of study are the questions of the 'other' – human, machine, cyborg – and the nature of multiple narratives of history and utopias and dystopias of the future". The connection between postcolonialism and science fiction therefore permits a realignment of significant issues, e.g. power relations between human and non-human societies or the consequence of unwise technological development and exploitation, as discussed among others by Banerjee (2011), and as a result it endorses narratives of denunciation that otherwise would probably be neglected and condemned to oblivion.

Postcolonial science fiction in India (and beyond)

In the postcolonial scenario of India, science fiction has often been considered a liminal, marginal or trivial genre, more suitable for a young, perhaps uneducated readership rather than a potential vehicle to convey important messages. In this sense, it has typically been compared with children's literature and neglected access to academic debate or a wider public (Adami, 2010). However, it might be argued that some forms of science fiction, which is in fact a sort of umbrella term for a range of various sub-genres, in reality draw from the cultural and literary heritage of the country, and their force reverberates throughout various narrative styles, patterns and motifs. An *ante litteram* example is represented by the Bengali writer Rokeya Sakhawat Hossain (also known as Begum Rokeya), who in 1905 authored *Sultana's Dream*, a kind of feminist utopia, which contemplates the reversal of the *purdah* system, i.e. the strict gendered division of public space that prescribes specific areas of the house for men and women. In the novella, the construction of this new type of society is possible thanks to the power of education, as women

scientists have used their knowledge to construct a fairer and more efficient society that does not consider gender as a barrier. To some extent, the text is reminiscent of, and somehow anticipates, another all-female utopia described in *Herland* by Charlotte Perkins Gilman (1915), in which a self-sufficient community of women manages to isolate themselves from the rest of the world and continue their life peacefully.

It should also be noted that some major recent authors from the Indian subcontinent have incorporated elements of science fiction, in its broad sense, into their works: for example both Salman Rushdie's postmodern literary debut *Grimus* (1975) and Amitav Ghosh's intertextual novel *The Calcutta Chromosome* (1996) blend themes of science fiction, such as the use of flying machines, the bacteriological spread of viruses and the power of supercomputers, with oriental epic narrations, through a digressive style in which the main storyline branches into minor articulations or the interference of myth, in order to create unique narratives that not only testify to the vitality of the genre as a whole, but also suitably inscribe it into the postcolonial context of belonging. Moreover, younger generations of authors such as Vandana Singh, Manjula Padmanabhan, Ruchir Joshi, Samit Basu, Anil Menon have started drawing attention from the general public, as they strive to enhance the circulation of their works, for example by addressing diasporic or international communities as well, since they often write in English rather than in Indian vernacular languages. In thus doing, they redesign and galvanise the coordinates of their narrative discourse.

The exact nature of defining labels sometimes implies ontological problems, as in reality borders and boundaries appear porous and fluid in many cases. Discussing the bond between postcolonialism and science fiction, Langer (2011) convincingly interprets the former not merely as a fixed geographical or historical category, but rather as an open-ended cultural and social condition, a way of understanding the many shapes of reality and identity in the worlds that have been affected by the phenomenon of colonialism. This perspective thus justifies the extension of the canon and allows attributing a value of postcolonial Indianness to

those subjects who were actually born in other parts of the world, such as the British novelist Ian McDonald. With a background rooted in Northern Ireland, a country subjugated by dense social and historical questions that are to a certain extent illustrative of the postcolonial world too, the author has produced a narrative textscape that fully cuts across the aesthetic, poetic and cultural dimensions of Indian science fiction. This is particularly evident in *River of Gods* (2004), a novel set in the holy city of Varanasi in 2047 (symbolically exactly one hundred years after the achievement of independence for India) that envisages the presence of forms of artificial intelligence (known with the almost unpronounceable and phonetically echoing name of aeais), the spread of nanotechnology, but also the threat of water pollution, juxtaposed with the mythical echoes of the Hindu lore (Solarewicz, 2014).

In the following sections, I will examine a few selected extracts from two stories by Manjula Padmanabhan and Vandana Singh, and concentrate on the textual and linguistic mechanics of their works, in particular the use of irony and the introduction of symbolism. A critical framework for such texts can be provided by the notion of architext, which for Stockwell (2000: 204) relates to "any science fictional narrative which configures a fully worked-out, rich world, and also provides stylistic cues that encourage a mapping of the whole textual universe with the reader's reality". The notion of architext, which is akin to Genette's *architexte* (as treated in his 1979 volume *Introduction à l'architexte*), represents the very nature of the narrative material of the science fiction genre in its ability to create, transform and hybridise metaphors and images in fruitful and stimulating manners. In this light, it is similar to the idea of megatext, originally developed by Damien Broderick and rephrased by Chris Pak (2011: 57) as "the thematic and linguistic expectations readers develop toward SF texts". Both architext and megatext thus account for possible imaginings of narrative structures that overturn, challenge or transform our mental representations of reality.

Irony as a narrative strategy in Manjula Padmanabhan

The first case study I intend to focus on here is a short story by Manjula Padmanabhan, an Indian writer, illustrator and cartoonist who has much contributed to the field of science fiction, in particular with *Escape* (2008), a dystopian novel grounded on the themes of nuclear pollution, gender cleansing and military totalitarianism, and *Harvest* (2003, originally written in 1997/8), a disturbing darkly skewered play that tackles the issue of organ transplantation and body modifications at the expense of the lowest classes of India (Adami, 2010). Here I will consider "Gandhi-toxin", a story originally written for the 1997 issue of *New Internationalist* and now featured in the collection *Kleptomania* (2004), in which the author adopts the modality of irony as a technique to build up, and subsequently overturn, a defamiliarising narrative world of the future, framed by the architexts of dystopian regimes, military superpowers and genetic manipulation. The recourse to irony is part and parcel of the author's entire literary project dedicated to science fiction, which concerns the construction of other wor(l)ds as well as the recasting of the real-life world through the orchestration, arrangement and modification of narrative structures:

> What I like about the genre, however, is that it offers a writer the opportunity to go directly to the heart of an ironical or thought-provoking situation by setting up a theoretical world. Science fiction is a bit like writing a problem in mathematics, reducing reality to a tangle of pipes and cisterns or a group of three people travelling at varying speeds up a mountain, in order to reveal the relationship between matter, time and space. (Padmanabhan, 2004: viii)

Portraying a dystopian scenario in which the power of nations has been substituted by the emergence of various agencies and corporations, the story imaginatively explores the possibility to retrieve Gandhi's DNA, or in symbolic terms his essence, to produce a substance able to mitigate violence and reaction in people. The scientist behind this experiment, Sitaram Desai, approaches Aidid Nilsen and Isabella, the supreme commanders

of United Gene Heritage (UCH), a pharmaceutical and research organisation engaged with the preparation and selling of new lethal genetic weapons in the world. Initially the two are not convinced by the project, but after some reflection they understand the potentials of the Gandhi-based product, not only in its military application, since it can be employed to transform masses into passive, weak and submissive subjects, but also as a revolutionising device that could radically disrupt the current configuration of social order and civilisation in their world. Aidid and Isabella's ideological position belongs to a dystopian vision, based on a new world order, as shown by the following passage, which is worth quoting at length:

> "Mr Desai," said Isabella, "we've analyzed your serum. Preliminary tests confirm what you say: diffused through the blood, the toxin disarms aggression vectors in mammalian brains, making it a formidable weapon. In the wrong hands, it could cause catastrophic pacifism and widespread loss of the competitive urge". [...] Aidid continued, "... your very existence represents a serious threat to security personnel in the free world. Any unscrupulous business house could misuse you to win its brand wars at the expense of right-thinking consumers everywhere. We have no option but to place you under life-arrest-' He droned on, citing the GeneSwap, agreements under which UGH could detain citizens around the world for the purpose of containing their genetic-hazard potential. 'Needless to say," he concluded, "we will mass produce the substance ourselves for the use of our own marketing troops." Sitaram continued smiling, even when he was renamed with a code number: Gamma Two-eight. (Padmanabhan, 2004: 94)

During his detention, Sitaram/Gamma is befriended by other inmates like "Pion Sixty-three, a wizened hunter-gatherer from Urban Borneo whose pituitary gland was a source of life-saving, anti-acne preparation" (Padmanabhan, 2004: 95) or "Xhi Square, a melancholy Peruvian whose blood was found to cause night-blindness in teenagers" (95). Such outlandish characters reinforce the atmosphere of weirdness in the story, but at the same time they might also work as intertextual echoes of the magical protagonists of Rushdie's *Midnight's Children* (1983),

given their uniqueness and otherness that makes them a threat to the dystopian establishment.

Thanks to the Gandhi-toxin, which was "delivered via clouds of reconstructed mosquitoes designed to function as airborne syringes" (96), the power of UGH seems to overwhelm every opponents. Yet some unexpected side effects emerge and rebalance the situation. In the words of Xhi, "'Gandhi-toxin survivors have become revolutionaries!' he said. 'They're dismantling commercial institutions and reorganizing marketplaces everywhere! They're inverting the whole structure of international finance!'" (96). The delirious project of total annihilation and dehumanisation of the planet falls apart because the cultural heritage of Gandhi's political vision appears to interfere with totalitarianism and violence, and subtly changes the dominating ideologies of the dystopian architext.

From a stylistic viewpoint, it is clear that the author abundantly foregrounds a variety of textual elements that cumulatively generate ironic effects in carrying meaning. For Wales (1995: 263), "irony is found when the words actually used appear to mean quite the opposite of the sense actually required in the context and presumably intended by the speaker", and this type of characterisation is achieved by the extensive use of reference, echoing allegory and atypical collocation. First of all, the very title of the story aims to deviate readers' expectations, as the technical term 'toxin' is premodified by the matching with Gandhi, a key historical figure (in particular in the postcolonial Indian context): since the former term is associated with negative images, whilst the latter is typically attributed connotations of freedom, independence and democracy, the estranging lexical combination of the two encourages readers to change or revise their expectations as well as their schematic knowledge. Consequently, the very sense of a substance called Gandhi-toxin constitutes a kind of novel oxymoron, similar to what Jeffries (2010) labels "constructed opposition", namely a creative process of language manipulation aimed at generating striking non-conventional contrasts to foreground and suggest peculiar meanings into words.

Irony is a principal paradigm in the entire narrative and it constantly surfaces through the careful elaboration of language. Neologism and lexical creativity in particular mark the discourse of science fiction, and the intradiegetic narrator frequently cites "incubation laboratories, organ-farms and dupe-cradles" (Padmanabhan, 2004: 95), "cyber-fighters" (96) and "gleaning caskets suspended in preconscious limbo" (95), thus mixing the natural with the artificial, the fictional with the real. Together with the transformation of the specialised jargon of the military, of medicine and of genetics, irony is engendered by the use of evaluative terms, for example via the defamiliarising collocation "catastrophic pacifism". This type of constructed opposition conveys and condenses the ideological orientation underlying the dystopian future in regulating life and its positioning: it completely denies the consideration of pacifism, a human stance that is represented by the figure of Gandhi, and advocates a scaffold endorsing violence, war and ruthless competition.

A plot-advancing stratagem in Padmanabhan's narrative, overflowing irony also operates through other textual practices, such as naming. For instance, it is worth noticing the onomastic allusions of the characters and organisations in the story: the protagonist eventually sticks to the emblematic name Gamma (used as a symbol in various branches of mathematics and science), whilst the name Pion in particle physics denotes any of three subatomic particles. However, the climax of irony emerges in the last section of the story during a confrontation between Gamma, Aidid and Isabella, who now have been arrested and are kept in a "stasis-cell" (98). The two former technocrats complain about the inheritance of Gandhi, who for Aidid "'wasn't merely a pacifist but a deeply subversive personality. He forced the British out of India and now you've destroyed the foundation of Civilization as we know it'" (97). By assuming the perspective of a totalitarian regime to define man's development through the capitalised term Civilisation, Aidid and Isabella affirm their idea of politics and values, but eventually they react to their defeat in different ways. On the one hand, Aidid accepts his reclusion because he knows

that his bio-copies, i.e. a kind of technological doubles that he has hidden in various secret locations, will allow him to be immortal, regenerating himself forever. On the other, Isabella prefers to face the possibility of being contaminated by the Gandhi-toxin in the external world, and when she is stung by the mosquitoes she experiences a kind of cathartic process, as she "lay back on the grass and, for the first time since childhood, slept without the aid of pills" (98). The effects of the product therefore seem to return Isabella to her very human condition, away from hostility and power: in metaphorical term, a humble insect operates as a means to spread the contagious reflection on identity, and once again reminds the reader of the incredible success of Gandhi's pacific revolution and fight against imperialism in the Indian subcontinent.

Symbolism and identity in Vandana Singh's speculative fiction

In order to observe different narrative and linguistic renditions, I will now turn to Vandana Singh, an Indian author of science fiction, children's fiction, and poetry, who has devoted herself to a particular branch of science fiction, that of speculative fiction, seen as a lens through which it is possible to reflect on the sense of the future, but also on the significance of the present. For Singh, speculative fiction triggers an apparatus of representational means that figuratively and powerfully express the route(s) of identity for humanity. As a specific, thought-provoking genre, indeed speculative fiction concerns a kind of introspective narrative that questions the manifestations of identity, since it "is about us as we are, right now. This may be the case even if the story is set on another planet, in another age, and the protagonist is an alien. Because haven't we all felt alien at some time or another, set apart from the norm due to caste and class, religion, and creed, gender and sexual orientation?" (Singh, 2008: 203). In this manner, writing becomes a way to explore not only the sense of the unknown, but also the confrontation between the self and the other, thus a fruitful

process of self-interrogation and consciousness development, in particular in the multicultural and multilingual context of the Indian subcontinent.

"Infinites" is a short and complex story pivoting around the character of Abdul Karim, a retired Muslim maths teacher, and his friend Gangadhar, a professor of Hindi literature. Obsessed with numbers and other abstract notions of mathematics and physics, the protagonist contemplates the very idea of infinity as an all-encompassing form of totality. The textual patterning of the theme somehow calls to mind Stockwell's idea of variegated polyphonic discourse defined as "documentary fragmentation" (2000: 57), by which a text merges various sources, and here it is rendered by virtue of devices such as opening quotations, references and mentions of mathematical essays, scientists and inventors, of all times and places, but also of Indian and Pakistani philosophers and Sufi poets. Collaboratively, the addition of these textual items, which pertain to the categories of textual and compositional deixis and include details such as the titles of essays, their year of publication and the name of their authors, brings to the fore a sense of an organic system, characterised by plurality, interconnectedness and multiplicity, whilst the architext also draws from metaphysical and existentialist questions that partake of the human condition.

In figurative terms, the gist of infinity may also apply to boundless religious, social and cultural dimensions, in particular the idea of a pacific cohabitation of Muslim and Hindu communities across India:

> But for Abdul Karim, numbers are the stepping stones, rungs in the ladder that will take him (Inshallah!) from the prosaic ugliness of the world to infinity.
>
> When he was a child he used to see things from the corners of his eyes. Shapes moving at the very edge of his field of vision. Haven't we all felt that there was someone to our left or right, darting away when we turned our heads? In his childhood he had thought they were *farishte*, angelic beings keeping a watch over him. And he had felt secure, loved, nurtured by a great, benign, invisible presence. (Singh, 2008: 57)

The mystical echo attached to the sense of infinity, signalled by the citation of the Muslim angels, in reality problematises the opposition between rational thought, namely the very basis of disciplines such as mathematics and physics, and the emotional sphere, which plays a fundamental role in the comprehension of abstract, intangible notions. Karim's examination and conjecture on the definition of infinity takes the forms of a metaphorical journey of discovery that eventually leads him to be "lost in a merry-go-round of universes, each different and strange" (Singh, 2008: 78). It is a pathway to totality, a wide-ranging pole of significance, in which the meaning of universe is replaced by the plural notion of multiverse: "He sees it: the bare bones of creation, here, in this place where all the universes branch off, the thudding heart of the metacosmos. In the scaffolding, the skeletal of the multiverse is beautifully apparent" (79). This attitude is mirrored in the narrative architecture of the story as well, since it is grounded on the Bakhtinian strategy of hybrid discourse (Black, 2006: 95), namely the use of both free indirect discourse and various sociolects (e.g. the specialised lexis of mathematics but also of philosophy and mysticism), leading to the effect of a mingling and overlapping of voices, such as the narrator's, characters' and others'.

The story can be interpreted in various ways, but in its speculative, almost postmodern insistence on the search for meaning (in mathematics, but in a wider sense in religion, in society and in life), it is coloured by symbolic echoes and, as such, it nears much postcolonial fiction devoted to the communal riots of India, the tragedy of Partition, and the intercultural and inter-religious discrepancies. From a critical perspective, symbolism is not easy to define, as it functions as a sort of broad category covering many possible meanings and effects, and often relying on the encyclopaedic knowledge of readers, who are to infer and process specific allusions (Wales, 1995: 445–7). However, it can also work in a pragmatic sense by violating the Gricean maxim of quantity (i.e. carrying more meaning than what overtly stated and thus implying or referring to other elements) at both character level and narrator level (Black, 2006), as it occurs in

Singh's "Infinites". Both the heterodiegetic omniscient narrator and Karim seem to unfold a range of suggestions, in between secularism and religion, politics and emotions, in particular in the protagonist's studies and in his relationship with Gangadhar through the dramatic outburst of religious intolerance and violence: "their friendship had even survived the great riots four years later, when the city became a charnel house – buildings and bodies burned, and unspeakable atrocities were committed by both Hindus and Muslims" (Singh, 2008: 63).

The conceptual abstractness of the idea of infinity and of other mathematic notions is compared with the actual brutality of manhood in everyday life. The ontological search for the sense of infinity maps the attempt of man to find a meaning in life, in himself, and in the others. Hence stems a wealth of symbolic suggestions of difference and unity, harmony and individuality, part and wholeness that recur throughout the text: if infinity indicates the state of having no end or limit, or in mathematics a number that is larger than any other, then its semantic perimeter can be figuratively extended to all aspects of life, in an effort to make sense of existence, and implicitly of identity. Vandana Singh's use of science fiction, therefore, does not rely on futuristic imagery of hyper-technologies or extraterrestrial creatures, but it is articulated as an innermost process of self-discovery, a voyage into the labyrinths of the self and infinity, against the backdrop of real life, with its members, communities, dreams and fears in the postcolonial setting.

Concluding Remarks

In this article I have considered some narrative features of Indian postcolonial science fiction and have highlighted its resonant evocative power in texts. A dynamic repository of heterogeneous styles, tropes and motifs, Indian science fiction finally seems to emerge from a subsidiary position and acquire a more prominent cultural role, from which it addresses an assortment of discourses, bearing in mind that "sf can do some discoursal things that no

other form of literature can do" (Stockwell, 2003: 195). Authors such as Manjula Padmanabhan and Vandana Singh, in fact, have energised the genre through their stories and words: either as instantiation of irony or with symbolic characterisations, their extravagant works involve the reader in projecting meaning and participating in larger processes of comprehension, imagination and representation of the complexity of the postcolonial world. In different measure, moreover, the two writers manipulate a notion that is central to both postcolonialism and science fiction, namely hybridity, a dense concept that can apply to plenty of issues: from the display of the "body other" because of skin colour or other somatic characteristics, through the menace of alterity, to the idea of colonised peoples as creatures of diversity. For Langer (2011: 125), "in a sense, all postcolonial science fiction – indeed, all postcolonial cultural production – is about hybridity": the grotesque future scenario depicted by Padmanabhan in "Gandhi-toxin" and the only apparently realistic representation offered by Singh in "Infinites" are marked by hybridity as they reshape or challenge boundaries of belonging, identity and meaning. And the same type of consideration can be extended to other postcolonial authors, including McDonald, for example in the way he conceives the city of New Varanasi, stemming from a mixed accretion of places, signs, stories, myths and memories.

Here it is not possible to take into account other important aspects of the work of the two authors, such as the narrative treatment of the gender issue, which is of central significance for Padmanabhan and Singh. In reality they both belong to the sub-genre of women's science fiction, which, according to Wolmark (1994: 24–5), "exists in a contradictory relationship to the hegemonic discourses to which it is opposed but on which it draws, and this is the reason for its oppositional capacity to open up new spaces for alternative representations of gender". This and many other themes too constitute the backbone of the whole literary production of the two authors, who employ the resources and schemas of fantasy and science fiction to narrate possible and impossible worlds.

Works Cited

Adami, Esterino, 'Feminist Science Fiction as a Postcolonial Paradigm', in *Scritture e interpretazioni*, Ed. by Alessandro Monti (Alessandria: Edizioni dell'Orso, 2010), pp. 145–157.

—, 'Waste-Wor(l)ds as Parables of Dystopian 'Elsewheres' in Postcolonial Speculative Discourse', *Anglistica AION*, 19.2 (2015), 91–102.

Banerjee, Suparno, 'Dystopia and the Postcolonial Nation', in *The Postnational Fantasy. Essays on Postcolonialism, Cosmopolitics and Science Fiction*, Ed. by Masood Ashraf Raja, Jason W. Ellis and Swaralipi Nandi (Jefferson, NC: McFarland, 2011), pp. 125–137.

Black, Elizabeth, *Pragmatic Stylistics* (Edinburgh: Edinburgh University Press, 2006).

Jeffries, Leslie, *Opposition in Discourse. The Construction of Oppositional Meaning* (London: Continuum, 2010).

Langer, Jessica, *Postcolonialism and Science Fiction* (Basingstoke: Palgrave Macmillan, 2011).

Mandala, Susan, *Language in Science Fiction and Fantasy* (London: Continuum, 2010).

McDonald, Ian, *River of Gods* (London: Pocket Books, 2004).

Padmanabhan, Manjula, *Kleptomania* (New Delhi: Penguin Books, 2004).

—, *Escape* (New Delhi: Picador, 2008).

Pak, Chris, 'The Language of Postnationality. Cultural Identity and Science Fictional Trajectories', in *The Postnational Fantasy. Essays on Postcolonialism, Cosmopolitics and Science Fiction*, Ed. by Masood Ashraf Raja, Jason W. Ellis and Swaralipi Nandi (Jefferson, NC: McFarland, 2011), pp. 56–70.

Singh, Vandana, *The Woman Who Thought She Was a Planet and Other Stories* (New Delhi: Zubaan, 2008).

Solarewicz, Krzysztof, 'The Stuff that Dreams are Made of: AI in Contemporary Science Fiction', in *Beyond Artificial Intelligence. The Disappearing Human-Machine Divide*, Ed. by Jan Romportl, Eva Zackova and Jozef Kelemen (Springer: Heidelberg, 2014), pp. 111–120.

Stockwell, Peter, *The Poetics of Science Fiction* (Harlow, Essex: Longman, 2000).

—, 'Introduction: Science Fiction and Literary Linguistics', *Language and Literature*, 12.3 (2003), 195–198.

Wales, Katie, *A Dictionary of Stylistics* (Harlow, Essex: Longman, 1995).

Wolmark, Jenny, *Aliens and the Others* (New York: Harvester Wheatsheaf, 1994).

ALIENATION, THE FANTASTIC, AND ESCAPE FROM HISTORY
Majīd Ṭūbiyā's Short Stories in the Egypt of the Sixties

LUCIA AVALLONE

University of Bergamo

When the new generation of Egyptian writers appears on the literary scene of the mid-1960s, they introduce themselves as subverters of the literary establishment.[1] "It is only natural therefore for earlier agents within the field, who have acceded to various dominant positions, guardians and propagators of certain symbolic values, to combat the new arrivals" (Mehrez, 2000: 267). These narrators,[2] with their antagonistic force, have

1 Modern Egyptian narrative emerges in a few decades during which writers take part in the production of a national identity, in the commitment against the British protectorate, and in seeking political and ethical foundations for the building of a new Egypt. It is a young literature, matured at the dawn of the 20th century, on the one hand based on Western narrative and on the other taking on new features fit for the Egyptian milieu, which it addresses. Over a period of sixty years the Egyptian literary canon acquires its form with narrative texts that have as a fundamental premise the search for truth and for representation of reality. These works are among the cultural steps on a historical path culminating with the 1952 coup, the overthrow of the monarchy and the expulsion of the British from Egypt. The following decade sees the full affirmation of Realism. The Egyptian canon, gradually established since the early 20th century, develops interest in the lives of ordinary people and is no longer linked to the literary models of classic and pre-modern traditions. The world now appears to narrators as a whole represented by the individual with direct observation, experience, and study of details. The different literary trends which follow one another, from Romanticism to historical fiction, up to Realism, define a set of shared symbolic values and form the tradition of modern Egyptian narrative which takes into consideration high culture, namely cultural heritage, education, knowledge of the classics, Arabic and otherwise.

2 An accurate survey of contributors of short stories printed in the literary magazine *Gallery 68* is given by Kendall (2006: 234–238); among the numerous names cited we remember: Yaḥyā al-Ṭāhir 'Abd Allāh,

a significant role in the development of contemporary fiction, so much that even today the so-called "writers of the Sixties" are a reference point for the 2000s' authors.[3] The 1960s witness major projects of industrialization, natural resource exploitation, public education expansion, but also see the abolition of many political activities, the stifling of oppositions and the limitation of some freedoms essential to democratic life;[4]

Ibrāhīm 'Abd Allāh al-'Āṭī, Ibrāhīm Aṣlān, Muḥammad al-Biṣāṭī, Jamāl al-Ghīṭānī, Ghālib Halasā, Khalīl Sulaymān Kalfat, Idwār al-Kharrāṭ, Ibrāhīm Manṣūr, Yūsuf al-Qiṭṭ, Muḥammad Ḥāfiẓ Rajab, Yūsuf al-Shārūnī, Bahā' Ṭāhir, Majīd Ṭūbiyā.

3 A new generation of narrators emerges at the beginning of the 2000s. Their narratives express the more recent changes Egypt has undergone, especially in urban contexts. One of the most singular writers, Aḥmad al-'Āydī (b. 1974), who has got among his mentors a writer of the 1960s, Ṣun' Allāh Ibrāhīm, connects the two generations by saying "after all we are like in the 1960s, at war. Today, we are in a time of unofficial, undeclared war. Now it is our regime to be against our people" (Caridi 2006, my translation), and in his novel *An takūn 'Abbās al-'Abd* he writes, paraphrasing the famous definition of the 1960s generation "we are a generation without masters", expressed by Muḥammad Ḥāfiẓ Rajab, in *al-Jumhūriyya*, Oct., 3rd 1963, p. 13 (Kendall, 2006: 144), "Egypt had its Generation of the Defeat. We're the generation that came after it. The 'I've-got-nothing-left-to-lose generation'. We're the autistic generation, living under the same roof with strangers who have names similar to ours" (Alaidy, 2006: 36).

4 In the first decade of the Revolution, the political parties are abrogated; a crisis within the ruling group, the Free Officers, occurs, and the first President of Egypt, Muḥammad Najīb, is removed from the scene; a socialist experiment starts. In the same period, a number of political initiatives directly concern cultural environments; we recall that in 1954 purges against several teachers at the University of Cairo are launched. In 1956, the regime begins to create a system of institutions aimed at monitoring and mobilizing intellectuals, among which is the Higher Council of Arts and Letters; in 1958, the Ministry of Culture is established. In the same period, the state institutions of the Radio and Theatre are expanded. In 1960, the State Television is founded and the press is nationalized. The following year the film industry and much of the editoria are nationalized, too. In 1962, the National Action Charter is promulgated: a single party is defined in the context of building a socialist society, regardless of class struggle, with a single trade union. The intellectuals, for the most part, do not provide the philosophical and ideological support required by the regime and the cultural

in that moment a vanguard of narrators and poets turn away from
the Realism that has characterized the literature of the previous
period, in particular in the 1950s, ranking break with narrative
modalities they no longer deem fit for the Egyptian societial
evolution. Modernism bursts into literature. Its task is "to express
the complexities of this epoch, and to illustrate – one might even
say, without prejudging the issue, to discover – the radical changes
in the national attitude towards reality" (Hafez, 1976: 68).

The new generation resumes the work of the Experimental
current[5] that in the 1950s developed a sensibility for existentialist
problems, opposing its narratives to Realism. Neither supported
nor encouraged by critics (Ferial Barresi, 1977: xvii), the
experimental writers leave a legacy assumed by younger narrators
when in 1961 the intellectuals' crisis is evident.[6] With them
are also some major writers of the previous generation – Najīb
Maḥfūẓ and Yūsuf Idrīs – reflecting the permanent state of crisis
in the 1960s using different techniques and instruments: indirect
critics to society; bare representation of reality; use of a poetic
style to render the characters' frustration; depiction of reality's
relativity; minimalist approach to illustrate the human world;
resort to history, tales, and fables to enlighten the decadence of
the present; use of realistic narrative strategies (Hafez, 1975).

personalities supporting it. Between March 12th and July 14th, 1962,
a memorable debate occurs on the main Egyptian newspaper, *al-Ahrām*.

5 Anxiety, alienation, and more broadly existential problems are faced by
the Experimental current which includes, among its exponents, Yūsuf
al-Shārūnī, Idwār al-Kharrāṭ, Fatḥī Ghānim, ʿAbbās Aḥmad, and Badr
al-Dīb.

6 Ḥasanayn Haykal, editor-in-chief of *al-Ahrām*, requests that Marxist
journalist Luṭfī al-Khūlī uses his newspaper to host the debate about the
lack of a Revolution theory and a supposed crisis of intellectuals. On
the whole, the debate does not reach a comprehensive and deep
understanding of the real causes and possible solutions. Besides, in this
era of protest and criticism in respect to Nasserism and to the cultural
circles supporting it, the establishment must face the rebellious vision
of a new generation, which often endures censorship and repression,
and the detachment of some prominent writers.

As in the early 20th century, young narrators[7] propose a new narrative culture and change the modes of reading reality. The representation of the "whole" through an extensive organization of its components gives way to fragmentation: "the emerging creativity adopts fragment as residue, as a still smoking ruin after the destruction" (Avallone, 2012: 19, translation of the author). In doing so, some narrative practices are recovered from traditional storytelling; for instance irony and the fantastic, which are rooted in classical and pre-modern Arabic literature, are significant in the 1960s and constitute specific traits of story writing. Fables and legends in the classical period and popular prose texts in the post-classical age provide materials of fantastic nature and legendary narratives. *Siyar sha'biyya*, *maghāzī*, *khurāfāt*, and *'ajā'ib*, together with *Arabian Nights*, constitute a wide and rich source of stories populated by imaginary, supernatural, and miraculous characters and events. Furthermore, popular narratives, such as *Arabian Nights*, but also canonical works, like al-Hamadhānī and al-Ḥarīrī's *Maqāmāt*, and Abū l-'Alā' al-Ma'arrī's *Risālat al-ghufrān* are often typified by a considerable irony that is, with parody, one of the more common techniques employed in satire (Scott Meisami and Starkey, 1998).

Draz considers irony as the main structural principle of the new narrative forms emerging in the second half of the 1960s. According to him, the "dominant", with the meaning given by Roman Jakobson, namely "the focusing component of a work of art, which rules, determines and transforms the remaining components", shifts "from the mimetic approach of modern social realism, to an ironical metafictional approach" (Draz, 1981: 137). His study of four Egyptian works leads him to analyze irony and the fantastic as fundaments of the structure of tales, both ruling

7 The avant-garde of the 1960s includes also some older writers, such as Idwār al-Kharrāṭ (b. 1927) and Yūsuf al-Shārūnī (b. 1927), who were already active in the Experimental current. Al-Shārūnī publishes his first collection of short stories, *al-'Ushshāq al-Khamsa*, in 1954, and al-Kharrāṭ releases his, *Ḥīṭān 'Āliya*, in 1958 (Ferial Barresi, 1977: xvi).

the development of "The Bulge-Eyed" by Majīd Ṭūbiyā,[8] one of the short stories this paper aims to present.

Revealing reality through the fantastic

The stories of Majīd Ṭūbiyā, who, like other young writers, finds his own space on the literary scene partly thanks to the avant-garde magazine *Gallery 68*,[9] is an example of the content and form changes occurring in those years. Through the four short stories here selected – "Vostok reaches the Moon", "The Bulge-Eyed", "Five unread newspapers", and "The following days"[10] – the author highlights some critical aspects of the post-revolutionary Egypt making use of the fantastic. The first season of Nasserism ends ruinously[11] with the failure of pan-Arabism, socialism, and a strong Egyptian political and military role in

8 Majīd Ṭūbiyā (b. 1938) was born in Minya, Upper Egypt, into a Coptic Christian family. He completes his early studies in his hometown and enrolls at the University of 'Ayn Shams in Cairo (1956), where he graduates in mathematics (1960). He gets a teaching post in a secondary school in Minuf and in the same period starts to cultivate his interest in Western theatre and cinema, which become a real passion, leading him to leave his job and to graduate in screenplay (1969) and direction (1972) at the Film Institute in Cairo. He works at the Superior Council for Arts and Humanities and at the Secretariat of the Ministry of Culture. His literary career starts in the late 1950s. In the mid-1960s, he begins to publish in the magazines *Rūz al-Yūsuf*, *Ṣabāḥ al-Khayr*, *al-Majalla*, and *Gallery 68*. In 1965, his short story "Vostok reaches the Moon" appears in *al-Majalla* and in 1967 it gives the title to his first collection published with a preface by Suhayr al-Qalamāwī. In 1966, the short story *al-Makāmīr* is awarded best subject for the cinema and becomes a film with the title *Ḥikāya min baladinā*. In his long literary career, he has published many novels and collections of short stories.

9 *Gallery 68* (*Jālīrī 68*) is an independent magazine with a pivotal role in the literary scene of the late 1960s, published between April 1968 and February 1971 (Kendall, 2006).

10 "Fūstūk yaṣil ilā l-qamar" (1965), "al-Jāḥiẓūn" (1970), "Khams jarā'id lam tuqra'" (1970), "al-Ayyām al-tāliya" (1972).

11 The defeat of the 1967 war against Israel is an event that marks the history of the Arab world, inflicting a deep wound on moral, political and territorial levels. The disappointment, the awareness of the collapse

the Arab area. In the 1960s, the Egyptian State corresponds to an autocracy, while oppressive political control and repressive measures pervade society. The Revolution's utopia, which continues to be transmitted through the official cultural circles, gives way to a dystopia. The regime allures part of the intellectuals and supports the emergence of many cultural institutions, magazines, and newspapers. For their part, the intellectuals take varying stances, from the conservative type, climbing to higher positions, to subversion. The latter attitude is assumed by Majīd Ṭūbiyā who creates narratives showing an inversion of the rules which dominate the mimetic representation of reality.

The short story "Vostok reaches the moon", written in 1963 and published in 1967, is considered a milestone in the author's literary career. For the first time Ṭūbiyā uses the fantastic and he does it embodying in a terrible monster all the upsetting elements afflicting the protagonist, a truck driver oppressed by a continuous noise that accompanies him at work and along the roads, where he observes a sore mankind similar to the animals scattered in the countryside.

> So many strange creatures everywhere. They had never looked like this before. The duck fluttering in the roadside canal to escape the August heat. The cows ceaselessly grazing. The buffalo roped to the water wheel. The dogs ran alongside barking, to back away and loll out their tongues in frustration. The sheep, its head bent down with anxiety like a family man wondering how to buy those clothes for his children. And people. So many human beings, doing different things. One busy with his waterwheel. Another just eating and eating. Others who followed him with curses because of the smoke from his exhaust. The sad man who sat and ruminated, his finger tracing something in the dust. The naked ones who had stripped off their clothes to swim in the canal. (Tobia, 1977: 370)

The monster never leaves him, not even in the poor cheap home he rented in front of the railway where trains clank past. It even took possession of his children.

of ideals championed by the Revolution triggers a crisis that deeply affects literature also.

He even passed into the bodies of the children so that they spoke so
loudly, even if there was total quiet, that he was forced, in spite of the
heat, to cover his head with the pillow, not only to hide his ear-drums
from this ever-persistent monster but also to get to sleep (Tobia, 1977:
371).

In an age when Egypt has entered a series of modernization and
industrialization campaigns, technology appears in two respects:
it has a power set against the man who lives in nonstop contact
with the machine, but it is also a vehicle for hope, dream, escape
on the road to the future and especially towards the quiet, the
liberation from modern society's gears.

The policeman shouted. Two snakes came out of his mouth. Their
fangs sank into the driver's eardrums. [...] And the car accelerated till
the road shook. And the clatter was so intense that instead of dying
as it rose in the air it hardened into the shape of a bottle out of which
the monster sprang with hammer and dagger and a malevolent grin. To
float slowly and surely down till he was slipping through the broken
side-window and sitting on the seat beside him. [...] The pain was
tremendous. If only he had brought some cotton he could have stuffed
his ears. He could have hidden his ear-holes from this monster. But no.
the doctors wouldn't allow him to. (Tobia, 1977: 368–369)

By inventing a monstrous creature, the writer gives a concrete
form to the fears agitating human consciences and places this short
story in a contemporary narrative culture which is very prolific
now, in the 21st century, and was similarly popular in the 1950s,
1960s, and 1970s in both written literature and filmic narrations,
especially in Western societies. In a representational approach,
the collective nightmares originated by a *surplus repression*, in a
Marcusian sense, namely a force exercised beyond the necessary
to adapt the individual to a social system (Marcuse, 2001: 22),
are shaped as monsters especially in historical moments of rapid
cultural, social, political, economic, and moral changes (Levina
and Bui, 2013: 2). A passage from *Collected papers of Herbert
Marcuse* is pertinent to Ṭūbiyā's mode of interpreting reality.

The technological processes which propel mechanization and standardization of production tend to eliminate individual autonomy from a vast area in which much of its force was previously spent; and this force could be released in a yet uncharted realm of freedom beyond that of necessity. Man would then exist as an individual to the extent to which he is eliminated from the mechanized work-world; his freedom would be autonomy over the apparatus of production and distribution. (Marcuse, 2001: 50)

In our text freedom is chased by resorting to a promising modernity; while alienating technology is personified in a monster, the liberating one is emblematically represented by Vostok ("the Orient" in Russian), a type of spacecraft launched into space by the Soviet Union for the first time in 1961.[12] As in the other three stories, next to the basic theme of alienation a collective imagination emerges; it is produced by a proto-globalization of information and culture, through radio, television, cinema, photography, newspapers, and literature, all means interacting in this epoch of rapid and significant changes.

The story opens with a slogan which is written on the back of the truck:[13] "Have a good trip to the moon, Vostok!". On the slogan's plate there is also a painting, "a little rocket nosing its way to the moon whose happy smiling beamed out from its fringe of radiant flowers" (Tobia, 1977: 368). The formula chosen by the character shows a faith not placed in transcendence but in modern technology. He seems to look positively at technological progress which opens an escape to another world – "Even if there were a monster on the moon I'd rather face him than this one here who's after me every-where" (372) – and to oppose

12 The space age begins in the second half of the 1950s with the launch of the Soviet satellite Sputnik 1 followed by the Mercury project, for human exploration in space, launched by NASA. The 1960s are dense with space programs that culminate with the moon landing in July 1969. The race between Americans and Russians for the conquest of space is part of the broader framework of the Cold War and has a strong media impact, with repercussions in the collective imagination and narrative culture of the time.

13 Typically, Arab drivers carry amulets or miniatures, which are replicas of holy places and texts, in their travel cabin, to invoke divine protection.

to traditional religious beliefs, when choosing the 'have a good journey' formula – "The owner had wanted to put something quite different: *O Lord Who granteth secret grace. Save us from all we fear.* But he hadn't budged and the owner had to agree" (368). Ironically the protagonist faces a supernatural being that gives him no respite, tangible as much as a living creature, and at the same time echoing the folk tales' genius living in a bottle[14] – [...] a bottle out of which the monster sprang" (369), "The coward. He's gone. Gone back into the bottle" (371).

Space travel is matter of discussion between the driver and a porter, and later between the driver and a hitchhiker. In one situation the author includes references to historical background – the American and Russian race to conquer space –, and in the other to imagination – American films of science fiction populated by monstrous creatures.[15] In both cases the desire for peace, represented by the moon, emerges: "Is it too much to ask? Just a quiet home. Anywhere. Even in the moon" (372). The story ends with a link to this leitmotif: the protagonist, because of an accident with his truck, is hospitalized; when he wakes up he finds himself in a place of total silence and sees doctors in white coats moving their lips without uttering a word. He then asks whether Vostok has reached the moon.

14 The motive of a spirit imprisoned in a bottle recalls some tales of the *Arabian Nights* and the Brothers Grimm's fable "Der Geist im Glas".

15 The 1950s see a real explosion of science fiction, which is widely spread not only through novels, pulp magazines and comics, but also thanks to the film industry, especially the American one. Enthusiasm for the aero-spatial achievements together with the desire of exorcising the anxieties related to the Cold War, and the fear of the atomic bomb are ingredients of the collective emotional background when Holliwoodian and independent films tell space exploration stories or imminent dangers of alien invasions and final cataclysms. Of the large cinema production in those years, we mention some significant titles: *The Thing from Another World* and *When Worlds Collide* (1951); *The War of the Worlds* (1953); *Creature from the Black Lagoon* and *Them!* (1954); *Earth vs. the Flying Sources* and *Invasion of the Body Snatchers* (1956); *The Blob* and *The Fly* (1958); *The Day of the Triffids* (1963). In the 1960s, science fiction cinema passes to more sophisticated literary modes with the New Wave arisen in British milieu.

Ṭūbiyā's narrative meets the requirements indicated by Todorov as necessary for defining the fantastic.[16]

> First, the text must oblige the reader to consider the world of the characters as a world of living persons and to hesitate between a natural and a supernatural explanation of the events described. Second, this hesitation may also be experienced by a character [...] Third, the reader must adopt a certain attitude with regard to the text: he will reject allegorical as well as "poetic" interpretations. (Todorov, 1975: 33)

Metamorphosis as an escape from reality and history

The topic of discomfort, psychological suffering, alienation, and escape from society is also central in a short story published by Ṭūbiyā in 1970, under the title "The Bulge-Eyed". Here the fantastic is generated through metamorphosis, which has a pronounced critical force and is a theme dear to Western literature, recalling in particular Franz Kafka's novella "The Metamorphosis".[17]

An autodiegetic narrative shows the protagonist walking along the bank of the Nile in one of the most crowded stretches in the modern heart of Cairo, approaching the water, entering it to continue until he completely immerses himself, or better, until the river itself acts against the protagonist: "I went on: the water came up to my thighs, to my waist" (Tubia, 1988: 80). The suicide leaves behind him a chaotic city which lasts moving, emitting lights, with shadows and sounds that are more and more confused. The only clear and impressive image is that of bulged-eye men persistently staring at him, at the point of penetrating, with their gaze, even the water. Human figures and shapes of

16 Todorov's definition has been recently questioned. However, it provides
 a basic theoretical description of the fantastic that is adequate to
 interpret our texts.
17 The story, published in 1915, is an allegory of man's alienation in
 modern society. It tells the isolation and lack of communication in the
 life of Gregor Samsa, a travelling salesman who one morning wakes up
 transformed into a beetle.

bridges and buildings overlooking the Nile serve as background to the protagonist's last decision, while near and distant memories materialize, in a disordered sequence, until the metamorphosis starts: the individual completely gives way, lets his body go, wrapped and seeped by water, first resting on the river bed and then floating towards the Delta. He makes the absurd act of continuing to tell, now dead, his journey. Hence narration enters a paradoxical dimension, a performative contradiction which is the core of the fantastic's *mise-en-scène*. "Every work of art sets up its own ground of rules. The perspectives that the fantastic contradicts are perspectives legitimized by these internal ground rules" (Rabkin, 1976: 4–5).

The hero's trip takes place without hurdles: when entangled in the vegetation of the river banks he meets a guard ready to free him and to let him go; an old Muslim, who is doing the ritual ablutions with the intention of praying in a *zāwiya*,[18] observes him for a long time and then recites some verses of the Koran over his dead body, without restraining him; when he remains a prisoner in a fishing boat's nets, the captain and his crew throw him into the sea, after saying a Christian prayer. The departure from the human world does not meet any hindrance, raising only fast pious acts. When the narrator's body begins to decompose a new event occurs, stopping the flesh corruption: a fish unintentionally swallows him. The metamorphosis is completed, his and the fish's become one flesh.

> There, inside the fish, I saw the umbilical cord of my mother... Its intestine began to secrete strange juices and acids. Soon I had completely dissolved and been absorbed into the body of the fish. (Tubia, 1988: 87)

Later on the fish-man is caught and cut into pieces, boxed to be sold. Ironically, the last step is in the dish of a man with bulging eyes, one of those who the narrator, conscious until the last moment of his unnatural new life, felt persecuted by and tried to escape from committing the extreme act of suicide.

18 Small mosque, prayer room.

Clearly, influences of Western literature and thought on Ṭūbiyā's narrative are considerable. Some key points of Albert Camus' philosophical thought, concerning the idea of the absurd, occur. Choosing not to live his life the narrator stops his rebellion and passes from a total rejection of a system, and its incomprehensible rules, to accepting his own limits. He can't afford to live the absurdity of his human condition and neither revolt against it. Yet, the absurdity of human condition cannot be avoided. A state of death lived in full consciousness, an extraneousness aware of the world, a reflection on himself and a search for a familiar world which can be explained, do not allow the subject to put an end by death to the absurd, but rather, the latter proposes itself again in a paradoxical way. It is worth mentioning that Camus and Becket were translated in Arabic in the mid-1960s, and that the Existentialism had already been introduced to the Egyptian readers through literary reviews, first of all the influential *al-Kātib al-miṣrī* (*The Egyptian writer*), in the 1940s, with critical articles on the works of Kafka, Joyce, Sartre, and Camus (Kendall, 2006: 56). In 1965, an interesting article on the 'absurd', entitled "al-Lāmaʿqūl fī adabinā al-muʿāṣir", is published in *al-Majalla* (*The review*) (al-Shārūnī, 1965).

> Yūsuf al-Shārūnī, dans son article *L'absurde dans notre littérature contemporaine*, rapporte deux tentatives qui annoncent, selon lui, dix ans avant la publication de l'ouvrage de Ḥarrāṭ[19] l'évolution que devaient provoquer les écrivains des années 1960. (Ballas, 1978: 113)

These tales of the fantastic are therefore a part of a wider context, Arabic and worldwide, which responds to the man's anxieties in the modern era.

> The fantastic in the twentieth century presents an interior next world, psychopathological and unconscious. It draws on the culture and society of his time, shows the loneliness and anxiety of man in front of the technological world, often denouncing its excesses or parodying its

19 Idwār al-Kharrāṭ was one of the leading members of the magazine *Gallery 68* as translator of Western authors, critic, and sponsor of young writers.

habits. To be considered by the contemporary world, the fantastic does not aspire to the emotional use of its elements, but to a meditation on nightmares and tensions of the modern man. (Zangrandi, 2011: 9, my translation)

The individual, disoriented and intimidated by an incomprehensible and absurd logic governing the mass society systems, ends up with not controlling forces which make ordinary situations unreal. For instance, some analectic passages sketch the narrator's relationship with bureaucracy and retirement procedures: these are excerpts from a conversation with an officer who refuses his retirement request, as not justified by an advanced age; the employee is only thirty-one years old, while claiming to be more than one hundred.

> "Sir, I wish to retire."
> He laughed:
> "That's a good joke."
> "Sir, I am totally serious."
> [...] "Here Sir, is an official request for retirement on pension, with all the necessary fiscal stamps attached..."
> The director opened my job file angrily and took out my birth certificate:
> "This proves you are not yet thirty [sic]! So how can you want me to pension you off?".
> [...] "Sir, I know myself best. I am telling you the truth so why don't you believe me?"
> "Birth certificates don't lie."
> "But I am made of flesh and bones, blood, iron, salts, cells, veins, lungs, a heart, ears, hands, a nose, eyes, a mouth... How can you call all these liars, and believe a little bit of paper with some ink on it?" (Tubia, 1988: 82–85).

In a metaphorical narration by images the metropolis and its symbols dominate the suicide: the panoramic tower, the crowded bridges, and the television building before which he decides to enter the Nile, as if to signify a rebellion also against the media and the lack of expression freedom.[20] When he is already in the

20 The Nasser period is affected by the paradox that literary and artistic production is strictly controlled but explicit censorship is relatively rare

water a piece of newspaper covers his mouth, then his nose and eyes, before he can pull it off, a reference recurring to media censorship. When he goes down under water different levels of consciousness are awakened. Memories and feelings come back to mind. It is an interior monologue[21] in which the hostile world of modernity contrasts with the coziness of familiar life during childhood.

> I immersed my ears and recognized the sound of the water, and the sounds of my father blowing his nose in the morning: the slap of my mother's slippers; Sayyid, our neighbor, whistling, thin and melodious, and Nabil calling for me... the school bell... "Sleep, sleep my love, and I kill you a brace of doves." (Tubia, 1988: 81–82)

The water revives memories of maternal womb and of his mother's premature death, suggesting a cut of roots, an estrangement in respect to life prior to his alienation from society as a mature man.

> The staring eyes on the bank continued their examination of me... I saw myself in my mother's belly, inside the womb; it contained strange things: entrails, cells, blood, strange juices, tissues, arteries, veins... and a protruding eye... political seminars, jet boom, a donkey's braying, and a computer... (Tubia, 1988: 83)

Estrangement, cut roots, escape from history that runs its course leaving on the margins victims unable to adapt to the system: this is the Egypt portrayed by Ṭūbiyā.

(Jacquemond, 2008: 43). Press and media are considered as instruments to promote the Revolution and Arab socialism. In the first years of the regime a censors' office is established at the Ministry of Information and in 1960, when editoria is nationalized, government-appointed boards are created to control publications. Then the Martial law of June, 5th 1967 empowers the state in respect to the media's activities with the aim of preserving security and public order (Jones, 2015: 723–724).

21 Among the most innovative narrative techniques adopted by the writers of the 1960s are the interior monologue and stream of consciousness, both drawn from Western modernism.

Speaking through death

Similarly to "The Bulge-Eyed", "Five unread papers" is built around a performative contradiction. The main character is already dead when his narration begins. The corpse is discovered; actions, words and thoughts of housemates, a door attendant, a police officer, and a doctor represent the main plot, alternated with flashbacks interrupting the logical flow of events' report. That outlines the profile of an immigrant from Upper Egypt arrived in Cairo, first guest of a neighbour, then client of a boarding-house, and finally tenant in the building where he dies, all situations in which the hero never feels integrated into the urban environment. The same door attendant considers him different from the other tenants.

The stream of images passing through the protagonist's conscience proposes again Cairo's streets noise. The clamor of people and the roar of vehicles are essential components in the individual's alienation and are represented by irony – which is the dominant narrative process used in this short story – as entering physically into the narrator's body (into his ear!).

> [...] I moved to a hotel in Clot Bey Street. I chose it because it was cheap... From the very first moment there something strange happened: my ear grew and grew and workers came and extended the tramlines into it, so that the tramcars drove into it with their bells, the screeching of their wheels, their drivers swearing at the donkey-cart men, and their conductors rowing with the passengers... Fleets of these tramcars drove into it with their bells, the screeching of their wheels, their drivers swearing at the donkey-cart men, these trams went into my head, never to return. (I hung a sign outside my ear saying «No Entry», but it didn't help). Frequently the electric cables would touch, and spark and crackle in my head! So I changed the position of the bed and slept with my right ear to the street (because it's hard of hearing). (Tubia, 1988: 73)

The analectic processes make childhood memories reappear: the links with his native village and family (his mother baking bread, his father sorrowful over the death of a mango tree,

children buying dates from a peddler),[22] and his desires, his first sexual experiences with a woman. Life in Cairo is such not to offer close relationships he still looks for, though in vain, in other countrymen immigrants and in the people he meets. The only friend seems to be the door attendant who calls him "the good", whose words are reported at the end of the story echoed by an aphorism of the protagonist's father.

> In distress, the hall porter cried:
> "It's the good ones who go!"
> My father answered tenderly:
> "He who is good and does good deeds goes to heaven where there are rivers of honey. But he who is bad and does bad deeds, goes to hell, the most miserable of fates."
> This puzzled me enormously. I did not want a miserable fate, nor did I want to go to hell, because I would hate to burn forever... However, at the same time I wasn't enthusiastic about heaven because I don't like honey. (Tubia, 1988: 77)

A narrator's comment follows, closing the narration and suggesting the effectiveness of the fantastic in moving the character from a paradoxical situation towards a new perception and a search for consciousness.

> Now I know full well where I am... And I have a strong inclination to tell what I know... Except that I am afraid of the consequences... For here too... (Tubia, 1988: 77)

Building a new utopia

Among the stories selected, "The following days" is the only one where the escape from a dystopian society leads to the rebuilding of a new utopia, through a voluntary detachment and

22 The link with the local reality, urban and rural, is a notable trait of Ṭūbiyā's and other writers' narrative in the 1960s, a fact that is opposed to the negative evaluation of mere imitation of Western literature given by some critics.

abandonment of every norm previously followed. The narration starts setting the action in a dystopian totalitarian society, unjust and irrational, apparently timeless but certainly representative of the current system. With a brief preamble, a narrator introduces his and the protagonist's departure from an exhausting urban reality towards a place of peace, where to recover. The initial dialogue between the narrator and a doctor, who advises convalescence to the female character, suggests that the story is set in an oppressive climate: the doctor whispers and recommends keeping his voice down.

The succeeding scene opens with a landscape unfolding before the two fugitives' eyes: a lonely shoreline, wild but peaceful, relaxing. They sleep in a wooden hut on the beach, where they discover a rusty old railroad which trains no longer pass along. In the monotony of gestures, images and sounds that typifies their vacation, some flashbacks offer a metaphorical depiction of the city.

> My mind strayed to the arches of the city.
> A dwarf had built them to his own short height and they were very low: a low arch at every few paces, and in every street I had to bow each time I passed beneath one, or my head bumped the vaulted ceiling. Whenever I saw a man with a hunched back I said to myself: this is a citizen of the city of low arches. (Tubia, 1988: 95)

And later on:

> A time had come... in those former days... when she had decided she would not bow below the arches of the town. Her head became a mass of cuts and bruises. She kept walking, her head held high, hitting the roves of the arches until she fell unconscious. They laid her on a stretcher, in which fashion she passed beneath many arches. The doctor said – the doctor whispered – that she needed to convalesce for a while in a remote place, empty of people... (Tubia, 1988: 96)

In the convalescence place some mysterious events occur, contradictory in respect to the actual reality the narrator is still able to discern during the first few days, while the female character

soon turns towards a utopian dimension. The transit of a train and the breaking of a clock are the key elements determining the fugitives' acknowledgement of being in a new promising scenario. Their optimistic vision culminates in the final conquest of nature and time.

> I was woken suddenly by a very loud noise. As I became aware of things around me, I knew – without the slightest doubt – that the noise was the sound of the train passing... now it's going into the distance... at this moment it's far away... I made no attempt to go out to see it. The sound was so clear it left no room for doubt.
>
> I reached for the watch under my pillow. I wanted to know the time this night-train passed. But the time was a little after ten precisely. I recalled the time problem and the difficulties we had encountered during the daytime, trying to remember the name of the day on which we were living. What was today called... and tomorrow... and the following days?
>
> [...] Hence yesterday, the day when the storm occurred, becomes storm day... and the following day, the day I became aware that the watch had stopped, is watch day, or awareness day... and so on.
>
> [...] "And let it also be the first of the month... and with it we shall start drawing up our calendar". (Tubia, 1988: 98–100)

When Ṭūbiyā writes this short story, utopian and dystopian narratives are not new to Egyptian literature, as some modern authors have developed in their works the contrast between ideal societies and oppressive social systems by resorting to the representation of possible, imaginary, generally future, worlds (terrestrial and not). Such literature clearly evidences the distortions of the new societies produced by modern-day changes. Farah Anṭūn's novel *al-Dīn wa-ʿilm wa-l-māl: al-mudun al-talāt* (1903), the short play *ʿAjalat al-ayyām* and the single episode *Dunyā al-ḥamīr*, both by Yūsuf ʿIzz el-Dīn ʿĪsā who broadcast them by radio during the 1940s, together with Tawfīq al-Ḥakīm's works *Riḥla ilā al-ghād*, a drama published in 1957, and "Fī sana malyūn" (1947), a short story, are some examples of works which criticize the existing political and social systems through fantastic futuristic interpretations found as well in Western authors such as George Orwell, Aldous Huxley and H.G. Wells.

While the foundations of an Egyptian science fiction are laid in the 1960s with the publication of three landmark novels written by Muṣṭafā Maḥmūd (*al-'Ankabūt, Rajul taḥta al-ṣifr*, and *al-Khurūj min al-tābūt*), by means of a quasi-filmic narrative Ṭūbiyā realizes stories based on fantasy, according to the Freudian meaning (Freud, 2010), which are a powerful synthesis of the contemporary crisis. What he writes is nothing else but daydreams arisen from a condition of privation that is not only personal but also generational.

At the end of this paper, we cannot do without dwelling on the fact that several Western authors have been cited, either with reference to Majīd Ṭūbiyā or to the general Egyptian literary milieu. Influences of other cultures are undeniable and, in the 1960s, they are matter of a debate contributed to by supporters and detractors who consider the new writers innovators or instruments of Western imperialism. The more hostile critics "levelled accusations of blind imitation and stirred up fears of encroaching foreign cultural hegemony" (Kendall, 2006: 140). Moreover the 1960s generation is perceived as working as a means of rupture with the realistic culture (literature, cinema, theatre, art) which has been committed in the Revolution's promotion for a decade. Nevertheless, this avant-garde is writing reality in a new way, proposing form and content novelties and innovations to express the contemporary age malaise by techniques created abroad but processed in the Egyptian context, giving birth to a narrative culture still relevant today.

Works Cited

Alaidy, Ahmed, *Being Abbas El Abd* (Cairo: American University in Cairo Press, 2006).

al-Shārūnī, Yūsuf, 'Al-Lāma'qūl fī adabinā al-mu'āṣir' (Cairo: *al-Majalla*, January 1965), 62–8; (February 1965), 41–52.

Avallone, Lucia, 'Conflitti e letteratura, gli anni della decostruzione', *Elephant & Castle. Laboratorio dell'immaginario*, 7 (2012), 5–33.

Ballas, Shimon, 'Le courant expressioniste dans la nouvelle arabe contemporaine', *Arabica*, 25.2 (1978), 113–27.

Caridi, Paola, 'Palahniuk sul Nilo', *Lettera 22*, 2006, <http://www.lettera22.it/showart.php?id= 5972&rubrica=84>.

Ferial Barresi, Concetta, *Narratori egiziani contemporanei* (Roma: Istituto per l'Oriente, 1977).

Freud, Sigmund, *Der Dichter und das Phantasieren: Mit Interpretationshilfen* (Norderstedt: Books on Demand GmbH, 2010).

Draz, Céza Kassem, 'In quest of new narrative forms: irony in the works of four Egyptian writers. Jamāl al-Ghīṭānī, Yaḥyā al-Ṭāhir 'Abdallāh, Majīd Ṭūbyā, Ṣun'allāh Ibrāhīm (1967-1979)', *Journal of Arabic Literature*, 12.1 (1981), 137–59.

Hafez, Sabri, 'The Egyptian Novel in The Sixties', *Journal of Arabic Literature*, 7.1 (1976), 68–84.

—, 'Innovation in the Egyptian Short Story', in *Studies in Modern Arabic Literature*, Ed. by Ostle, Robin (Warminister: Aris and Phillips, 1975), pp. 99–113.

Jacquemond, Richard, *Conscience of the Nation. Writers, State, and Society in Modern Egypt* (Cairo, New York: The American University in Cairo Press, 2008).

Jones, Derek, *Censorship: A World Encyclopedia* (New York: Routledge, 2015).

Kendall, Elisabeth, *Literature, Journalism and the Avant-Garde. Intersection in Egypt* (New York: Routledge, 2006).

Levina, Marina, and Bui, Diem-My T., *Monster Culture in the 21st Century: A Reader* (New York, London: Bloomsbury, 2013).

Marcuse, Herbert, *Towards a Critical Theory of Society*, vol. 2, Ed. by Douglas Kellner (New York: Routledge, 2001).

Mehrez, Samia, 'Dr. Ramzī and Mr. Sharaf: Ṣun'allāh Ibrāhīm and the Duplicity of the Literary Field', in *Tradition, modernity, and Postmodernity in Arabic Literature. Essays in Honor of Professor Issa J. Boullata*, Ed. by Kamal Abdel-Malek, and Wael Hallaq (Leiden: Brill, 2000), pp. 262–83.

Rabkin, Eric S., *The Fantastic in Literature* (Princeton, N.J.: Princeton University Press, 1976).

Scott Meisami, Julie, and Starkey, Paul, *Encyclopedia of Arabic Literature* (New York: Routledge, 1998).

Tobia, Magid, 'Vostok reaches the moon', in *Arabic Writing Today. The Short Story*, Ed. by Manzaloui, Mahmoud (University of California Press, 1977), pp. 368–73.

Todorov, Tzvetan, *The Fantastic: A Structural Approach to a Literary Genre* (Ithaca–New York: Cornell University Press, 1975).

Tubia, Majid, *Nine Short Stories*, Translated and Introduced by Nadia Gohar (Cairo: General Egyptian Book Organization, 1988).

Zangrandi, Silvia, *Cose dell'altro mondo. Percorsi nella letteratura fantastica italiana del Novecento* (Bologna: ArcheotipiLibri, 2011).

A CONFUSION OF IDENTITIES: UNFULFILLED AND PUNISHING WOMEN FROM THE GREEKS TO HINDUISM

ALESSANDRO MONTI

University of Turin

Dreaming his wish, fulfilling her wish

In his Introduction to *La littérature fantastique*, Tzvetan Todorov (1970: 28–9) recognizes in a condition of hesitancy the founding category of the fantastic. Hesitancy concerns primarily the reaction of a character facing the supernatural, but also involves the reader, who must, as the character does, accept or refuse at once the suspension of the natural laws, on behalf of a phenomenology of deregulation. Jacques Finné (1980: 71) adopts in *La littérature fantastique. Essai sur l'organisation surnaturelle* the definition of chronological aberration to indicate the transition from everyday experience to a continuum different with respect to our present: an elsewhere in time.

Both categories are used by Todorov and Finné when they discuss Théophile Gautier's *Arria Marcella* (1852). Octavien, a young Frenchman travelling in southern Italy, sees the petrified body of a woman in the archaeological museum of Naples and feels immediately a strong feeling of attraction for this ghostly eidolon. At night he dreams of her and finds himself in old Pompeii. He meets Arria Marcella but her Christian father sends her back to the limbo in which she lives, apparently in promiscuity with her lovers.

The act of seeing has aroused a wish in Octavien. To be fulfilled his wish must entail a vision of the past that he accepts after a short while to be true or a least likely. His hesitancy measures the distance that separates the consciousness of the present from the accomplishment of the subjective motif inherent to his wish: the regret that he did not live in old Pompeii. A dream is the vehicle

that makes the encounter with the wished for woman possible. But what kind of dream? According to Finné, this chronological aberration has nothing to do with an oneiric experience. He just speaks of a sensation, here visual, which leads back to the past. He reduces what happens in *Arria Marcella* to a case of somnambulism, without giving however more details and information. I would like to trace down a more complex rhetorical lineage for this story and consider how the ancient Greeks understood and explained the act of dreaming. Dreams were "seen" and were endowed with a strong power of evocation. Consequently, I would not separate the visual experience from dreaming, as Finné does. I would rather speak of the so-called chronological aberration in terms of passage from a reality *ýipar*, that is of wakefulness, to a state *ónar*, that is of dreaming (Dodds, 1951: 104–5; Vernant, 1965; Guidorizzi, 2013).[1] The easily enticed Octavien "sees" an overflowing vision whose evocative power makes *psyché*, the soul, aware of a new and extended perception of reality.

However, a double act of seeing supports the wish of the extravagant (etymologically, beyond or across the borders of reality) traveller: he sees the eidolon of Arria Marcella, she sees him and reciprocates his wish. They see each other and their joint vision originates the dream that allows the trespassing to a site in-between the nowhere of Arria Marcella and the present in which Octavien lives (Monti and Rozzonelli, 2017).

The catalyst: From armier to flâneur

After the museum, Octavien visits the ruins of Pompeii. His sightseeing, after his wish has been aroused, makes an

1 In *Arria Marcella*, Gautier (1852: 185–86) explains as follows the meeting of the living with the dead: "Rien ne meurt, tout existe toujours; nulle force ne peut anéantir ce qui fut une fois. Toute action, toute parole, toute forme, toute pensée tombée dans l'océan universel des choses y produit des cercles qui vont s'élargissant jusqu'aux confins de l'éternité. La figuration matérielle ne disparaît que pour les regards vulgaires, et les spectres qui s'en détachent peuplent l'infini".

archaeological *flâneur* of him. Walter Benjamin tells that a *flâneur*, in its urban version, may evoke the "secret magnetism" of the past in places, buildings and, I would add, ancient ruins (Castoldi, 2013: 142–3).[2] Octavien arouses the shadows of the past and meets the dead. His power, however unconscious, is reminiscent of the capacity that the medieval catalyst had to communicate with the dead. The *armier* (from *arma*, "soul", in langue d'oc) was supposed to evoke the dead. They were thought to be living in a world contiguous to ours; in particular, they shared at night the houses in which men lived (Scotti, 2013: 65–6). In some folkloric beliefs they did not eat our food, but just drank red wine. The same happens with Arria Marcella, but this feature is the key to a potentially dangerous mutation. The evoked Arria Marcella may be assimilated to the unsatisfied and unfulfilled dead women who came back at night in search of sexual pleasure.

These women were not female ghosts, but the ancient Greeks knew them by the name of *áoroi*, untimely, or *àgamoi*, "unmarried" (Ogden, 2009: 146). The first authoritative tale about the coming back of an *áoros* is considered to be the mutilated story, whose first half has been lost, of Philinnion. It is found in a medley of uncanny or extraordinary events collected by Phlegon of Tralles in *The Book of Marvels*, dating back to the 3rd century A.D. (Flegonte di Tralle, 2013).

The dead Philinnion, a young Macedonian widow, leaves her grave at night for a love encounter with a lodger in her household. Her parents discover the two lovers, she dies again and her corpse is burnt outside the walls of the polis. This basic scheme is followed faithfully in *Arria Marcella* as far as two of its leading features are concerned, namely the *dyseros*, "unhappy", quality of the paradoxical, impossible, love and the opposition of the family, represented here by the controlling father.

2 A fictional character, Palumnus, who appears in the *Gesta Regum Anglorum* (William of Malmesbury, around 1125) can go back across space and time, in order to summon forth the ghosts of the heathen past, including the gods themselves.

Mutated dead women. The brides of Corinth

Concerning the possible, or likely, mutation in the nature of the dead woman, we should mention above all Goethe with "Die Brauth von Korinth" (1798). The clash that takes place in the ballad between the heathen *àoros* and the Christian mother leads to a vampire-like identity of the young woman, who becomes a dangerously mutated creature, "Nightly from my narrow chamber driven, / Come I fulfil my destin'd part, / Him to seek to whom my troth was given, / And to draw the life-blood from his heart. / He had served my will; / More I yet must kill, / For another prey I now depart" (Goethe, 1859: stanza XXVI).

Goethe has made a vampire of his peculiar 'bride'. She refuses food, but only drinks deep purple red wine. This loathing connects her to Arria Marcella, and before to the Medieval dead, whereas Philinnion does not have apparently any dietary taboos. The pejorative mutation of the dead woman is found originally in the highly influential *Vita Apollonii*, after 217 A.D. It narrates the story of a 'snakewoman' who seduces a young man. She lives with him in gorgeous but illusory surroundings until the philosopher Apollonius obliges her to revert to her non-human identity and she disappears. The story is also found in Ogden (Philostratus, 1876).[3]

3 Francesco Maria Guaccio gives a demonic interpretation of Philinnion in his *Compendium Maleficarum*, 1626. Here the young woman is equated with a demonic succuba, who borrows the corpse of Philinnion in order to copulate. Ogden (2009: 161) seems to endorse the demonic interpretation. He writes, "Philinnion may have loved Machates as genuinely as the Empusa loved her bridegroom, but both men may nonetheless have been destined to death". Ogden appears to be biased here by Goethe's bride and possibly by the ambiguous dead women in Gautier. Curiously enough, Anatole France *Les noces corinthiennes*, 1878, here *The Bride of Corinth*, 1920 sees in the Macedonian *àoros* widow a vindication of Christian ethos against the heathen world. He sees in the bride of Corinth a victim "of the battle of the gods which shook the world".

Eve revisited and the return of Mélusine

The appearance of the metamorphosing "changeform" impresses a new turn to the *áoros* woman. Her pejorative nature will become common since the Christian age. It is seminal to this process, the so-called *Phisiologicus* (2nd century A.D.), which asserts the affinity between woman (a devilish temptress) and the serpent of Eden, of which Eve becomes the eidolon (Giallongo, 2012). This "bad" metamorphosis might be explained, following Todorov, in terms of pan-determinism, namely as a process that breaks the separation between matter and spirit. A metaphor becomes a metonymy; a supposed attributive quality of serpentine nature makes a real snake of the woman. This change is most evident in the pictorial iconography in which Eve is represented as a horned serpent with the face of a woman (Todorov, 1970: 119; Giallongo, 2012).

In "Lamia" (written in 1817), John Keats impresses a romantic imprint to the story of the snakewoman. His diegetic construction follows Apollonius almost word-by-word, but the rational standard reaction against the condition of promiscuity caused by the love encounter acquires a different significance (Jackson, 1981, 1986: 67–8, 73–6). The state of entropy caused by the too many metamorphoses of Lamia is somewhat brought to order by the joined deaths of the two lovers. The *dyseros* conclusion of their impossible love leads however to a condition of homogeneity, since it goes emotionally beyond the difference that separates the two lovers.

If Apollonius restores a measure of taxonomic identification against the pathetic statement of chaotic homogeneity attained through death, Lycius acknowledges in full awareness the "ghosts of folly" that accompany his "sweet dreams". He accepts at once, without hesitancy, the dream-like atmosphere and illusory surroundings of his encounter with Lamia. His attitude of acceptation does not clear however Lamia of her ambiguous and potentially dangerous status.

She vanishes with a frightening cry when her serpentine identity is laid bare. This is the Medieval *cri de la fée* (the cry of the fairy),

here a demonic creature which haunts the medieval imagination, still obsessed by the presence of heathen feminine beings in forests and secluded watery spots. It is the cry of Mélusine, the snakewoman who flies away when her husband spies on her bath and her metamorphosis. This cry marks the disjunction from the human world and seems to confirm the ghoulish nature of Lamia, ready to prey on the young flesh of Lycius.[4]

The gendered hybridization to which the snakewoman is submitted cannot be always detected easily. Such seems to be the case with another story of Gautier, "La morte amoureuse" (1836). Here an enthralled monk, Romuald, meets, or imagines he meets, a fascinating courtesan, with whom he spends in lovemaking and revelry all his nights. He is no more able to discriminate between reality and illusion, life and death, till the seductress is revealed to be a vampire.

However, matters are not that simple. A further mark of identity in the figuration of the courtesan Clarimonde is given by her descriptive proximity to a typical figure of the decadent art, that is Salomé, such as it will be painted by Gustave Moreau in *Salomé dansant devant Hérode ou Salomé tatouée* (1876). In this painting, the similarity between a woman and a serpent is suggested by the fact that Salomé wears a transparent and colourful dress, decorated with bright geometrical motifs that are reminiscent of the skin of a serpent, such as the snakewoman in "Lamia".[5]

In any case this de-identification which makes a serpent of a

4 "[She] croit [cried] moult piteusement, et se lamentait de voix femmenine, dont ceulx de la forteresse et de la ville furent tous esbahis et ne sorent que penser, car ils voient la figure d'une serpente et oyent la voix d'une dame qui yssoit [came out] de lui. Lors, quant elle ot [had] le fort environné trois foiz, si se vint fondre si rudement et si horriblement" (d'Arras, 1932: 260).

5 The name derives from *lamuros* ("voracious") through *lemure/lemures*. It represented originally the spirit of a woman who had lost her child or had not been able to take care of him/her. In India, it is the *churail* (from *churana*, to steal). She is the spirit of a woman who has died in childbirth. Her feet are turned inwards, she steals children and haunts crossroads, this last a feature that shares with the Greek *empùsa*. For more details lamias see Hope Robbins, 1960: 259–60.

woman is quite recurrent. For instance, in Barbey d'Aurevilly's "Le plus beau amour de Don Juan" (written in 1867) a woman is thus described, "mince et idéale comme une arabesque et comme une fée, dans sa robe de velours, dont la longue traîne se tendait autour de sa chaise, figurait assez bien la queue de serpent par laquelle se terminait la croupe charmante de Mélusine" (1985: 95). The passage suggests a dangerous juxtaposition between an exterior beautiful or beautified, appearance and a diabolic inner identity.

Incubative dreams and the monsters of the night

This multiplicity of possible, and sometimes partially concealed, identities engenders a narrative of confusion between dream and reality. The obsession nourished by an unfulfilled sexual desire, whose seducing eidolon is the *porné* Clarimonde, becomes subservient to the recurrent dream that "stands upon", *épistẽnai*, the monk. The woman he dreams of becomes an objective and recurring presence in his life, the material or concrete token left behind by his "incubative dream". The dreamer is the protagonist of the vision. A similar "incubative" process should be seen equally at work in *Arria Marcella* (Dodds, 1951: 152–53).[6]

Clarimonde is a "monster of the night" (a nightmare, from *mere*, monster), insomuch her "incubative" nature instructs the notion of an objective culpability inherent to women. She is the estranging and extraneous Other, in which duality and hegemonic will, the rule of the irrational upon the rational are the norm.

Such creatures need the authority of the family, of religion, of a denouncing male who embodies the power of the Logos to be sent back to their twilight dimension. Their emotional and biological overflowing makes weird predators of them. The promiscuous

6 Several techniques provoked incubation, for instance by sleeping in a
 holy place so as to evoke a vision ('to see a dream'). In *Arria Marcella*
 this function is attributed partly to the magnetic aura the ruins of old
 Pompeii are imbued with, partly to the catalyst persona of the *flâneur*,
 whose power is reciprocated by the unfulfilled *áoros*.

and highly ambiguous relationship of the monk with Clarimonde deflects the 'good' identity of the man to a behaviour of wild lechery that must be concealed to the world. She is the "Shadow" of Romuald, the dark product of his imagination and stifled wish. As such, Clarimonde represents a desire that cannot be accepted by Romuald, who would relegate her to the world of dreams. By doing so, he imparts a kind of life to her.

She becomes his "Shadow", whose growing autonomy will originate a 'presence' more and more demanding. Finally, to satisfy his desire she needs to be nourished by his blood and in the end she must be killed to reintegrate Romuald into the fold of religion and decency. So she is made a vampire, a "Shadow" that may be destroyed by someone who has not generated the 'dark' duplicate. The unremitting blame that is meted out against the negative quality attributed to a woman makes it impossible to integrate her within the domain of the soul. Her disturbing and perturbing nature sucks down as a vortex what our conscience has blotted out. Thus, the "Shadow" is a giant that does not reflect our accepted identity; a feature also found in the invisibility of a vampire in front of a mirror (Carotenuto, 2010: 58–59).

This condition of blindness tells us that we should not mistake the "Shadow", a false duplicate, for an image reflected in a mirror. So the woman, in particular when a vampire, stands against us as an unidentified Other. In Freudian terms this leads to a process of non-differentiation that is moulded after the relationship mother-foetus and the exchange of blood through the umbilical cord (Romuald gives his blood to nourish Clarimonde). This link operates from the organic to the inorganic and culminates in the achievement of pleasure (Freud, 1920).

A spiritual way to voluptuous pleasure

The achievement of pleasure is one of the touchstones by which the spiritualism of the 19th century analyzes the duality of matter and spirit. In the short story "The Brown Hand" (1922), Conan Doyle upgrades the archetypal motif of the unfulfilled wish:

> In the case of earth-bound spirits [...] someone dominant idea obsessing them at the hour of death is sufficient to hold them in this material world. They are the amphibian of this life and of the next, capable of passing from one to the other [...]. The causes which may bind a soul so strongly to a life which its body has abandoned are any violent emotion. Avarice, revenge, anxiety, love and pity have all been known to have this effect. As a rule it springs from some unfulfilled wish, and when the wish has been fulfilled the material bond relaxes. There are many cases upon record which show the singular persistence of these visitors and also their disappearance when their wishes have been fulfilled (Doyle, 2013: 17–8).

Incidentally, this notion might account for the three nights of pleasure allotted to Philinnion by the Gods. In *Miracles and Modern Spiritualism* (1875), Alfred Wallace speaks of a "grievous want" the leads the life of the spirit after death, when his or her spirit "survives in an ethereal body, gifted with new powers, but mentally and morally the same individual as when clothed in flesh" and a spirit had depended in his previous life "more on body than on the mind for his pleasures will, when the body is no more, feel a grievous want" (chapter IX, "The Moral Teaching of Spiritualism": 108–9). In *Spirite* (Gautier, 1865), the ethereal body of a young dead nun, who had once seen the male protagonist and had fallen in love with him, haunts sweetly his mind, till he will be united to her in death. A sensual game of imagined voluptuous pleasure ("elle laisse quelques secondes sa main fantastique sous le baiser imaginaire de Guy", 2013: 591–92) takes the place of a gross intimacy devoted to vulgarity. In *Séraphîta* (1835), Honoré de Balzac writes that the voluptuous pleasure to which are prone the two sexes during their natural lives ("dans l'état naturel") makes the couple sick and tired, whereas "le couple devenu le même Esprit trouve en lui-même une cause incessante de volupté" (Balzac, 1980: 855). A similar remark is found in Girard de Caudemberg, "Rien ne peut donner l'idée de la douceur dont l'âme est inondée d'une pareille intime relation, quand des lèvres tièdes et légères semblent toucher mes lèvres" (Girard de Caudemberg, 1857: 16).

However, these creatures of light belong to the night, so as to suggest a rather embarrassing contiguity with the less respectable

coming back dead women. Gautier seems to be well aware of their mixed ancestry, when he negates a possible vampire-like identity of Spirite. "Spirite, ange de lumière, n'avait rien à douter du soleil [...] si elle choisissait de préférence la nuit pour faire ses apparitions, c'était parce que, le mouvement de la vie vulgaire étant suspendu, Guy se trouvait plus libre" (Gautier, 2013: 661). In any case she enters the bedroom of a sleeping rival as a vampire would do, "Au chevet peu à peu se condensa une légère vapeur transparente et bleuâtre [...]; cette vapeur prit des contours plus arrêtés et devint bientôt une jeune fille d'une beauté céleste" (608).

In "Véra" (1874) Auguste de Villiers de l'Isle-Adam leaves ambiguity aside; the epigraph at the beginning of the novella defines exactly the twist he impresses to the spiritualistic mode, "La forme du corps lui est plus essentielle que sa substance". The count d'Athol has lost his wife and lives in complete isolation, pretending she is still alive and present. The magnetic power of his obdurate wish gives progressively "form" to his imagined vision of the dead wife. Although Véra has died in consequence of a devouring surfeit of sensual excitement and pleasure – as Clarimonde does in "La morte amoureuse"–, her ethereal nature meets totally the purified attitude requested by spiritualism, even if with a hint of teasing, "Une fois d'Athol la sentit et la vit si bien auprès de lui, qu'il la prit dans ses bras: mais ce mouvement la dissipa" (2012: 26). On the anniversary of her death, the count becomes suddenly aware that she is no more and she, a product and a creature of his illusion, disappears forever. She leaves behind the key of her funerary chapel, which the count had thrown over its gate: an invitation to join her in death.

In "Véra" the dead woman acquires a dominant power of her own and obliges the man to the respect of the immaterial relationship that links them each other. If the catalyst evokes the past, d'Athol does not dream of a lover encounter, but makes one out of a temporary belief.

Further narratives concern the transformation of the love encounter into a pact, either maintained or broken. In Rudyard Kipling's "A Madonna of the Trenches" (1924), a couple of would-be clandestine lovers, hindered by the surrounding family groups, decides that the first of them to die would be joined by

the other. The woman dies and appears in the trenches of the First World War to take him away with her.

This "harrowing" is witnessed by a shocked despatch rider who cannot accept this private, and to him blasphemous, Resurrection. Similarly, in "The Captain of The Polestar" (Doyle, 1883) a haunting woman disappears with the man she loves into the polar icy desert. In "The Cold Embrace" (Braddon, 1867) a betrayed fiancée kills herself and the doors of Heaven are closed to her. She starts haunting the man and leads him to madness and death.

A Stri Mahatmya. A praise for the qualities of women

A punishing, or even an avenging, nature is the dominant feature in the representation of the Indian women who are killed after being raped, or take their lives to avoid rape, or are sorely offended in various ways. This theme is central to the cinematic narration and substantially absent in fiction.

As a rule, Indian cinema neither recognizes a demonic identity in women, nor makes killing 'changeforms' of them. At the very centre of these fantastic stories resides the need that an offended woman has to obtain justice.

However, she is not driven by a mere judicial impulse. On the contrary, she embodies a numinous persona, invested with the power of the Devi, untamed by marriage. This force (*prakrit*) allows her to transcend her own individuality, or individual aim. She is intended to restore punishing justice in the world. This is the kernel of the film *Kahaani, A Mother of a Story* (Sujoy Ghosh, 2012). A woman whose husband has been killed by a terrorist group reaches Kolkata in order to destroy the culprits. To achieve her aim she pretends to be pregnant, but she has lost a baby when shocked for the death of her husband. She finally kills the terrorist on the background of the Durga Puja, while the female devotees celebrate the Goddess as the fighting guardian of the world against *asura* foes (demonic beings).

The point with *Kahaani* is that a woman does not have to die in order to acquire the power of the Devi, namely a numinous

identity. She becomes the external sheath that is imbued with, or contains, the *dýnamis* attributed to women, namely an energy that transcends any individual quality or wish. Thus, the Devi is also called a Nirguna, one that sums up within herself all qualities, and identities, so as to become a divine "Everybody".

A numinous confusion of identities is at the bottom of such a feminine metamorphosis, whose reference leads to the *Devi Mahatmya* (a medieval text), the qualities of the Goddess, hence the praise of her greatness. Mahisha, the great buffalo *asura* has defeated the gods and threatens the cosmos. The Devi in her beautiful form throws the demons into confusion, as they take her warlike words for declarations of love. For instance, when she says that she will kill them with her arrow they misunderstand her words and think that she is speaking of her eyes (see Mackenzie Brown, 1992). It is not casual that in Hindu culture the archetypal seductress is known by the name of Mohini. Her name derives from *moh* (bewilderment, delusion, but also folly, error, infatuation, attachment). Its feminine form, Mohini, adds incantation, spell to the meaning of fascination. As a name Mohini designates an avatar of Vishnu, who assumes a feminine body, or external sheath, in order to seduce the *asuras* and trick them out of the *amrita*, a Hindu celestial ambrosia.

In the *Devi Mahatmya*, the seductive strategy enacted by the Goddess should be explained in terms of inverted understanding of her language, which means a *viparita* language in Sanskrit lexicon. Her words constitute a sort of semantic mimicry, which suggests to the *asuras* an inversion in meaning, not a duality in the woman, but her composed nature as a Nirguna. She is both a man and a woman, and a goddess within the woman. This condition does not imply a possibility of metamorphosis, but the coming out of a salvific and warlike identity.

The theological imprint in the representation of the avenging, or punishing, woman such as featured in *Kahaani*, and which does not require the death of the woman, is replaced by a teleological imprint in the films that deal with killed women who come back in search of justice. Such is the case with the film *Bhoot* (loosely *Ghost*, Ramgopal Varma 2004) in which a woman and her son

die in their flat, during an attempted rape. A suicide is believed to be the cause of her deaths but the woman has been plunged down the balcony. The dead woman takes possession of the young wife who has moved with her husband into the flat. The spirit (*bhoot*) speaks through her voice and makes her violent against her husband, in a rupture of the usual respect relationship women must observe.

This assumption of a vengeful identity indicates the surfacing out of a feminine fury (*shakti*), whose roots are to be found in the warrior-like nature of the fighting Devi, who is a personification of the power attributed to women, when they are not tamed by marriage and respect relationships. *Bhoot* (or *bhutir*) is the English rendering of the Sanskrit and Hindi word *bhut*, meaning 'been, become, existent' and usually rendered with 'ghost, spirit' (*bhut-pret* is the evil or malignant spirit). *Bhoots* "generally denote the spirit of a person that has died an unnatural death, such an accident, suicide or even capital punishment, or one for whom the funeral ceremonies were not carried out, thereby denying the spirit rest" (Krishna, 2007: 115–7). They are not ghosts, but occupy a space between ghosts and the eaters of raw human flesh (ghouls). *Bhoots* can be assimilated to *churails*; like them they are traditionally found at crossroads and on the boundaries of villages. With respect to Greek traditions they seem to belong, at least considering these features, to the family of the *biànàthanatoi* for their post-human nature and to the *empùsae* for their demonic identity. *Bhoots* usually deploy a nature full of rage and are able to acquire the external aspect of people, in order to take revenge.[7]

In the film *Krishna Cottage* (Santram Varma 2004), the *bhutni* is a young woman who out of jealousy comes back to her fiancé after assuming a new identity, in a sort of uncanny triangle with the other woman. This case of untimely and also violent death (she died because of a car accident in which the man survived) can evoke in Hindu culture the demon of restlessness, an overloaded word that suggests both extreme seducing feminine

7 "Bhutas inhabit a sub-world of magical by which they possess unwary people" (Krishna, 2007: 117).

behaviours and also the agony of the separation in love.[8] In the film the restlessness of the *àgamos* woman wrenched prematurely from life turns her unquenched passion sour: the desire for the corporeal part ever accompanies her. A different type of *bhoot* appears in the film *Help* (Rajeev Manoj Virani 2010). Here the ghost or spirit is a revengeful girl, a triplet let to die at birth in order to save her mother's life. She becomes a demonic spirit, who takes possession and kills one by one almost all the members of her family, so that no offspring will be born. This would also happen with the surviving twin, but her husband exorcizes the *bhoot*. The film ends on an ambiguous note: the sister gives birth to a baby girl, already possessed by the spirit. In this film *bhoots* are said to live in a world coterminous to ours and they are visible only when they want to achieve, or fulfil, their revengeful aims. They are akin to the unfulfilled dead of the Greeks. Mirrors constitute their ways of passage into our world and they can be sent back through them.

A further type of offended *bhoot* appears in an episode ("A Bride's Revenge") of the film Darna *Zaroori Hai* (*Getting Scared is Necessary*, Ramgopal 2006). A "kerosened" wife[9] tracks down her domestic murderers, in a judicial hunting down. She assumes the exterior appearances of several people, among them an official of police, in order to unmask and punish her killers.

The dead avenging or demonic woman who comes back as a 'shapeshifting' creature signifies a dual interpretation of her nature. She partakes in the unchangeable character of the ghosts with respect of their previous life, but at the same time she acquires a numinous strength in womanhood. The returning *bhutni* may imply a difference of temperament (*prakrit-bed*) in feminine nature, with the loss of domestic tameness and the unchecked

8 In the film *C. I. D.* (Raj Khosia, 1956) a bunch of rustic beauties sings that they are restless and that seduction is their constant aim.

9 It is a common practice in Indian domestic life to burn wives to death in provoked kitchen accidents, in punishment or as an easy way to separation, without having to give back the dowry paid to the husband. In Indian kitchens kerosene stoves are common and flimsy polyester saris are easily set on fire. See the film *Fire*, Deepa Mehta, 1996.

growing of raw rage. She is not a hostile presence a priori, a ghoulish creature because such is the nature of women. In Indian cinema, women claim for a bitter query against the indifference shown by the institutions in face of the epidemic rapes against them. The embedding of the feminine persona into her double has been anticipated in *Madhumati* (Bimal Roy 1958). Here a young woman jumps out of a terrace to avoid rape.

Her fiancé and a police officer stage a fake apparition of her ghost in order to unmask the culprit. At the moment given the real ghost appears and the murderer cracks down. Here the institutional, and not merely private, trend of the story (crime – police authority – revelation – punishment by law) is related to a narrative of national progress from a feudal-like past to a modern nation-state. This discourse is further endorsed by the function rebirth has in the film. It opens sequences of identity-tricks; first the ghost of the murdered woman appears on the scene instead of her acting persona, then the ghost reappears in flesh and blood in the ending scene of the film, as the reincarnated wife of the man she had loved in her first life.

Primary sources

Braddon, Mary E., "The Cold Embrace", in *Ralph the Bailiff and Other Tales* (London: Ward, Lock and Tyler, 1867).

Conan Doyle, Arthur, "The Captain of the Polestar", in *The Captain of the Polestar and other stories* (Auckland, N.Z.: Floating Press, 2010).

—, "The Brown Hand", in *Tales of Twilight and the Unseen* (Richmond: Alma Classics, 2013).

D'Arras, Jean, *Mélusine, Roman du XIV siècle* (Dijon: Bernigaud et Privat, 1932).

D'Aurevilly, Barbey, "Le plus beau amour de Don Juan", in *Les Diaboliques* (Paris: Le livre de Poche, 1985).

De Balzac, Honoré, "Séraphîta", in *La Comédie humaine* (Paris: Gallimard, Bibliothèque de la Pléiade, 1980).

Flegonte di Tralle, *Il libro delle meraviglie e tutti i frammenti*, Ed. by Braccini, Tommaso, and Scorsone, Massimo (Turin: Einaudi, 2013).

France, Anatole, "Les noces corinthiennes", in *The Bride of Corinth and Other Poems and Plays* (London & New York: John Lane, 1920).

Gautier, Théophile, "La morte amoureuse", in *Contes fantastiques* (Paris: Gallimard, 1999).

—, "Arria Marcella", in *Contes fantastiques* (quoted).

—, "Spirite" (1865), in *Fortunio, Partie Carrée, Spirite*, Edition annotée (Paris: Gallimard, 2013).

Goethe, Wolfgang, "Die Brauth ov Korinth", in *Poems and Ballads* (New York: Delisser and Procter, 1859).

Keats, John, "Lamia", in *Lamia, Isabel, The Eve of St. Agnes, and Other Poems* (London: Taylor and Essey, 1820).

Kipling, Rudyard, "A Madonna of the Trenches", in *Debits and Credits* (Harmondsworth: Penguin, 1987).

Philostratus, Flavius, *Flavii Philostrati opera Auctiora*, Ed. by C.L. Kayser (Lipsiae: B.G. Teubner, 1871).

de Villiers de l'Isle-Adam, Auguste, "Véra", in *Contes cruels* (Paris: Garnier, 2012).

Filmography

Madhumati, Bimal Roy, 1958.

Bhoot (Ghost), Ramgopal Varma, 2004.

Krishna Cottage, Santram Varma, 2004.

Darna Zaroori Hai (Getting Scared is Necessary), Ramgopal Varma, 2006.

Help, Rajeev Manoj Virani, 2010.

Kahaani, A Mother of a Story, Sujoy Ghosh, 2012.

Works Cited

Mackenzie Brown, Cheever, *The Triumph of the Goddess* (Delhi: Sri Satguru Publications, 1992) (State University of New York, 1990).

Carotenuto, Aldo, *Il fascino discreto dell'orrore. Psicologia nell'arte e nella letteratura fantastica* (Milan: Bompiani, 2010).

Castoldi, Alberto, *Il flâneur* (Milan: Bruno Mondadori, 2013).

Dodds, Eric C., *The Greeks and the Irrational* (Berkeley: University of California Press, 1951).

Finné, Jacques, *La littérature fantastique. Essai sur l'organisation surnaturelle* (Bruxelles: Éditions de l'Université de Bruxelles, 1980).

Freud, Sigmund, *Jenseits des Lustprinzips* (Wien: Internationalerer Psychoanalytischer Verlag, 1920).

Giallongo, Angela, *La donna serpente* (Bari: Dedalo, 2012).

Girard de Caudemberg, Scoevola-Charles, *Le Monde Spirituel ou Science chrétienne de communiquer intimement avec les puissances célestes et les âmes heureuses* (Paris: Dentu, 1857).

Guidorizzi, Giulio, *Il Compagno dell'anima. I Greci e il sogno* (Milan: Cortina, 2013).

Monti, Alessandro and Rozzonelli Carole, *Tales of Unrestful and Undomesticated Women* (Lyon and Turin, New Dost Edition, 2017).

Jackson, Rosemary, *Fantasy, The Literature of Subversion* (London and New York: Methuen, 1981).

—, *Il fantastico, la letteratura della trasgressione* (Napoli: Pironti, 1986).

Krishna, Manditha, *The Book of Demons* (New Delhi: Penguin India, 2007).

Ogden, Daniel, *Magic, Witchcraft, and Ghosts in the Greek and Roman Worlds* (New York: Oxford University Press, 2009) [2002].

Hope Robbins, Rossell, *The Encyclopedia of Witchcraft and Demonology* (London: Peter Nevill Limited, 1960).

Scotti, Massimo, *Storia degli spettri* (Milan: Feltrinelli, 2013).

Todorov, Tzvetan, *Introduction à la littérature fantastique* (Paris: Seuil, 1970).

Vernant, Jean-Pierre, *Mythe and réalité. Études de psychologie historique* (Paris: Maspero, 1965).

Wallace, Alfred, *Miracles and Modern Spiritualism* (London: James Burns, 1875).

CIRCULATING FEARFUL OTHERNESS

ORNIAS AND THE OTHERS
The Demon Tales of the *Testament of Solomon* between East and West

University of Turin

The *Testament of Solomon* can be considered a textbook example of what is called an "active tradition" or a "living text".[1] Each of the sixteen known Medieval and Early Modern manuscripts of this work (DiTommaso, 2012) can be considered an almost separate version. They are so different that, in fact, it is exceedingly difficult to print a unified text – let alone to establish a *stemma codicum*. This is hardly surprising: the *Testament of Solomon*, in fact, is a non-canonical, multi-layered Greek Christian text, probably written in Late Antiquity and surreptitiously attributed to King Solomon. The first layer of the text is a narrative frame describing Solomon intent on subduing many demons, forcibly employed in the construction of the Temple of Jerusalem. A second layer consists of exorcisms and incantations against the abovementioned demons, considered the causes of illnesses and diseases affecting human beings. Finally, these exorcisms may be accompanied by brief narratives, sometimes classifiable as *historiolae*, short stories permitting "the performative transmission of power from a mythic realm articulated in narrative to the human present" (Frankfurter, 2001: 464), in particular to the incantations against the "evil spirits" mentioned in the *Testament*.

The very nature of the text, a non-canonical treatise whose core is a technical repertoire of exorcisms associated with specific demons, wrapped by at least two different layers of narrative context, ensured that the scribes felt free to intervene and alter the text to their liking. On the one hand, it was possible to change the

[1] The standard edition is McCown (1922); an English translation is available in Duling (1983).

identity and number of the demons, adapting them to the particular needs of the scribe (often an exorcist himself) or of his clients. On the other, scribes could expand or reduce narrative parts, or modify entire episodes. This means that the text of the *Testament of Solomon*, in this way, was permeable from the beginning to local traditions and related narratives. Moreover, the *Testament* could be read aloud during exorcisms, which, it should be noted, were meant to cure diseases – allegedly caused by demons – rather than diabolical possessions *stricto sensu* (Jackson, 1988: 21–2 and *passim*). This, in turn, means that the content of the *Testament of Solomon*, and especially its narrative parts, could also travel in reverse, and move from the text to the narrative culture of the environment in which the work was read and recited.

The first aim of this paper is to highlight some cases of this twofold passage, from and to the text. The second aim is to show how this process of bidirectional osmosis remained active until recent times in the "natural environment" of the *Testament of Solomon*: that is, the Eastern Mediterranean, especially (but not only) the Greek-speaking areas. When text was exported to the West, instead, it struggled to take root, and it is only through a late scholarly intermediary that some elements of the text have succeeded, albeit with difficulty, to settle in literary imagination.

From Middle East legendary traditions to the Testament of Solomon

Although the genesis of the text is shrouded in obscurity, the influence and presence of local traditions can be detected from its very structure, and in particular from its narrative framework. It has already been observed, for instance, that the tradition about King Solomon subduing the demons with the help of a holy ring is mentioned at least since Flavius Josephus in the first century AD.[2] The ring with which Solomon subdued Asmodeus, described

2 See *Antiquitates Judaicae* 8.45-9, mentioning the use of a ring containing a root whose exorcistical power had been showed by

as "prince of demons", is also mentioned in a passage of the Babylonian Talmud (*bGiṭ* 68a; see Ranke, 1977; Yassif, 1999: 87–9; Busch, 2006: 120). The core of the narrative framework of the *Testament*, focused on this powerful ring, seems therefore to stem from legendary traditions that circulated about Solomon and which were known in Christian as well as in Jewish culture. In Christian times, in particular, these traditions were mainly disseminated from Jerusalem, where local guides told the story of the ring and of the subduing of the demons by Solomon to the pilgrims, and showed them the "relics" kept in the church of the Holy Sepulchre.[3]

The influence of oral traditions seems detectable also in other parts of the text. This is not the venue, of course, for a comprehensive review, but it will not be out of place to provide at least some examples. An important point of contact between the *Testament* and traditional narratives documented especially in the Middle East is found in the chapters dedicated to the demons of the wind. In chapter 7 (present in six known manuscripts), Solomon meets the so-called Whirlwind of Ash (*Helix Tephras*),[4] characterized by a tumultuous entrance:

> He was bearing his face on the air high above and the remaining part of his body was crawling along like a little snail. Suddenly, he broke through a large contingent of soldiers, raised up a blustering cloud of dust from the earth, transported it upward, and hurled it against me many times (while I watched) in amazement.

Interrogated about his activities, the demon answers:

Solomon; see also Duling (1985: 14–7, 21–3), Johnston (2002: 39–40). For the various traditions surrounding the figure of Solomon, and in particular those related to magic and demonology (Thompson's motif D1711.1.1, *Solomon as master of magicians*), see Torijano (2002: 41–87, 192–224) and Lassner (2003: 1072–3).

3 For the influence of the Jerusalem legends about the ring on the *Testament*, see Torijano (2002: 85–6) and Busch (2006: 27–8).

4 This is the correct name that must be reconstructed from the readings of the manuscripts; McCown instead printed his conjecture, *Lix Tetrax*, which, however, proves unsatisfactory to a cogent analysis. See Braccini (2011).

I create divisions among men, I make whirlwinds, I start fires, I set fields on fire, and I make households non-functional. Usually, I carry on my activity in the summertime. If I get the chance, I slither in under the corners of houses during the night or day (Duling, 1983: 969).

In chapter 22 (present in four manuscripts), Solomon receives a letter from the king of Arabia, Adarkes, asking for his help against a noxious spirit. In his words,

> There still exists a spirit in Arabia. Early in the morning a fresh gust of wind blows until the third hour. Its terrible blast even kills man and beast and no (counter-) blast is ever able to withstand the demon.

Solomon's plan against the demon (that, as we learn later, is called Ephippas) is very clever. He sends a carefully instructed boy servant against the wind-spirit:

> The boy obeyed the orders and went to Arabia. Now the men from the region doubted whether it was possible to bring the evil spirit under control. Nonetheless, before dawn the house servant got up and confronted the spirit of the wind. He put the flask on the ground and placed the ring on (its mouth). (The demon) entered the flask and inflated it. Yet the boy stood firm. He bound up the mouth of the flask in the name of the Lord Sabaoth and the demon stayed inside the flask (Duling, 1983: 984).

The first of these chapters, the one relating to the story of the Whirlwind of Ash, allows us to establish a precise parallel with beliefs, present in ancient Mesopotamia and still attested in modern and contemporary times in the Middle East, considering as demonic entities, or *jinn*, both tornadoes and more modest eddies of wind and sand, moving in the desert or in the scorched and dusty landscape.[5] One could cite many narrative examples,

5 For Mesopotamian demons related to winds, see Barbu-Rendu Loisel (2009: 309, 314, 316), where it can be seen that these entities have a tendency to infest "corners": maybe there is a connection to the activities of the Whirlwind of Ash, slithering in "under the corners of houses during the night or day". The belief that whirlwinds are inhabited by demons, by the way, is not confined to the Middle East: see

starting with *Arabian Nights*: already in the second story, the *Tale of the trader and the Jinni* (Burton, 1886: 21–3), there is a scene strikingly similar to the seventh chapter of the *Testament of Solomon* (McCown, 1922: 28*-31*). While the protagonist, a merchant, and other travelers are sitting in waiting, "a dust cloud advanced and a mighty sand devil appeared amidmost of the waste. Presently the cloud opened and behold, within it was that Jinni handing in hand a drawn sword, while his eyes were shooting fire sparks of rage" (Burton, 1886: 23). Beliefs of this kind were still living in the Egypt of the 19th century: according to the testimony of a traveler, "it is the general belief of the Arabs of Egypt that the Zobaáh, or whirlwind, which carries the sand or dust in the form of a pillar of prodigious height, so often seen sweeping across the fields and deserts of this country, is caused by the flight of one of these beings; or in other words, that the Jinneh rides in the whirlwind" (St. John, 1845: 207; Gadsby, 1855: 320; Van Vloten, 1893: 180).

Also the second narrative present in chapter 22 of the *Testament*, the one about Ephippas' imprisonment in a leather flask or goatskin, has strict parallels especially in the Jewish and Middle East tradition, as attested by Thompson's well-known motif D2177.1, *Demon enclosed in a bottle*, and in the even better known type ATU 331 *The Spirit in the Bottle* (Horálek, 1987: 922–8). As it has been observed, traces of an oral tradition relating Solomon's dominion over the demons with the subduing of a stormy wind by God can be detected also in the *Qur'ān* (Schwarz, 2005: 134; Busch, 2006: 261–2; the passages in question are 21.81-82; 34.12; 38.34-38).[6]

Even more important, however, is the fact that the episode of Solomon's servant sent to subdue the wind-demon plays a very

Thompson's motifs F411.1, *Demon travels in whirlwind*; F455.2.9, *Troll as whirlwind*; F455.3.3.2 *Troll rides in whirlwind*; G303.3.4.4.1, *Devil as whirlwind*, G303.6.3.2 *Devil comes in the whirlwind*. Whirlwind demons known as *scijjune, dragunara, sufunara* are attested in Southern Italy too (Braccini, 2011: 33).

6 For later Arabic traditions personifying the wind in question, see Salzberger (1907: 90–1).

important role in what is considered an Arabic version of the
Testament. Published and translated for the first time in 2006,
the so-called *Testamentum Salomonis Arabicum* represents,
according to its editor, a heavily reworked version of the
Greek *Testament* (Monferrer-Sala, 2006: 9–10), in which the
exorcistical element has been massively dropped. The episodes
of the narrative framework, on the contrary, were kept and even
augmented. Among these, as mentioned, the story of the defeat of
the wind-demon occupies a considerable space (Monferrer-Sala,
2006: 67–72). It is probably no coincidence that, in the Arabic
translation of the *Testament of Solomon*, such an important role
is played by a story with marked folktale traits that, in the Greek
text, refers expressly to Arabia. This indicates, if anything, that
the narrative about the wind-demon (as shown for the parallel
story of the whirlwind-demon) was actually present within Arab
and Middle Eastern culture and, in the unspecified time in which
the *Testament* was translated, it was still active and vital, so that
the episode was even expanded. The presence of an episode in
a version of the *Testament of Solomon* could act, in a way, as a
thermometer indicating the presence or the permanence of the
related motif(s) in the cultural humus in which that version was
developed. When these motifs are not (or no longer) present, the
related episodes tend to be reduced or disappear altogether. Being
permeable and porous with respect to local narrative traditions
regarding demons is basically in the nature of a "living text"
as the Greek *Testament*, with its practical use in exorcisms and
wide array of *historiolae*. And this meant also that some narrative
element, enacted or read aloud during the exorcisms, could gain
a foothold in the surrounding narrative environment.

From the Testament *to Greek narrative space*

Surely it is very difficult to prove, or even to argue, that a
motif attested in the Greek narrative space may have been put
into circulation by a non canonical text as the *Testament*: it's
always possible (and often advisable) to think that this motif is

independent. But there is at least one case for which it does not seem too far-fetched to assume that the *Testament* influenced a Greek folktale. The case in point concerns the Greek version of the abovementioned type ATU 331, "The Devil in the Bottle", that in a limited number of variants (five out of thirteen, but scattered all across Greece) presents this curious preamble: "The Devil seeks the hand of the priests' daughter; as soon as he marries her, he drinks her blood by sucking her finger. The priests learns the truth; he encloses the Devil in a bottle; carries out exorcisms; after first closing all the holes in the house so the Devil cannot escape; he throws the bottle into the sea, or has someone else throw it" (Megas et al., 2012: 80; compared with Angelopoulou-Brouskou, 1999: 438–440). Then, the story goes on with the Devil freed by some unknowing fisherman or by someone else.

The motif of the monster sucking the blood from the victim's finger, although rare, is not unattested in international folktales and is registered as Thompson's G332.1, *Ogre sucks victim's finger and drinks all his blood*, present in Spain, France and Italy, and, in the Arab world, in Iraq, Algeria and even in Jerusalem (El-Shamy, 2004: 120–1, 125). Its combination with motif D2177.1, *Demon enclosed in a bottle*, however, is rather peculiar, such as the association with a priest and his exorcisms. The structure of this preamble, however, is strongly reminiscent of the very preamble of the *Testament of Solomon*, which begins in such a way:

> Once upon a time, when the Temple of the city of Jerusalem was being built and the artisans were working on it, Ornias the demon came as the sun was setting and took half the wages and provisions of the master workman's little boy. Also, each day (the demon) was sucking the thumb of (the boy's) right hand. So the little boy, who was much loved by me [Solomon], grew thin (Duling, 1983: 961).

Ornias is going to become the first demon subdued by Solomon with the help of his ring. Also the second element appearing in the preamble to the Greek version of ATU 331, the imprisonment of the demon in a bottle subsequently thrown into the sea, is somewhat traceable back to the *Testament*. In chapter 16, this is

the fate of the cruel sea-demon Kunopegos: "I [Solomon] ordered him to be cast into a broad, flat bowl, and ten receptacles of seawater to be poured over (it). I fortified the top side all around with marble and I unfolded and spread asphalt, pitch, and hemp rope around over the mouth of the vessel. When I had sealed it with the ring, I ordered (it) to be stored away in the Temple of God" (Duling, 1983: 976).[7]

Although the individual components of the preamble of some Greek variants of ATU 331 exist independently as folk-literature motifs and, at least in the case of the demons imprisoned in vessels, there is also a connection to the Middle Eastern magic custom of incantation bowls (Duling, 1983: 943 and 947–8; Schwarz, 2005: 125–32), their peculiar combination strongly suggests that the development of this kind of prologue, linking together motifs G332.1 and D2177.1 in an exorcistical context, could be reminiscent of the narratives of the *Testament of Solomon*. If this is the case, it could be a demonstration of the symbiotic relationship existing between the written text of the *Testament* and the surrounding narrative environment, at least in the Eastern Mediterranean, its natural habitat.

The Testament *arrives in the West: A difficult acclimatization*

It is interesting to notice, in fact, that when the *Testament* arrived in the West, it never fully succeeded to "take root", probably because it was not integrated in the system of local

7 In chapter 15, moreover, the demon Enepsigos talks about the vessels in which Solomon entrapped the demons, and prophesies that they shall be broken by the hands of men. Although these last two chapters are rather poorly attested (only two manuscripts, plus traces of a third: Delatte, 1927: 235–6, and Braccini, 2014: 292–4). The tradition of Solomon imprisoning the demons in vessels is very old, and moreover it is associated with Solomon also in Greek collections of exorcisms (Torijano, 2002: 85–6, n. 69; Busch, 2006: 209). For other mentions in Coptic texts and fragments from Nag Hammadi, see Duling (1983: 950–1).

beliefs and healing practices, and had to contend with competing and already well-established Solomonic traditions.[8] Apart from a single reference to Ornias as "prince of the demons" in an eighth-century Latin glossary (James, 1903: 224–5 and 239; McCown, 1922: 73; Busch, 2006: 97), nothing suggests an actual familiarity with the *Testament* during the Middle Ages. Even the later arrival of many manuscripts of the text in Italy, France, Austria and England failed to produce any genuine dissemination of its narrative material, in oral or written tradition. Actually, more than half of the known surviving manuscripts of the *Testament* are preserved in Western libraries, where they arrived, in some cases, as early as the sixteenth century. Knowledge of the *Testament*, however, was strictly confined to a few scholars (undoubtedly because of its non-canonical status and the difficulty presented by its Greek, far from the classical standard and often obscure), and it was not until 1837 that the text was printed for the first time by the German scholar Ferdinand Florenz Fleck. An English translation published in 1898 by F.C. Conybeare increased awareness of the content of this work, that however, detached from the cultural context in which it had been conceived and developed, seemed bound to languish as a mere curiosity for scholars.

It was precisely a scholar who gave an unexpected turn to the vitality of the *Testament* in the Western narrative imagination. Montague Rhodes James (1862-1936),[9] over the years provost of King's College, Cambridge, and Eton College, developed a keen interest in apocryphal and uncanonical literature, and this gave him more than a passing acquaintance with the *Testament of Solomon*, that he managed to know very well: "the book is

8 In addition to the texts of ceremonial magic, of Greek origin but very different in purpose and content from the healing exorcisms accompanied by *historiolae* of the *Testament* (Johnston, 2002: 47–8), it should be recalled the Western tradition of the dialogue between Solomon and Marcolf. This one too, according to a plausible theory, could come from (or at least be influenced by) ancient Oriental narratives on the disputes of the King with the demons (Röcke, 2003: esp. 1083–4).

9 Cox (1983) is still the reference biography about James.

without any doubt very foolish, and superstitious, and corrupt, and bad; but [...] at the same time, it is extremely interesting and amusing, and sometimes picturesque" (James 1899: 367). The obvious fascination with the text led James to summarize some episodes, with some extent, in his *Old Testament Legends*, an illustrated collection of tales taken from apocryphal literature and destined to young readers (105–19).

James, however, today is known mainly for his writing of very refined ghost stories destined, before the actual publication, to a selected audience of friends and students. These tales abound in learned references to apocrypha, medieval lore and demonology, and it is more than a guess to assume that the *Testament of Solomon* had an influence on James' literary production. Obviously this is not the place for a detailed analysis: a single case will suffice, concerning the opening tale in the first collection published by James (*Ghost Stories of an Antiquary*, 1904). The story entitled *Canon Alberic's scrap-book* (in reality written in 1894) is about Dennistoun, an English scholar visiting the decaying town of Saint-Bertrand-de-Comminges, in the Pyrenees, and buying from the sacristan of the local, dilapidated cathedral an old scrap-book, where a 16th century canon pasted cuttings of illuminated leaves from the cathedral library manuscripts. Among them, a disturbing drawing of a bizarre scene that, as the reader will learn later, is the key to a horrible secret:

> On the right was a king on his throne, the throne elevated on twelve steps, a canopy overhead, soldiers on either side—evidently King Solomon. He was bending forward with outstretched sceptre, in attitude of command; his face expressed horror and disgust, yet there was in it also the mark of imperious command and confident power. The left half of the picture was the strangest, however. The interest plainly centred there.
> On the pavement before the throne were grouped four soldiers, surrounding a crouching figure which must be described in a moment. A fifth soldier lay dead on the pavement, his neck distorted, and his eyeballs starting from his head. The four surrounding guards were looking at the King. In their faces, the sentiment of horror was intensified; they seemed, in fact, only restrained from flight by their implicit trust in their master. All this terror was plainly excited by the being that crouched in

their midst. [...] At first you saw only a mass of coarse, matted black hair; presently it was seen that this covered a body of fearful thinness, almost a skeleton, but with the muscles standing out like wires. The hands were of a dusky pallor, covered, like the body, with long, coarse hairs, and hideously taloned. The eyes, touched in with a burning yellow, had intensely black pupils, and were fixed upon the throned King with a look of beast-like hate. [...] One remark is universally made by those to whom I have shown the picture: "It was drawn from the life." (James, 2011: 8–9)

As Dennistoun will discover later, there is also a caption for the drawing: *Contradictio Salomonis cum demonio nocturno* (Dispute of Solomon with a demon of the night). This description is strikingly reminiscent of the many similar scenes in the *Testament of Solomon*, where the demons are often unruly and go so far as to challenge or threaten the king.

For Eastern narrative material related to the demons such as this, the only, albeit limited, possibility to take root in the West could be through a reworking placed halfway between scholarship and fiction, and so it was. James' ghost stories are still enjoying considerable success, and their influence on the imaginary of supernatural fiction (also by the agency of later writers who were inspired by them, as Howard Phillips Lovecraft) is undeniable. Since 2005, a stage adaptation of *Canon Alberic's scrap-book* was performed over one hundred times in Ireland and the United Kingdom by actor Robert Lloyd Parry;[10] this is a remarkable and quite unique case of a theatrical reenactment of motifs coming (albeit indirectly) from the *Testament of Solomon*.

Concluding remarks

It is obvious that the possibility of dissemination of the *Testament* in the West has always been mostly limited in content

10 A factsheet for this production and other adaptations of James' tales is available at *http://www.nunkie.co.uk/theatre.html* (last consulted: 8/9/2015).

and distribution and, above all, one-way. Language barriers and contents very remote from common experience, appealing only to learned esoterists or lovers of the Oriental and demonic picturesque, meant that the *Testament*, a living text in the Eastern Mediterranean, became a dry specimen in the West, like a pressed flower in a herbarium.

As it has been seen, the situation in the cultural area where the *Testament* was born and remained a living text till recently (roughly corresponding to the Middle East, in particular – but not only – to Greek-speaking places) was quite different. Religion, traditional beliefs, rituals and ceremonies, folktales and legends all interacted in an incessant two-way relationship between the *Testament*, its practitioners and its/their audience. The extreme instability of the manuscript tradition is a clear indicator of this phenomenon. The absence of an episode, the inclusion of another, the space given to the narrative framework and to *historiolae* are commensurate with the cultural context in which the manuscripts were created. This is a typical "active tradition", to be opposed to a "dormant tradition", the latter mainly affecting the authoritative classical or Christian texts, expected to retain a fixed and crystallized structure. Active traditions, it is well known, do not fit very well with the tenets of the so-called Lachmann's method, primarily intended to serve the needs of scholars dealing with the great texts of classical antiquity, or with later works marked by similar conditions. This means that, to this day, many living texts are neglected, let alone the tendency to unify them in a single "standard text" at the cost of pruning the very aspects differentiating single manuscripts and versions. The very condition of the *Testament of Solomon*, in sore need of a new edition finally superseding the glorious but ultimately unsatisfactory work of McCown (1922), testifies to this situation. In the case of the *Testament*, however, it is precisely in its "active" tradition that lies one of its major attractions: its multiple layers of demon stories, in fact, are crucial to detecting the presence, the spread, the diffusion capacity of folktale motifs and types related to demons, spirits, exorcisms and traditional healing, both in East and in West.

Works Cited

Angelopoulou, Anna, and Aigle Brouskou (eds.), Επεξεργασία παραμυθιακών τύπων και παραλλαγών: I, *AT 300-499*. Athina: Kentro Neoellinikon Erevnon, 1999.

Barbu, Daniel, and Rendu Loisel, Anne-Caroline, 'Démons et exorcismes en Mésopotamie et en Judée', *I Quaderni del Ramo d'Oro*, online 2 (2009), 304–66.

Braccini, Tommaso, 'Demoni e tempeste: su un passo del *Testamento di Salomone*', *Medioevo greco*, 11 (2011), 23–33.

—, 'Per il testo e l'esegesi del *Testamento di Salomone*: in margine a una recente pubblicazione', *Medioevo greco*, 14 (2014), 289–305.

Burton, Richard, *Lady Burton's Edition of her Husband's Arabian Nights*, vol. 1 (London: Waterlow and Sons Ltd., 1886).

Busch, Peter, *Das Testament Salomos: die älteste christliche Dämonologie*, kommentiert und in deutscher Erstübersetzung (Berlin: De Gruyter, 2006).

Cox, M., *M.R. James: an Informal Portrait* (Oxford: Oxford University Press, 1983).

Delatte, A., *Anecdota Atheniensia*, vol. I (Liège - Paris: H. Vaillant-Carmanne - E. Champion, 1927).

Di Tommaso, Lorenzo, 'Pseudepigrapha Notes IV: 5. The *Testament of Job*. 6. The *Testament of Solomon*', *Journal for the Study of the Pseudepigrapha*, 21.3 (2012), 313–20.

Duling, Charles (ed.), 'Testament of Solomon', in *The Old Testament Pseudepigrapha*, Ed. by J.H. Charlesworth, vol. 1 (Garden City: Doubleday, 1983), pp. 960–87.

Duling, Dennis C., 'The Eleazar Miracle and Solomon's Magical Wisdom in Flavius Josephus's 'Antiquitates Judaicae 8.42-49'', *Harvard Theological Review*, 78 (1985), 1–25.

El-Shamy, H., *Types of the Folktale in the Arab World: a Demographically-Oriented Tale-Type Index* (Bloomington: Indiana University Press 2004).

Frankfurter, David, 'Narrating Power: The Theory and Practice of the Magic *historiola* in Ritual Spells', in *Ancient Magic and Ritual Power*, Ed. by M. Meyer, and P. Mirecki (Leiden: Brill, 2001), pp. 457–76.

Gadsby, John, *My Wanderings, being Travels in the East in 1846-1847, 1850-1851, 1852-1853* (London: Gadsby, 1855).

Horálek, Karel, ,Geist im Glas', in *Enzyklopädie des Märchens*, vol. 5, Hrsg. von K. Ranke (Berlin–New York: De Gruyter, 1987), pp. 922–8.

Jackson, H.M., 'Notes on the *Testament of Solomon*', *Journal for the Study of Judaism*, 19 (1988), 19–60.

James, Montague R., 'The Testament of Solomon', *The Guardian Church Newspaper*, March 15, 1899, 367.

—, 'Inventiones nominum', *The Journal of Theological Studies*, 4 (1903), 218–44.

—, *Old Testament Legends* (London: Longman, Greens and Co., 1913).

—, *Collected Ghost Stories*, Ed. by D. Jones (Oxford: Oxford University Press, 2011).

Johnston, S.I., 'The Testament of Solomon from Late Antiquity to the Renaissance', in *The Metamorphosis of Magic from Late Antiquity to the Early Modern Period*, Ed. by J. Bremmer, J. Veenstra, and B. Wheeler (Leuven: Peeters, 2002), pp. 35–49.

Lassner, Jacob, 'Salomo', in *Enzyklopädie des Märchens*, vol. 11, Hrsg. von R.W. Brednich (Berlin: De Gruyter, 2003), pp. 1071–6.

Marzolph, Ulrich, ,Salomonische Urteile', in *Enzyklopädie des Märchens*, vol. 11, Hrsg. von R.W. Brednich (Berlin: De Gruyter, 2003), pp. 1087–94.

McCown, Chester Ch. (ed.), *The Testament of Solomon*, edited from manuscripts at Mount Athos, Bologna, Holkham Hall, Jerusalem, London, Milan, Paris and Vienna, with Introduction by Ch. Ch. McCown (Leipzig: J.C. Hinrichs'sche Buchhandlung, 1922).

Megas, G.A., Angelopoulous, A. Brouskou, A. Kaplanoglou, M. Katrinaki, E., *Catalogue of Greek Magic Folktales* (Helsinki: Suomalainen Tiedeakatemia, 2012).

Monferrer-Sala, Juan Pedro (ed.), *Testamentum Salomonis Arabicum*, edición, traducción y studio (Córdoba: Servicio de publicaciones de la Universidad de Córdoba, 2006).

Ranke, K., 'Asmodeus', in *Enzyklopädie des Märchens*, vol. 1, Hrsg. von K. Ranke (Berlin: De Gruyter, 1977), pp. 880–2.

Röcke, W., ,Salomon und Markolf', in *Enzyklopädie des Märchens*, vol. 11, Hrsg. von R.W. Brednich (Berlin: De Gruyter, 2003), pp. 1078–85.

Salzberger, G., *Die Salomo-Sage in der semitischen Literatur* (Berlin-Nikolassee: Kommissionsverlag von Max Harrwitz, 1907).

Schwarz, Sarah L., *Building a book of spells: The so-called* Testament of Solomon *reconsidered* (Diss. Philadelphia, 2005).

St. John, James A., *Egypt and Nubia* (London: Chapman and Hall, 1845).

Torijano, P.A., Solomon the Esoteric King: From King to Magus, Development of a Tradition (Leiden-Boston-Köln: Brill, 2002).

van Vloten, Gerlof, ,Dämonen, Geister und Zauber bei den alten Araben', *Wiener Zeitschrift für die Kunde des Morgenlandes*, 7 (1893), 169–87.

Yassif, Eli, *The Hebrew Folktale: History, Genre, Meaning* (Bloomington and Indianapolis: Indiana University Press, 1999).

FIGHTING BEASTS
The Pseudo-Callisthenes Account of Alexander the Great in India
From Rhetoric to Narrative and Return

ALESSANDRO MENGOZZI

University of Turin

Persia capta graecum victorem cepit

The *Alexander Romance* attributed to his court historian Callisthenes is one of those global literary phenomena that challenge philology both as text criticism and as study of the history and interpretation of a literary text. The fluid textual tradition derives from the literary nature of the text and therefore requires a philological approach that recognizes literary features specific to it and copes with its vast diffusion across languages and cultures (Traina, 1998). "Texts such as the Alexander Romance are so-called 'open texts', which present their own particularities and idiosyncrasies with respect to both their internal characteristics and the methodological approach appropriate for them" (Karla, 2012: 638).

Like but perhaps more than the *Story and Proverbs of Ahiqar*, the *Confession and Prayer of Aseneth*, *Kalīla wa-Dimna*, the *Acts of Peter*, *Barlaam and Josaphat*, *The Seven Wise Masters*, *The Thousand and One Nights*, *Vis o Rāmin*, *The Life of Aesop*, *Leylī o Majnūn*, *The Alexander Romance* rather than an open text in itself is part of a saga describable as a "text network", that is an autopoietic, self-organizing narrative system, and develops into a diffusional pattern of interrelated texts (Selden, 2009 and 2012).[1] The narrative plot and the system of values attached to it

1 A description of the Pseudo-Callisthenes as a "text network" in more traditional terms can be found in Stoneman (1994: 121): "the Romance was composed by a process of accretion and is the work not of scholars like the histories, but of popular writers. The development of a text through successive redactions is a characteristic of popular works: other

combine in the open structure of an inclusive patchwork, but are continuously re-told and re-written in multiple versions, hardly conceivable as witnesses of an original or archetypal text. The self-generative, open, inclusive character of the composition makes the *Romance* "a huge narrative aircraft carrier, well equipped with submarines and thereby giving the researcher a good catch of textual artifacts" (Piemontese, 2003: 305). The closed, circular nature of the single act of narration and composition does not produce copies, manageable following a text-critical method, but an instable, fluid, magmatic textual tradition, in which no version can be said to be identical to another.

Text networks – or narrative aircraft carriers – largely employ narrative frames, multiple framing and "narrative in the narrative" technique to construct well-organized collections of texts, be they stories told by a higher-frame character, fictional letters or narrative records of marvelous deeds, places and creatures. Internal narratives are thus safely packed within the main frame or plot which fosters their diffusion through time and space. In the meantime, they can be dropped out of the network or modified to adapt to specific purposes and maybe re-used in other genres: open networks and text carriers, however, do not collapse.

The enormous diffusion of text networks raises serious problems for a comprehensive philological and literary analysis. From the date of composition of its first nucleus, conventionally placed as early as in the third century BC, the Alexander saga is attested through late antiquity, the Middle Ages, until pre-modern times.[2] Crossing linguistic and confessional borders, it was told, written and re-written in the vast territory of Selden's (2009 and 2012) "Levantine-Mediterranean tributary states".

examples include *Appolonius of Tyre*, the Medieval Greek *Digenis Akritas* and perhaps the Gospels". On the popular character of the *Romance* and its relationship with folk-tales, see, below, n. 6.

2 For the circulation of the *Romance* through the 19th century in "pre-capitalistic" Ethiopia and Ottoman Empire, see Selden (2012: 34, n. 111).

The ancient novel flourished as an epiphenomenon within the multi-ethnic tributary empires of the Mediterranean and Middle East—Īrān, Makedonia, Rome, Byzantion, the Caliphates—where it achieved both its greatest artistic complexity and its widest geographical diffusion between the second and twelfth centuries CE (Selden, 2012: 19).[3]

The area that Selden, from a slightly Euro-centric perspective, labels as "Levantine-Mediterranean", seems to correspond to one of the four "parallel worlds" that Vlassopoulos (2013) identifies as the main contexts in which Greeks and non-Greeks met and interacted. Rather than around the "Roman East" or the Eastern part of the Mediterranean, Selden's and Vlassopoulos' "empires" are centered on Persia.[4] The *Story and Proverbs of Ahiqar* is the first of Selden's text networks, and it is written in Aramaic, the official language of the Achaemenid Empire. The creation and diffusion of the Pseudo-Callisthenes is conceivable only after the Macedonian conquest of the Persian Empire, India included. The victory of Aristoteles' pupil over Darius is explicitly thematized in the *Romance* and, as we shall see, redeployed in the narration of the Indian campaign. Indeed, after Alexander's birth, the foundation of Alexandria and the destruction of Thebes, the Persian and Indian Wars – thus the formation of the Graeco-Macedonian "tributary empire" – constitute the main narrative clusters of the *Romance*. We should probably consider a *Persia capta* – or even *Asia capta* – phenomenon that introduced the art of text networks in the Hellenistic world and later on, from the East westwards, in Byzantium.

The *Romance* itself, which is an almost epic narrative record of the creation of the Hellenistic world, has been perceived and criticized, not too paradoxically, as an oriental pastiche, "not distinguished either by historical accuracy or (at least for

3 Stoneman (1994: 126–7) suggests that the *Romance* offers a quasi-psychological interpretation of the relationship of Alexander with "Makedonia" as a tributary empire: "response to empire is the underlying theme of the Romance. Alexander's concern with immortality is a metaphor of his anxiety about his imperial rule".

4 On the connections between Greek – especially as regards the Hellenistic romance – and Iranian storytelling, see Stoneman (2012).

our modern taste) any particular literary merit" (Gero, 1993: 3). More recently, and by a first-class Alexander scholar: "it is hard to identify the appeal and the reasons for the endurance of the artless farrago that is the Alexander Romance" (Stoneman, 2003: 612). From his historical and theoretical standpoint, Selden (2009: 13) replies to Steneman's dismissive judgment, that the Alexander saga firstly "conforms to what is arguably the most common type of diffusional patterning—the text network—in the Roman East. Secondly, all such narratives explicitly thematize their own dissemination, which suggests that their crosscultural transmission is less an arbitrary matter dependent upon taste, than structurally encoded in the works themselves".

Alexander is not only a Greek national hero, but a crosscultural and, indeed, imperial hero who embodies the virtues necessary to circulate and surf on the global network that tells his story. He adopts and continues the Persian approach to governing a multinational, multicultural and multilingual empire (Vlassopoulos, 2013: 46–52) and "proves a shrewd tributary administrator, who fosters the independent welfare of his subject peoples, allowing each its own customs and traditions, privileging or homogenizing none" (Selden, 2012: 36).[5]

A closer examination of the narrative structure, the stylistic and rhetorical techniques of the *Alexander Romance* shows that it is anything but an "artless farrago". Karla (2012: 638) argues for a reading of the text as a *literarisches Kunstwerk* and suggests that

> the huge success of the work and the evident charm it has continuously exercised since it was written is due, among other reasons, to the relatively predictable and straightforward linear narrative of the text, to its simple and easy to- follow structure and to the emphasis on adventure, suspense and the marvelous, as occurs in folktales.[6]

5 On this point, see also Vlassopoulos (2013: 77): "It was Alexander's ability to replicate successfully the patterns through which the Persian kings had managed to create their own empire which played a crucial role in creating his own".

6 Since Rohde's (1914: 197–204) reading of Pseudo-Callisthenes, scholars point out that the rhetorical formalism of certain pages – especially those reporting speeches, dialogues and epistolary exchanges

There is probably no scholar who has enough knowledge of the languages and of the cultures in which the *Alexander Romance* – let alone the saga – has been transmitted and continuously reshaped, to deal with all its witnesses with equal confidence and efficacy. Text networks challenge Pasquali's (1934) ethical ideal of a scholar who strives after the best possible knowledge of the history of a text. Philology should probably confine to (copies of) texts and versions, leaving text networks to literary and historical considerations. Each version, however, needs to be read and placed within the network of authors, readers and texts in which it has been produced and transmitted, i.e., the literary tradition to which it belongs. The *Storia della tradizione* is always there, precedes and – as it were – encompasses text criticism.

In the specific case of the Pseudo-Callisthenes, scholars seem to be modern victims of the blundering prejudice of Greek superiority, which is part of ancient Greek culture and is yet another theme of many a page of the *Alexander Romance*. Classical scholars are generally unprepared, maybe unwilling, to cope with the languages and cultures that do not belong to the

– is to some extant counterbalanced by the attention to the marvelous, unknown East and the narration of fabulous adventures that answer the needs of a popular readership. For example, Cizek (1978) describes Alexander as a folk-tale hero and interprets "the distortion of historical data" in the text as due to narrative techniques that can be read in the light of Proppian functions. Stoneman (1994: 118) interprets most "wonder-tales" of the *Romance* as "derived from folk-tale and other non-historical genres". More positively, Karla (2012) recognizes folk-narrative techniques – basic leitmotifs associate with the hero, redeployment of a motif and of narrative sequences, triadic schema and antithesis – as factors that ensure cohesion to the text and eventually its success. The critical instruments created for the structural analysis of the folk-tale can certainly provide insightful explanations of the narrative structure of the Hellenistic romance and of Pseudo-Callisthenes in particular. The popular character of the *Romance*, however, should not be emphasized. In fact, the perspective could be reversed: we find in folk-tales a formulaic, almost stereotyped, use of some of the narrative techniques, stylistic features and motifs of major text networks such as the *Alexander Romance*. Kotar (2013: 543) describes the Syriac version of the *Romance* as an occasionally ambitious piece of literature, demanding from the readers a good background in Greek philosophy, mythology and geography.

Greek and Roman world, as if the fact of considering all non-Greek peoples barbarians – according to the widespread ancient conviction – prevents them from acquiring a scientific knowledge of the other languages (Morani, 1998: 175).

Moreover, as we will see from the narrow – though revealing – point of view of the episode of the elephant battle in India, the *Alexander Romance* has served as a depository of topics and narrative materials and has been used to imagine and tell other stories, ideologically bound to, yet historically detached from the original Hellenistic frame. The kaleidoscopic variation of motifs and episodes as organized within the main narrative plot and the chameleonic – glocal – adaptation to different cultures, authorial agendas and readerships make it rather difficult not only to gain a comprehensive picture of its diffusion as "one of the most enduring legacies of Greek antiquity to the medieval world" (Stoneman, 2003: 612), but also to draw a plausible stemma of the relationships and contamination and hybridization processes between various versions, sub-versions and interrelated texts. "With no *Urtext* and lacking any definitive redaction, text networks of this sort remained fundamentally decentered, which makes it virtually impossible to chart with any certainty either their historical development or their full global diffusion" (Selden 2012: 42). Advantages and limitation of a stemmatic approach to the motifs attested in the Arabic Alexander tradition will be dealt with shortly.

A triumph of rhetoric and fiction

The episode of Alexander in India,[7] at the beginning of the third part of the Pseudo-Callisthenes, re-proposes two intertwined

7 For an overview of Greek historical and ethnographic sources about India, see Xydopolous (2007), who argues that the representation of India and Indians in the *Romance* is slightly more realistic and less stereotyped than in pre-Hellenistic works, thanks to the radical change of Greek attitudes towards barbarians that occurred after Alexander's conquests in Asia (on "The Hellenistic world" see Vassopoulos, 2013: 278–331). Although a number of themes, such as the size and strength of Porus soldiers and war-elephants and Alexander's fear of elephants, are shared by the Pseudo-Callisthenes and the so-called Alexander's

themes that contribute, as unifying features, to the narrative skeleton of the *Romance*: the superiority of Greek knowledge and culture over the barbarians[8] and the cunning intelligence of the hero, Alexander the φρενήρης (*ḥakkīmā* in Syriac), obviously reminiscent of the other Greek national hero: the trickster, conqueror, traveler and explorer, πολύμητις Odysseus (Centanni, 1988: xxviii; Karla, 2012: 641–2).

The Indian episode allows us to exemplify the problems raised by textual variation among versions of the *Romance*, as preserved in Greek and other languages and, at the same time, to appreciate the high level of literary re-elaboration that occurs in the narrative construction of various versions. Arguably, the process of accretion – "wonder-tales" are "more with each successive recension" of the *Romance* (Stoneman, 1994: 122) – is not chaotic. Narrative details come to carry new meanings and structural functions in the fluid textual transmission, in which each witness adds precious pieces to complete a fascinating puzzle. In an accordion-like textual transmission, scribes play as narrators and squeeze and expand the bellows by suppressing, refining or adding narrative details to get desired effects. I will

historians (Xydopolous, 2007: 24–5), the narrative and rhetorical agendas clearly prevail in the *Romance*.

8 Pseudo-Callistenes' Alexander the Great seems to follow, maybe foster or contribute to create, an almost trivial paradigm of orientalistic thought, as described by Edward Said (1978). Western Alexander knows the East, attacks and overcomes all Eastern kings, with the imperialistic goal to conquer their lands and exploit their resources – see the opposition of poor Greece vs. rich India in the episode discussed in the present paper. Indeed, Alexander was a model and the Pseudo-Callisthenes a favorite reading among 19th-century Britons, engaged in the construction of the myth of British imperial superiority and the description of subjected India as retrograde and barbarian (Hagerman, 2009; more generally, on the British "obsession with Alexander", see Ball, 2012). Tackling Said's Orientalism, Vlassopoulos (2013) critically describes the relationship between Greeks and Barbarians in terms of global vs. glocal processes, within a complex network of cultural, social, political and economic exchanges. See, e.g., in his conclusions: "the interactions between Greeks and non-Greeks took place in a world that was infinitely more complex than any simplistic distinction between West and East" (Vlassopoulos, 2013: 321).

focus on the Syriac Pseudo-Callisthenes,[9] since precisely in this episode it has narrative details that differentiate a branch of the oriental versions from the Greek texts. The Indian king Porus had prepared troops to help the Persian king attacked by Alexander. However, when he heard that Darius was dead, he returned to India. Aware of Porus' hostility, Alexander decides to wage war against him. When the troops

9 For a list of the works, in poetry or prose, that form the Syriac Alexander legend, see Brock (2011), with bibliography. A number of Iranian elements that naturally – if we take a Persian-oriented standpoint such as Stoneman (2012) – led Nöldeke (1890) to assume that the Syriac Pseudo-Callisthenes had been translated from a lost Pahlavi – more precisely, Middle-Persian – intermediary are interpreted today as the late Neo-Persian patina of a text originally translated from the Greek and later transmitted in an East-Syriac milieu exposed to Persian influence (Ciancaglini 1998 and 2001; Ciancaglini, 2015, responds to van Bladel, 2007, defense of Nöldeke's hypothesis). The relationship of the Syriac Pseudo-Callisthenes with the Greek recensions of the Romance have been recently investigated by Kotar (2013). Mainly building on Reinink's works, the living overview of the Alexander legend in the Syriac tradition by Monferrer-Sala (2011) does not consider Ciancaglini's finds on the Pseudo-Callisthenes and rather focuses on the spread and fortune of motifs of the *Apocalypse of Pseudo-Methodius* and of the *Christian Syriac Alexander Legend* (see, below, n. 23–5). A key witness for the East-Syriac Alexander legend (*Romance* and *Legend*) is the manuscript British Library Add. 25875 (1709), that was used as the base text by Budge (1889). The manuscript was compiled according to an ideological agenda, that assigned to Alexander a specific providential role within the late East-Syriac theological interpretation of history and eschatology (Desreumaux, 2000; for the scribe and the cultural environment in which the manuscript was produced, see Murre-van den Berg, 2015: 273 and 276). See Moennig (2016) on similar considerations on the Byzantine reception of Pseudo-Callisthenes' *Life of Alexander* as "a phenomenon of monotheistic medieval cultures" (in general, 163) and the variation among its recensions as "ongoing process of a narrative integration of Alexander into a Christian world" (on recension λ, 165). While the theological motifs of the Syriac Alexander legend and their political implications have received scholarly attention, the position of the *Alexander Romance*, especially as a medieval literary product, in the history of Syriac literature would require further investigation, which falls beyond the scope of the present paper.

arrive in India, soldiers are tired and their chiefs try to convince Alexander that, while the war against Darius had been necessary to liberate Greece from the tax yoke of the Persians, the Indian war is not necessary, since they do not share their leader's love for war and conquest. Alexander, furious, reminds them that they had won thanks to his knowledge of Persian warfare and habits and invites them to return home on their own, if they have courage to "guide themselves wisely".[10] They decide then to follow him (III.1).

After a few days, Alexander receives a letter from Porus.[11] In the letter, the Indian king, "a king of gods and men" reminds the Macedonian that even the Greek "god Dionysius returned defeated by the hands of the Indians" and orders him three times to go back to Greece, that is such "a wretched place and has nothing worthy of a king" that Indians never thought to conquer it. The hero's reactions to the letter are masterpieces of rhetorical dialectics.[12] He asks that Porus' letter be read to his troops and then he himself comments on the letter, overturning by antithesis the arguments of the Indian king and foreshadowing his smart stratagem to defeat him. Far from being gods, the Indians and their king are beasts and barbarians,[13] only proud

10 Direct quotations are from the English translation by Budge (1889).

11 Fictional letters are skillfully inserted throughout the *Romance*. Often they have specific functions in the construction of the narrative, as in the case of Darius and Porus, whereas in other cases the narrative seems to be built upon them, as in the case of the Brahmans or the Amazons. "Scholars ancient and modern have long recognized the association between letter-writing and progymnasmata, school exercises best attested from the Hellenistic and Imperial periods which prepared students for rhetorical composition and declamation" (Arthur-Montagne, 2014: 170).

12 Papyrus finds have demonstrated that Rohde's (1914) theory that insisted on the schools of rhetoric of the Second Sophistic (1st-3rd centuries AD) as instrumental for the emergence of the Hellenistic romance is untenable from a chronological point of view (Hägg, 1991: 243). From a much earlier period and probably constantly in the following ages, rhetoric school exercises remained influential formal models for narrators and novelists.

13 The description of non-Greeks as ignorant beasts is rooted in Greek culture. In the Near East, e.g. in Assyrian historiography, a whole set of formulaic topoi are used to depict a deformed image of the enemy, but in human, moral and political terms: he does not do what he is supposed

of the number of their soldiers.[14] The Syriac Alexander presents thus himself as embodiment of Dionysus ruling over all nations, even more clearly than in the Greek recension α (Kotar 2013: 303).

> Verily I say unto you that the barbarians and dwellers in all these regions are all as stupid and as ignorant as the wild beasts that live in their country. Leopards and lions and elephants and panthers are over confident by reason of the strength of their bodies, and it is well known that they can be easily captured by the knowledge of man with stratagems and artifices. In the same way the kings who dwell in these regions, and all the barbarians, are proud by reason of the number of their troops, but they will be easily defeated by the knowledge of the Greeks (Budge, 1889: 89).

Alexander then sends an answer to Porus, in which he resumes and bends to his advantage one of Porus' arguments. Indeed, Greece is a poor country and the awareness of this strongly motivates his troops to defeat rich Indians and prey on their riches. Alexander denounces Porus' arrogance in considering himself a king of gods and the Indians capable of winning over gods. He will not fight against a god, but as a human warrior against a human warrior (III.2). Like in the preceding campaign against Darius and in other episodes of the *Romance*, "the paired letters function like the paired speeches common in histories, employing

to do for and does what he is not supposed to do against Assyrian royal power (Fales, 1982). He is an internal enemy. In Greek culture we find "polarized representations of non-Greeks as an incarnation of everything that was different and opposed to the values and customs that the Greeks held dear" (Vlassopoulos, 2013: 190–1). Barbarians are external enemies and otherness is represented in half-human, non-human or bestial forms. So is depicted the Other in archaic vase painting (Vlassopoulos, 2013: 178) and the marvelous creatures who have inspired many pages of the *Alexander Romance* recall the battle scenes "between Order and Choas, between Self and Other" that populate Classical Greek art (Amazonomachy, Centauromachy and Gigantomachy; see Vlassopoulos, 2013: 191).

14 That military glory and the number of soldiers are inversely proportional variables is a Greek topos, at least since the battle of Leonidas at Thermopylae.

an antithetical parallelism to rhetorical effect" (Arthur-Montagne, 2014: 174).

As it happened to Nikolaos in the first part of the *Romance* and to Darius in the second, keen readers know that the king's arrogance will be punished, since hubris punishment is one of the "leitmotifs running through the whole body of the narration" (Karla, 2012: 644 and 649–50).

Much to his – and the readers' – surprise, Alexander finds that the wild beasts to which he had compared the Indians in his rant to the soldiers are lined up in Porus' army. From the elegant and reassuring level of the verbal contest, the Indians-beasts and the Indian beasts descend now flank to flank on the story level, ready for a real battle. The Greeks and the hero himself are afraid. Alexander's rant has created a nightmare on the narrative level. Indian troops are troops of real beasts.

Although admittedly more realistic than dog-men and other wonderful monsters that feature in the *Romance*, the fearful army of beasts is one of Alexander's – and his readers' – encounters with the marvelous as a narrative device. It is the unconventional weapon that the villain antagonist deploys to struggle against the hero and that the narrator employs – clearly against the folk-hero paradigm – to trigger and reveal the hero's ability to devise trickery.

> Alexander himself was afraid, because he was accustomed to fight with men and not with wild beasts. Then he sat down and reflected in his mind, and gave orders to bring such brazen images as could be found among his troops. And when the images were collected, which were in the form of men and quadrupeds, – now they were about twenty-four thousand in number – he ordered a smith's furnace to be set up; and they brought much wood and set fire to it, and heated those images in the fire, and the images became glowing coals of fire. Then they took hold of them with iron tongs, and placed them upon iron chariots, and led the chariots before the ranks of the warriors; and Alexander commanded horns and trumpets to be sounded (Budge, 1889: 90).

The hero reacts to fear as a ζῷον λογικόν: he sits down and thinks, then speaks. As we shall see especially in the Ethiopic version, the stratagem he devises is a triumph of fiction in the

etymological and current sense. He orders the collection of all the bronze that could be found, no less than twenty-four thousand statues of men and quadrupeds. He heats them and puts them on chariots, forging an army of beasts and men and doubling the bestial and human army of the Indians. Just as reality in fiction, Indian troops do not recognize themselves or the enemies in the distorting mirror of the bronze burning army created by Greek knowledge and intelligence. Forged beasts and men triumph over real beasts and men. The artifice of the burning statues indeed captures and defeats the barbarians, as announced by Alexander in the speech that follows the reading of Porus' letter.

> When the wild beasts that were in the ranks of the king of the Indians heard the sound of the trumpets, they rushed upon the ranks of Alexander's army; and since the brazen images which were full of fire were in the van, they laid hold of them with their mouths and lips, and burnt their mouths and their lips. Some of them died (on the spot), and some of them retired beaten and fled away to the camp of the king of the Indians. The wise Alexander, having turned back the wild beasts by this artifice, began to fight with the Indians themselves (Budge, 1889: 90–1).

Hot burning statutes created after reflection overcome the marvelous of fighting beasts, evoked by the hero for rhetorical purposes and suddenly embodied in the narrative text as a dangerous and fearful war machine. Finally the wise Alexander begins his true battle. Of course, he eventually wins.

Both from the macro-perspective of the *Romance* as a text network and at the micro-level of the episode as a narrative segment, the story of Alexander in India is the work of a fine artist and a skilled narrator, who disseminates generative details all along the narrative furrows. The episode is inserted in the main narrative plot of the *Romance* as a second redeployment of the motif of the villain king, arrogant and punished,[15] and as

15 The Greek recension β of the Indian campaign not only redeploys the
 epistolary exchange – and the motif of the arrogant king – but also
 Alexander's visit in disguise of the enemy's camp. Two crucial themes
 of the Indian episode are reprised in the addition: the enemy as a beast

further evidence of Alexander's intelligence – two of the features that according to Karla (2012) ensure unity and cohesion to the narrative and thematic structure of the *Romance*. In itself, it is constructed on the interaction of different levels: fictional letters and diplomatic exchanges, rhetorical contest and actual battle. Antithetic oppositions – men and gods, men and beasts, Greeks and barbarians, knowledge and ignorance, statues and real troops – are proposed and resumed at the various levels, creating the sophisticated web on which the needlework of narration embroiders the story. The theme of fighting beasts, in particular, is redeployed at the micro-level of the episode, from rhetoric speech to military action, from mockery to marvelous battle.

Generative details

In telling Alexander's trickery in the struggle with Porus, the Syriac text must be broken or abridged. A copyist may have reacted to different versions of the story. If we compare it with other oriental versions, especially the Ethiopic Romance and some of the Arabic sources, a number of narrative details appear to be misplaced in the Syriac narrative. If the bronze statues of men and quadrupeds were to be found, nice and ready, among the soldiers – as the Syriac text suggests[16] – it is not clear what is the purpose of the smith's furnace that Alexander orders to set

and the divine ancestry of the hero. Porus overturns Alexander's mockery and asks Alexander, disguised as a soldier, to report to the Macedonian king that he will use against him beasts that are as fierce as he is. Alexander risks betraying himself: "King Porus – replies Alexander – before I am back to Alexander, he will hear with his ears all that you have said. – And from whom? – Porus asks. – From Porus, because he is the son of a god and knows everything that is said" (Centanni, 1988: 124–7).

16 The Greek recension β, III.3 explicitly says that the statues are part of the booty that the soldiers had collected (Centanni, 1988: 126–7). The Armenian version specifies that they had been made in Persia and Alexander ordered to put them on chariots when moving to India (Wolohojian, 1969: 116).

up. The metal simulacrums had only to be filled with burning wood and installed on chariots to cope with the two main reasons for Porus's military superiority: the number of soldiers and the presence of both men and beasts in his army.

In this episode, the Ethiopic Alexander is less a solitary, reflective and astute hero than his Greek and Syriac possible ancestors. Counsellors and friends advise him to make twenty-four thousand images of elephants.

> He took counsel with his counsellors and with the wise men his friends, and they advised him to make brazen and iron images of elephants. And they made for him twenty and four thousand exact images of elephants, for when Alexander came into the country he brought with him from their various provinces a great number of smiths skilled in the art of metal work, and there were in his army fifty thousand workers in metal. And when the elephants were finished soldiers filled them inside with wood and set it on fire, and when the images had become blazing hot the Greeks brought out the chariots and set the images before them, and they dressed [images of men and placed them] inside them as if they had been men in very truth (Budge, 1896: 120).

The tactical problems are solved by making twenty-four thousand statues of elephants and probably – the text is not very clear – placing on them human-shaped puppets. Both narrative details preserved in the oriental versions – the number of statues and the fact that that they represent animals (quadrupeds in Syriac, elephants in Ethiopic) and men – are not attested in the Greek recensions of the Romance. As Budge (1896: 120 n.2) notes, "there is no authority in the Greek for this number". The available Greek,[17] Armenian (Wolohojian, 1969: 119) and

17 The text of the Greek recension α ("*vetusta*", based on a 11th-century manuscript) can be found in Kroll (1926, reprint 1958: 101–2; German transl. in Ausfeld, 1907: 86–7); an Italian transl. of the text of the Greek recension β (based on the 15th-century manuscript L) is found in Centanni (1988: 126–7), facing the Greek text edited by van Thiel (1983). The five recensions of the Greek Romance, as reconstructed by modern philologists (α, β, γ, ε, λ), have a purely conventional value, as a working hypothesis to classify the manuscript witnesses of the Romance (e.g., Centanni, 1988: xxxiii and Traina, 1998: 313). See

Latin[18] versions speak of statues of men. In a popular Armenian version, in prose and quatrains, orally transmitted and written down in the 18th century (Simonyan, 1998: 286), Alexander lines up sixty thousand heated copper statues of men against the sixty thousand elephants of Porus' army (Bernardelli, 2010: 78–9). In her detailed survey of the motifs preserved in the Arabic Pseudo-Callisthenes tradition, Doufikar-Aerts (2010: 83, n. 269 and 270) describes the variation of the two narrative details under discussion in five of the six sources that she has individuated and collated as Arabic repositories of narrative materials of the Romance:[19] two of them (Q and M) have the number 24.000, in

Moennig (2016) for a contextualization of recensions β, γ, ε, λ – and especially of highly Christianized ζ* – in Byzantine history, culture and literature.

18 See Julius Valerius (4th century), *Res gestae Alexandri Macedonis* (Rosellini, 2004: 129) and the *Historia de preliis Alexandri Magni* by Leo of Naples (10th century), recension J[1] (Hilka-Steffens, 1979: 146).

19 Q – The *Sīrat al-Malik Iskandar* (Biography of Alexander) is preserved in a 17th-manuscript copied by a certain Ibn 'Aṭiyya, surnamed Quzmān, and represents "the most important exponent of the Alexander Romance in Arabic" (Doufikar-Aerts, 2010: 71).

M – The *Mukhtār al-ḥikam* (Selected Aphorisms) by 11th-century author Mubashshir ibn Fātik sketches a biography of Alexander, probably based on a shortened form of the Alexander Romance (Doufikar-Aerts, 2010: 25).

A – The *Qiṣṣat Dhī l-Qarnayn* (Story of the Two-Horned One, second half of the 9th century) is preserved in a late Maghribi manuscript and attributed to a story-teller called Abū 'Abd al-Malik.

U – The *Qiṣṣat al-Iskandar* is a romance-like composition by a certain 'Umāra (late 8th-early 9th century?) and is preserved in a single manuscript dated 1510. In many places, the text contains "fragments, and sometimes continuous sections, of Pseudo-Callisthenes" (Doufikar-Aerts, 2010: 37).

N – The *Nihāyatu l-arab fī akhbāri l-Furs wa-l-'Arab* (The Ultimate Aim on the History of Persians and Arabs, 9th cent.?) contains a *Qiṣṣat al-Iskandar wa-'ajā'ibu-hu wa-aḥādīthu-hu* (Story of Alexander and Marvelous Things and Tales about Him). Like other Arabic historians, the author places Alexander within the history of the Persian royal dynasty.

The episode of the Indian battle is not attested in the anonymous *Leyenda de Alejandro*, one of the three Western Arabic versions of the Alexander legend studied by García Gómez (1929).

three of them (M, U and N) we find statues of men, whereas the other two (Q and A) have elephants.

We can summarize the variation as follows:

	Alexander lines up heated bronze statues of
Greek, Latin, Arabic U and N, Armenian	men
Armenian (oral)	60.000 men
Syriac	24.000 men and quadrupeds
Arabic Q and Ethiopic	24.000 elephants
Arabic M	24.000 men
Arabic A	elephants

The inclusion of other – unpublished, unknown or lost – witnesses would probably further complicate the picture. This kind of variation in narrative details is hardly manageable with a stemmatic approach. The versions with 24.000 statues probably derive from a sub-archetype in which statues of both quadrupeds/ elephants and men occurred. The Ethiopic Romance probably derives from an Arabic version very similar to Q (Doufikar-Aerts, 2010: 71). Far less clear is whether and how they derive from a story as told in the broken Syriac text that we read – with generic quadrupeds instead of specific elephants[20] – and whether and why elephants were dropped in or before Arabic M. Interestingly, two Arabic sources (U and N) are in line with the main-stream versions, which do not give the number and have no elephant statues.[21] They may ultimately derive from Greek versions, by-

20 In the mind of the Syriac translator-narrator or the author of his *Vorlage*, the more generic "quadrupeds" may have appeared preferable to "elephants" alone, so as to mirror both elephants and wild beasts of Porus' army.

21 U, where "we find passages which represent the Syriac Pseudo-Callisthenes quite closely" (Doufikar-Aerts, 2016: 200), would prove that an Arabic, perhaps partial, translation of the Syriac Romance was available by the end of the 8th century (Doufikar-Aerts, 2010: 45). As

passing the Syriac intermediary that is usually postulated as a stemmatic node between a lost Greek recension δ* and the Arabic and Ethiopic Pseudo-Callisthenes traditions.[22] On the contrary, it is rather easy to imagine how these narrative details have sprouted up in the process of retelling and rewriting. Skillful narrators felt the need to stress the smartness and efficacy of Alexander's trickery. The shrewd general had to fight the high number of Indian combatants and the elephants and wild beasts lined up in Porus' army. The bronze statues had to be numerous, maybe twenty-four thousand or, as in the Armenian oral version, sixty thousand, perfectly equal to the number of elephants of Porus' army. Since there were both beasts and men in Porus' army, the statues had to represent men and quadrupeds, as in Syriac, or men and elephants, as in most sources that share this narrative innovation.

In the episode of Alexander in India, textual variation does not primarily derive from imperfect translation, mistakes or misunderstandings in the copying process, but it is part of the

far as narrative details of the Indian episode are concerned, however, U is one of the Arabic sources that is in line with the Greek recensions rather than with the Syriac Romance we read. Necessity and role of a Syriac intermediary need further systematic investigation.

22 See, e.g., the stemmata in Stoneman (2007: LXXXIV) and Doufikar-Aerts (2010: 91). Doufikar-Aerts (2016:190) claims that the Syriac translation of the Alexander Romance was "the primary source" for the whole'oriental' tradition ("Middle East, North-Africa and the entire Islamic world") and singles out as desiderata for further research an internal comparison of the witnesses of δ* (the Syriac Pseudo-Callisthenes, the 10th-century Latin *Nativitas et Victoria Alexandri Magni*, completed by Leo Archipresbyter, and the *Historia de Preliis*) and, in a stemmatic perspective, the comparison of the Syriac Pseudo-Callisthenes with the Armenian version that is believed to be "the best preserved exponent of the α* recension" (Doufikar-Aerts, 2016: 192). Stoneman (forthcoming) suggests that the innovations of the Syriac version of the *Romance* are due to the creativity of the Syriac copyists rather than to an alleged Greek version δ* and focuses on two episodes of the *Apocalypse* of Pseudo-Methodios and the *Legend*: the Water of Life and Gog and Magog. I am grateful to the author for sharing with me a previous version of the paper, as read at Mardin Artuklu University, 20-22 April 2012.

autopoietic potential of the text, not only at the macro-level of the text network, but also at the micro-level of narrative details. It is the narrative itself that creates textual variation. The seeds of the multitude and bestial nature of Porus' troops sprout and put forth narrative shoots in the various versions.

Quaedam nova et inaudita ars

The immense fortune of the Pseudo-Callisthenes as a text network is certainly linked to its literary quality as a text of entertainment. It was composed, transmitted and re-elaborated by storytellers – be they narrators, copyists or translators – who mastered the finest and most efficacious rhetorical and narrative techniques and were able to fully exploit the potential of the smallest narrative detail.[23] As such, entertainment appealed to all communities of bourgeois readers and not necessarily literate listeners and functioned as the formal framework or a virtual space within which ethnic and communal identities could be negotiated with the global culture associated with imperial authority.

> As the characteristic fiction of the Levantine-Mediterranean tributary state – stretching from the Achaemenid Empire through Rome to the Ottoman regime – the ancient novel aided readers in negotiating the political, economic, and ethnological complexities of tributary rule, in particular its peculiar dialectic between the persistence of local communities under government protection, and their concomitant negation by the apparatus of the state (Selden, 2012: 49).

23 This inclination of translators and scribes to fully exploit the potential of the story and fill all narrative gaps recalls the midrashic *horror vacui* in interpreting and re-writing Biblical narratives and the encyclopedic collection of narrative reconstructions, sometimes competing with each other, in the Islamic *Stories of the Prophets*.

As a vehicle of a shared value system, the *Alexander Romance* triggered a process of globalization of Hellenistic culture in the East, paradoxically including the Greek conviction of their superiority over Eastern barbarians. The superiority of Greek "knowledge" – possibly perceived as a hypernym encompassing Hellenistic science and philosophy – was a globally accepted value, while a Greek trickery to win over an oriental king was simply a well-thought and skillfully told particular case of that general ideological assumption. In this kind of episode, global ideology and culture neatly prevail against glocal claims of any specific oriental culture. Eastern Christian – Byzantine, Syriac, Arabic or Ethiopic –, Arab Muslim, Persian, Indian readers and listeners are free to cheer on the Greek hero, celebrating their belonging to a cosmopolitan culture in which they share the Hellenistic heritage as part of their own "knowledge".

Syriac apocalyptic motifs of the Alexander legend, probably mediated by Islamic sources, reached Central and Eastern Asia before the *Romance* (Boyle, 1979: 128–9).[24] The stories derived from the originally Christian legend, notably the narrative of Alexander – Dhū l-Qarnayn in the Qur'ān – who imprisoned the peoples of Gog and Magog behind a wall and a gate of brass and iron, had been familiar to the peoples of North- Eastern Asia for so long that their Christian origin had been forgotten and they became "part and parcel of the native tradition" (Boyle, 1974: 225).

The peoples of Gog and Magog as mentioned in Ezekiel 38–39 may be identified with the Cimmerians or, as Josephus did, the Scythians. The (7th-century?) Syriac *Apocalypse of Pseudo-Methodius*[25] and the *Christian Syriac Alexander*

24 Van Bladel (2007: 54–61) offers a clear and comprehensive overview of the Syriac (Christian) and Arabic (Islamic) sources on Alexander. At the present state of research, it is not clear "whether any Arabic version of the Alexander Romance was ever known without some content derived from the Syriac apocalypses" (van Bladel 2007: 56).

25 The text has been published by Reinink (1993). For a discussion of the dating and an ideological discussion of the contents of the Apocalypse, together with other related Syriac texts, see Reinink (1985, 1999, 2002 and 2003); on the dating and various Greek, Latin and Armenian translations, see Bonura (2016), with up-to-date bibliography.

Legend[26] typologize the Eurasian nomad populations as Gog and Magog barbarians that, provisionally liberated from the prison where Alexander the Great had enclosed them, will eventually be defeated at the end of time. Having been identified with the Scythians, the Alans and the Huns, and in fact with every successive invader from the North and North-East, Gog and Magog were in the thirteenth century, as was both logical and predictable, identified with the Mongols by a number of European authors (Boyle, 1979: 124).[27]

Motifs from the Alexander saga found their way into the oral and written literatures of both Turks and Mongols. A badly damaged manuscript from Turfan (Xinjiang, China) has preserved a fragmentary short version of a Mongolian Sulqarnai (Dhū l-Qarnayn) romance. The text was edited by Poppe (1957) and Cleaves (1958). Unfortunately, it does not contain the Indian episode. Alexander's struggle against Porus, instead, has an interesting, reversed echo in a series of stories that the Franciscan Giovanni da Pian del Carpine (1185 c.ca-1252) collected from Hungarian and Russian informants (Lungarotti, 1989: 84) or directly from Mongol informants (Boyle, 1974: 222 and 1979: 128). Four years after the Mongol invasion of Eastern Europe, Giovanni was sent as a legate of Pope Innocent the IV to open diplomatic contacts with the Mongols and his report of the journey, known as *Historia Mongalorum*, is the earliest European account of Mongol customs and the first attempt to narrate their history.

Two recensions of the report are known. The second recension seems to have been revised, among other reasons, in reaction to

26 The Pseudo-Methodius and the *Christian Syriac Alexander Legend* (edited by Budge 1889 as a sequel of the Alexander Romance) were influential texts that contribute along with Pseudo-Callisthenes as significant nodes in the macro-text network of the Alexander saga. Part III of Arabic Q and the Ethiopic Romance – as already noted by Weymann (1901) – incorporate into the Pseudo-Callisthenes tradition part of the Syriac Legend, including the building of the wall against Gog and Magog (Doufikar-Aerts, 2010: 60).

27 For an overview of European sources on the Mongols and, more generally, on the contacts between Europe and the Mongols in 12th-13th centuries, see Borbone (2008: 37–40).

critics who had found too many fabulous and marvelous details in the first recension (Lungarotti, 1989). In fact, especially in chapter V, where the *Historia* tells how Genghis Khan, founder of the Mongol Empire, fought all neighboring peoples and subjected the Tartars, the narrative rather naively includes wonderful episodes, encounters with wild mountain men, dumb men deprived of their knee joints, dog-men, etc. As an Alexander *redivivus*, Genghis Khan fights against a "people of the Sun" that can be easily compared with the cave-dwellers variously mentioned and described in the Syriac Legend, the Qur'ān, Pseudo-Methodius and other Alexander-related sources (Boyle, 1974: 222).

Giovanni da Pian del Carpine's informants tell Mongol history copiously drawing narrative materials from the Alexander legend and it is remarkable that the Italian friar does not seem to be aware of this, as if stories of this kind were new and unknown to the Western world (Lungarotti, 1989: 84). The theme of the pretended novelty of the narrative is explicit in the informants' account of the Indian campaign of Genghis Khan's second son, i.e. presumably Ögedei Khan. We read it in the English translation facing the Latin text of the first recension, Chap. V, Par. 17.

> When they reached Greater India, which the apostle Thomas converted, the king of the country, who is always called Prester John, although he was not well prepared, immediately sent an army against them which used a new and unheard-of device against the Tartars. They organized a special force of three thousand warriors carrying on the front of their saddles statues of iron or bronze containing live fire in their hollow interior, and before the Tartars' arrows could reach them they began to shoot fire against them, by blowing it with bellows which they carried on either side of the saddle under both thighs. After the fire they began to shoot arrows and in this way the Tartar army was put in disorder. Some burned, others wounded, they took to flight, and the pursuing Indians felled many and ejected the others from their country, so that the Tartars never returned to India (Skelton-Marston-Painter, 1995: 68).[28]

28 The Latin text of this episode (Chap. V, Par. 12) as told in the second recension can be found in Menestò (1989: 258–9; Italian transl. by Lungarotti, *ibidem*: 354).

Whoever the informants of Giovanni da Pian del Carpine were, their account is not very favorable to Genghis Khan's son. In keeping with the method and the same type of sources of the whole chapter, they use materials from the Alexander legend, in this specific case from the Pseudo-Callisthenes, but they reverse the roles of the actants. Like Alexander who was scared before Porus' army, the Indians, led by Prester John their king, are initially not well prepared to fight against the Tartars, a constitutive part of the Mongol army since Genghis Khan's time. They devise then against the Tartars a trickery very similar to that used against them by the wise Alexander, their enemy in the Pseudo-Callisthenes. They organize a gunnery troop of cavalry with iron or bronze statues that, filled with fire, function as fire weapons. Despite what Giovanni writes in his report or his informants pretend – *fecerunt quandam novam et inauditam artem contra Tartaros*, the device of hot burning statues is all but new and unheard of. The narrator employs and refines Alexander's stratagem, so as to account for a battle in which the Mongol archery is easily defeated by the Indian improvised artillery.

The insistence on warfare details and possible weak points of the Mongol army answers to needs and expectations of the European readers of the *Historia*, shocked by the recent invasions from the Barbarian East, frightened by the Mongol peril and eager to find military and cultural tactics to contrast it.

The generative potential of the Alexander text network appears not only in the internal, autopoietic proliferation of narrative details and variants, but also in its nonchalant re-use by much later narrators as a repertoire and depository of narrative materials. Probably oral sources of the *Historia Mongolarum* first present Genghis Khan as a reborn Alexander who fights with mixed fortunes against wonderful creatures, moving them from the end of times to the utmost imagined borders of the earth. In an almost ironic reversal, they expand then on the Pseudo-Callisthene's episode of Alexander in India to depict the heir of Genghis Khan as an ignorant oriental king defeated by the Indians, as if the latter had learnt the lesson of the Greek "knowledge" in Alexander's time.

Alexander's trickery of the troop of statues has become a *topos* that can be employed as a new and unheard of narrative device in Eastern oral history and Western historiography. The Alexander legend enters new rhetorical and ideological webs as a ready-to-use framework for new scenarios of confrontation between West and East, knowledge and ignorance, otherness and self-identity, fear and barbarian bestiality, a local threatened citadel and imperial apocalyptic forces. Barely recognizable and more or less consciously reversed narrative nodes tighten together the grandiose text network of the Alexander saga and texts such as the *Historia Mongalorum*, whose author falls into the trap of its charming web, seemingly unaware of the ultimate sources he is using.[29]

29 Research for the present paper was financed by the Department of Humanities, University of Turin. In the academic year 2013-2014, Arabic and Syriac texts of the Alexander saga were read in the courses of Arabic Literature (dr. Francesca Bellino) and Semitic Philology (myself). I wish to express my gratitude to my colleague and students for their stimulating comments on texts and topics we dealt with in class and in joint sessions.

Works Cited

Arthur-Montagne, Jacqueline, 'Persuasion, Emotion, and the Letters of the Alexander Romance', *Ancient Narrative*, 11 (2014), 159–89.

Ball, Warwick, 'Some Talk of Alexander. Myth and Politics in the North-West Frontier of British India', in *The Alexander Romance in Persia and the East*, Ed. by R. Stoneman, K. Erickson and I. Netton [*Ancient Narrative*, Supplementum 15] (Groningen: Barkhuis, 2012), pp. 127–58.

Bernardelli, Milena, *Alessandro Magno nel Medioevo armeno: quando l'effimero diventa eterno*, Tesi di dottorato (Venezia: Università Ca' Foscari, 2010) (http://hdl.handle.net/10579/983).

van Bladel, Kevin, 'The Syriac Sources of the Early Arabic Narratives of Alexander', in *Memory as History. The Legacy of Alexander in Asia*, Ed. by Himanshu Prabha Ray and Daniel T. Potts (New Delhi: Aryan Books International, 2007), 54–75.

Bonura, Christopher, 'A Forgotten Translation of Pseudo-Methodius in Eighth-Century Constantinople: New Evidence for the Dispersal of the Greek Apocalypse of Pseudo-Methodius during the Dark Age Crisis', Ed. by Nicholas S.M. Matheou, Theofili Kampianaki and Lorenzo M. Bondioli (Leiden: Brill, 2016), pp. 260–76.

Borbone, Pier Giorgio, *Un ambassadeur du Khan Argun en Occident. Histoire de Mar Yahballaha III et de Rabban Sauma (1281-1317)* (Paris: L'Harmattan, 2008).

Boyle, John Andrew, 'The Alexander Legend in Central Asia', *Folklore*, 85.4 (1974), 217–28.

—, 'Alexander and the Mongols', *The Journal of the Royal Asiatic Society of Great Britain and Ireland*, 2 (1979), 123–36.

Brock, Sebastian P., 'Alexander Cycle', in *Gorgias Encyclopedic Dictionary of the Syriac Heritage*, Ed. by S.P. Brock, A.M. Butts, G.A. Kiraz and L. Van Rompay (Piscataway NJ: Gorgias Press, 2011), p. 16.

Budge, Ernest A. Wallis, *The History of Alexander the Great, being the Syriac Version of the Pseudo-Callisthenes* (Cambridge: Cambridge University Press, 1889).

—, *The Life and Exploits of Alexander the Great: Being a Series of Translations of the Ethiopic Histories of Alexander by the Pseudo-Callisthenes and Other Writers* (London: C.J. Clay and Sons, 1896).

Centanni, Monica, *Il romanzo di Alessandro* (Venezia: Arsenale, 1988).

Ciancaglini, Claudia Angela, 'Gli antecedenti del Romanzo siriaco di Alessandro', in *La diffusione dell'eredità classica nell'età tardoantica e medioevale: Il "Romanzo di Alessandro" e altri scritti*, Ed. by R.B. Finazzi and A. Valvo (Alessandria: Edizioni dell'Orso, 1998), pp. 55–93.

—, 'The Syriac Version of the Alexander Romance', *Le Muséon*, 114.1/2 (2001), 121–40.

—, 'Ancora sulla versione siriaca del *Romanzo di Alessandro*: le oscillazioni grafiche nella resa dei nomi greci', in *Rappresentazioni linguistiche*

dell'identità, Ed. by Marina Benedetti, Quaderni di AIÙN N.S. 3 (Napoli: Università degli Studi di Napoli "L'Orientale", 2015), pp. 51–92.

Cizek, Alexander, 'Historical Distortions and Saga Patterns in the Pseudo-Callisthenes Romance', *Hermes*, 106.4 (1978), 593–607.

Cleaves, Francis Woodman, 'An Early Mongolian Version of the Alexander Romance', *Harvard Journal of Asiatic Studies*, 22 (1958), 1–99.

Desreumaux, Alain, 'Alexandre, la Couronne et la Croix. Le rêve syriaque du royaume perdu', *Mélanges de l'École française de Rome*, 112:1 (2000), 43–9.

Doufikar-Aerts, Faustina C.W., *Alexander Magnus Arabicus. A Survey of the Alexander Tradition through Seven Centuries: From Pseudo-Callisthenes to Ṣūrī* (Leuven: Peeters, 2010).

—, 'A Hero without Borders: 2 Alexander the Great in the Syriac and Arabic Tradition', in *Fictional Storytelling in the Medieval Eastern Mediterranean and Beyond*, Ed. by C. Cupane, and B. Krönung (Leiden: Brill, 2016), pp. 190–209.

Fales, Mario F., 'The Enemy in Assyrian Royal Inscriptions: "The Moral Judgement"', in *Mesopotamien und seine Nachbarn. Politische und kulturelle Wechselbeziehungen im Alten Vorderasien vom 4. bis 1. Jahrtausend v. Chr.*, Ed. by Hans-Jörg Nissen and Johannes Renger (Berlin: Dietrich Reimer Verlag, 1982), pp. 425–45.

García Gómez, Emilio, *Un texto árabe occidental de la leyenda de Alejandro* (Madrid: Instituto Valencia de Don Juan, 1929).

Gero, Stephen, 'The Legend of Alexander the Great in the Christian Orient', *Bulletin of the John Rylands University Library of Manchester*, 75.1 (1993), 3–9.

Hägg, Tomas, *The Novel in Antiquity* (Berkeley and Los Angeles: University of California Press, 1991).

Hagerman, Christopher A., 'In the Footsteps of the "Macedonian Conqueror": Alexander the Great and British India', *International Journal of the Classical Tradition*, 16.3/4 (2009), 344–92.

Hilka, Alfons – Karl Steffens (eds.), *Historia Alexandri Magni (Historia de preliis). Rezension J¹* (Meisenheim am Glan: Anton Hain Verlag, 1979).

Karla, Grammatiki A., 'Folk Narrative Techniques in the Alexander Romance', *Mnemosyne*, 65 (2012), 636–55.

Kotar, Peter, *Der syrische Alexanderroman. Eine Untersuchung über die Beziehungen des syrischen zum griechischen Alexanderroman des Pseudo-Kallisthenes* (Hamburg: Kovac, 2013).

Kroll, Guilelmus (ed.), *Historia Alexandri Magni (Pseudo-Kallisthenes)* (Berolini: Weidmannos, 1958).

Lungarotti, M. Cristiana, 'Le due redazioni dell'"Historia Mongalorum"', *Menestò* (1989), 79–92.

Menestò, Enrico (ed.), *Storia dei mongoli. Edizione critica del testo latino* (Spoleto: Centro italiano di studi sull'alto Medioevo, 1989).

Moennig, Ulrich, 'A Hero Without Borders: 1 Alexander the Great in Ancient, Byzantine and Modern Greek Tradition', in *Fictional Storytelling in the Medieval Eastern Mediterranean and Beyond*, Ed. by C. Cupane and B. Krönung (Leiden: Brill, 2016), pp. 159–89.

Monferrer-Sala, Juan Pedro, 'Alexander the Great in the Syriac Literary Tradition', in *A Companion to Alexander Literature in the Middle Ages*, Ed. by Z.D. Zuwiyya (Leiden: Brill, 2011), 41–72.

Morani, Moreno, 'Tradizioni orientali e filologia greca', in *La diffusione dell'eredità classica nell'età tardoantica e medioevale: Il "Romanzo di Alessandro" e altri scritti*, Ed. by R.B. Finazzi and A. Valvo (Alessandria: Edizioni dell'Orso, 1998), pp. 175–87.

Murre-van den Berg, Heleen, *Scribes and Scriptures. The Church of the East in the Eastern Ottoman Provinces (1500-1850)* [Eastern Christian Studies 21] (Leuven: Peeters, 2015).

Nöldeke, Theodor, *Beiträge zur Geschichte des Alexanderromans* (Denkschriften der Kaiserlichen Akademie der Wissenschaften, Philosophisch-historische Classe, Band 38, Abhandlung V) (Wien, 1890).

Pasquali, Giorgio, *Storia della tradizione e critica del testo* (Firenze: Le Monnier, 1934).

Piemontese, Michele A., 'Tracce del romanzo di Artù in testi narrativi persiani', in *Macrotesti fra Oriente e Occidente: IV colloquio internazionale, Vico Equense, 26-29 ottobre 2000*, Ed. by G. Carbonaro, E. Creazzo and N.L. Tornesello (Soveria Mannelli: Rubbettino, 2003), pp. 295–312.

Poppe, Nikolaus, ‚Eine mongolische Fassung der Alexandersage', *Zeitschrift der Deutschen Morgenländischen Gesellschaft*, 107 (1957), 105–29.

Reinink, Gerrit J., ‚Die Entstehung der syrischen Alexanderlegende als politisch-religiöse Propagandaschrift für Herakleios' Kirchenpolitik', in *After Chalcedon: Studies in Theology and Church History Offered to Professor Albert Van Roey for His Seventieth Birthday*, Ed. by C. Laga, J.A. Munitiz, and L. Van Rompay (Leuven: Peeters, 1985), pp. 263–81.

— (ed.), *Die syrische Apokalypse des Pseudo Methodius* [CSCO 540–1, Scriptores Syri 220-1] (Leuven: Peeters, 1993).

—, 'Alexandre et le dernier empereur du monde: les développements du concept de la royauté chrétienne dans les sources syriaques du septième siècle', in *Alexandre le Grand dans les littératures occidentales et proche-orientales. Actes du Colloque de Paris 27-29 novembre 1997*, Ed. by L. Harf-Lancner, C. Kappler and F. Suard (Paris: Université de Paris X-Nanterre, 1999), pp. 140–59.

—, 'Heraclius, the New Alexander: Apocalyptic Prophecies during the Reign of Heraclius', in *The Reign of Heraclius (610–641): Crisis and Confrontation*, Ed. by G.J. Reinink and B.H. Stolte (Leuven: Peeters, 2002), pp. 81–94.

—, 'Alexander the Great in Seventh-Century Syriac 'Apocalyptic' Texts', *Byzantinorossica*, 2 (2003), 150–78.

Rohde, Erwin, *Der griechische Roman und seine Vorläufer* (Leipzig: Breitkopf und Härtel, 1914[3]).

Rosellini, Michela (ed.), *Iulius Valerius, Res gestae Alexandri Macedonis. Editio correctior cum addendis* (Munich and Leipzig: K.G. Saur, 2004).

Said, Edward W., *Orientalism* (New York: Pantheon Books, 1978).

Selden, Daniel L., 'Text Networks', *Ancient Narrative*, 8 (2009), 1–23.

—, 'Mapping the Alexander Romance', in *The Alexander Romance in Persia*

and the East, Ed. by R. Stoneman, K. Erickson and I. Netton [*Ancient Narrative*, Supplementum 15] (Groningen: Barkhuis, 2012), pp. 19–59.

Simonyan, Hasmik, 'La versione armena del *Romanzo di Alessandro* e i principi ispiratori dell'edizione del testo', in *La diffusione dell'eredità classica nell'età tardoantica e medioevale: Il "Romanzo di Alessandro" e altri scritti*, Ed. by R.B. Finazzi and A. Valvo (Alessandria: Edizioni dell'Orso, 1998), pp. 281–7.

Skelton, Raleigh A., Thomas E. Marston and George D. Painter, *The Vinland Map and the Tartar Relation* (New Haven–London: Yale University Press, 1995).

Stoneman, Richard, 'The Alexander Romance. From History to Fiction', in *Greek Fiction. The Greek Novel in Context*, Ed. by J.R. Morgan and R. Stoneman (New York: Routledge, 1994), pp. 117–29.

—, 'Introduzione', in *Il romanzo di Alessandro*, Ed. by R. Stoneman, It. transl. by T. Gargiulo (Milan: Fondazione Lorenzo Valla, 2007).

—, 'Persian Aspects of the Romance Tradition', in *The Alexander Romance in Persia and the East*, Ed. by R. Stoneman, K. Erickson and I. Netton [*Ancient Narrative*, Supplementum 15] (Groningen: Barkhuis, 2012), pp. 3–18.

—, 'Alexander the Great and the End of Time: The Syriac Contribution to the Development of the Alexander Romance', in *Syriac in its Multi-cultural Context*, Ed. by H. Teule, E. Keser-Kayaalp et alii (Leuven: Peeters, forthcoming).

van Thiel, Helmut (ed.), *Leben und Taten Alexanders von Makedonien. Der griechische Alexanderroman nach der Handschrift L.* (Darmstadt: Wissenschaftliche Buchgesellschaft, 1983²).

Traina, Giusto, 'La Recensio α e i suoi paralleli orientali: osservazioni sull'edizione di Kroll', in *La diffusione dell'eredità classica nell'età tardoantica e medioevale: Il "Romanzo di Alessandro" e altri scritti*, Ed. by R.B. Finazzi and A. Valvo (Alessandria: Edizioni dell'Orso, 1998), pp. 311–22.

Vlassopoulos, Kostas, *Greeks and Barbarians* (Cambridge: Cambridge University Press, 2013).

Weymann, Karl Friedrich, *Die aethiopische und arabische Übersetzung des Pseudocallisthenes. Eine literarkritische Untersuchung* (Heidelberg Univ. Diss. Kirchhain, 1901).

Wolohojian, Albert M., *The Romance of Alexander the Great by Pseudo-Callisthenes* (New York and London: Columbia University Press, 1969).

Xydopoulos, Ioannis, 'Alexander's Historians and the Alexander Romance: A Comparative Study of the Representation of India and Indians', in *Memory as History. The Legacy of Alexander in Asia*, Ed. by Himanshu Prabha Ray and Daniel T. Potts (New Delhi: Aryan Books International, 2007), pp. 19–27.

RA'S AL-GHŪL, THE ENEMY
OF 'ALĪ AND BATMAN
Upturned Narratives from Arabic literature
to American Comics

FRANCESCA BELLINO

University of Turin

At any latitude and time, heroic narratives exhibit characters, themes and motifs that convey the complexity of the culture they come from as well as the anxieties of the historical moments in which they arose. In the present article, I will focus on the way in which two radically different literary cultures – Arabic literature on the one hand and American comics on the other – portray Ra's al-Ghūl (in Arabic "Demon's head"). The chance of having a namesake fictional character, who performs the role of an enemy both in the Islamicate and American-Western context and contrasts an alleged project of civilization supported or defended by the main hero, allows us to reflect on the function that Ra's al-Ghūl has. More broadly, it allows a reflection on the function that narratives on the enemy and the villain convey in different times and spaces (Eco, 2001; Eco, 2003: 219–61). Ultimately, the talent of the storytellers and comic artists to fit Ra's al-Ghūl into different genres, and, within the same genre, to adapt him to different storylines or reworkings, returns the dynamism of the narrative cycles that originated about this character.

Ra's al-Ghūl from East to West

The character of Ra's al-Ghūl is intimately associated with pseudo-*maghāzī* (i.e. military expeditions) or legendary *maghāzī* literature. It appears for the first time in a work dating back to the Mamluk period, attributed to Abū al-Ḥasan al-Bakrī (*ca.* 13th cent.? See Shoshan, 1993: 23–39), and variably entitled *Futūḥ al-Yaman (Conquest of Yemen)* or *Ghazwat Ra's al-Ghūl*

(*Expedition against Ra's al-Ghūl*) (Basset, 1893: 73–81; Paret, 1930: 131; Bellino, 2010). The *Ghazwat Ra's al-Ghūl* narrates the military expedition (*ghazwa*) of 'Alī ibn Abī Ṭālib (599–661), the cousin and son-in-law of the Prophet Muḥammad, against the Yemeni tribe of the Banū Khath'am, headed by the idolatrous tyrant Mukhāriq ibn Shihāb, nicknamed Ra's al-Ghūl for his villainy and for the great size of his head (al-Bakrī, [1970]: 3). Throughout the whole expedition, 'Alī and Ra's al-Ghūl fight each other in seven consecutive valleys (*wādīs*), each controlled by one of Ra's al-Ghūl's sons, up to the final duel in which 'Alī kills Ra's al-Ghūl and the idolatrous worship is replaced with Islam.

The *Ghazwat Ra's al-Ghūl* is one of the longest and most elaborated works of the legendary *maghāzī* literature and falls for language and style within the broader context of "Middle narrative Literature" (Chraïbi, 2016: 62–4). It is preserved in several manuscript versions and printed editions, which attest in their whole to the great popularity that this work has had from the Mamluk period until recent times. Its narrative setting, structure, and characters, but also the way in which its "epic material" (Guillaume, 1996: 92) is used and remodeled, recall the dynamism of the textual traditions of the Arabic epic cycles. "It differs only in its scale from the principal *Sīras*" (Norris, 1989: 127). Actually, "many a passage from the *Futūḥ al-Yaman* or *Rā's al-Ġūl* recalls the style and ferocious gallantry of the *Sīrat 'Antar* or *Ḍāt al-Himma*. The mighty figure of 'Alī appears in the armour of the Black Knight, his magic sword, Ḍū'l-Faqār, is matched, in its deadly power, by the blows of 'Antar's Ḍāmī" (Norris, 1986: 71).

In American pop culture, the character of Ra's al-Ghul – also spelled Rā's al-Ghūl, simply Ra's, or as, in Arabic, Ra's al-Ghūl; "Demon's Head" – reappears as one of Batman's most enduring enemies (Greenberg, 2008: 305–307; Marano, 2008). Created by Dennis O'Neil and Neal Adams, he firstly appeared in the episode "Daughter of the Demon" (June 1971). Since then, Ra's al-Ghul and his relatives have had leading roles in numerous series and the most important episodes were novelized and reedited as graphic novels (*The Son of the Demon*, 1987; *Tales*

of the Demon, 1991; *Birth of the Demon,* 1992). In recent years, new episodes (*Batman: Death and the Maidens,* 2004; *Year One: Batman-Ra's al-Ghul,* 2005; *The Resurrection of Ra's al-Ghul,* 2008) give rise to a real saga that narrates Ra's al-Ghul's origin, death and rebirth(s), along with the major events related to his family members and their ambivalent relations with Batman.

In comic books, Ra's al-Ghul is described as a centuries-old world-wide eco-terrorist, with origins dating back to the Middle Ages, who continually regenerates thanks to the immersion in the Lazarus pits. He knows the secret identity of Batman (i.e. Bruce Wayne) to whom he is related since his daughter Talia had a child with Batman (Damian Wayne or Damian al-Ghul). Ra's al-Ghul's ultimate goal is a world in perfect environmental balance. His mission is to eliminate as many people as possible and to return to the cradle of the civilization in the Arabian Desert from which he originates. However, his agenda is not limited to that of being an opponent of the Caped Crusader: he is also the founder of the League of Assassins (Greenberg, 2008: 231–2), having a strategic and leading role in the collective of adversaries that make up the so called Batman's Rogues Gallery.

Although the narratives in which Ra's al-Ghūl appears are set in spaces and times that are very different from each other, and even though the modern American character does not draw direct inspiration from the Arab one, these narratives display a number of similarities in terms of roles and functions insofar as they convey a highly sophisticated discourse on the enemy in popular or mass culture. Both in Arabic literature and in American comics, Ra's al-Ghūl acts as an opponent who regularly chooses conflict (especially at global level) to interact with the hero (Paret, 1930: 184; Coogan, 2006: 87–8). As with many other popular narratives of this kind, both the Arabic and American narratives are built on a series of opposites in which 'Alī and Batman on the one hand and Ra's al-Ghūl/Ghul on the other constitute definite poles with a limited number of permutations and interactions (Eco, 2001: 148). These narratives are essentially organized around specific ideological constructs, an idiosyncrasy of the clash of civilizations – "the world system as a competition between blocs", as Douglas-

Malti-Douglas (1994: 159) would say –, in which the perception of otherness is modeled on the characterization of the (super) villain and the (arch)enemy. Nevertheless, the character of Ra's al-Ghūl is highly sophisticated, multidimensional and complex. The origins of this character are difficult to determine. In Arabic astronomy, Ra's al-Ghūl (known as "the Demon Star"; Latinized in Algol) is the name of a bright star in the constellation of Perseus who, in turn, is named "the carrier of the Demon's head" (in Ar. *ḥāmil ra's al-ghūl*). According to the Ptolemaic tradition, this constellation represents Perseus who kills the Gordon Medusa carrying her head in his hand. Algol is thus referred as the Gorgon of Perseus and associated with death by decapitation. "Contrary to classical tradition, the Islamic figure no longer carries Medusa's head, but that of a male demon, the streams of blood flowing from Gordon's neck having perhaps been misinterpreted as a beard" (Wellesz, 1959: 9, fig. 7). The connection with the theme of violence as well as with the fighting, culminating with the killing, between the hero and the monstrous creature remains unchanged.

The image, behaviors and beliefs of Ra's al-Ghūl's character refer to a ghoul, of devilish origin, an ugly human-like monster that dwelt in the desert (al-Rawi, 2009). In the narratives here analyzed, Ra's al-Ghūl's identity may be inferred, in some way, from that of the hero to whom is opposed. But whereas 'Alī had been a historical personality, who was turned into the fictional character of the Muslim hero par excellence by the legendary *maghāzī* literature, Batman was born as a fictional superhero. He was created by the artist Bob Kane and writer Bill Finger for DC Comics in 1939 and since then has lived the duality of being both a man (Bruce Wayne) and a bat (the Batman). In this regard, it is worth noting that, even in a fictional plan, the conflict against a Yemenite ruler (embodied in Ra's al-Ghūl) epitomizes a well-known moment in 'Alī's biography as well as in Islamic history, connected with the Muslim expedition in Yemen which took place around 630 in Muḥammad's lifetime (Bellino, 2010). Conversely, Batman's biography is clearly entirely fictitious. It lacks a real primary *urtext* set in a specific period, but has rather

existed in a plethora of equally valid texts constantly appearing over the years (Pearson-Uricchio, 1991: 185). The biography of Batman is conventionally divided into ages that correspond to the different periods in which the series and the graphic novels have been written, i.e. golden age (corresponding to 1930s-1940s), silver age (mid-1950s-1960s), bronze (1970s-1980s), modern ages (from 1985's *Crisis on Infinite Earths* to 2005's *Identity Crisis*), and 21st century (from 2005's *Identity Crisis* to the present).

The American Ra's al-Ghūl should therefore be placed in this huge amount of iconographic and narrative materials. From the seventies onwards, the Ra's al-Ghūl-Batman conflict roughly followed the various steps of the evolution of the Batman's character and the introduction of the concept of "multiverse" (i.e. Batman's movements from Gotham city to the earth, and then into "Infinite Earths" and "post-Crisis universes"; Kukkone, 2010: 48–49). These changes echo, only at times, the events connected to the postwar world, from the Cold War to the emergence of forms of global terrorism and the post 9/11 crises.

In the early DC universe Ra's al-Ghūl has had the distinction of being the first supervillain coming from outside Gotham City (indeed from the Middle Eastern Medieval Era), skilled in bringing the conflict outside its confines and in displacing the war from a domestic to a global plan. By doing so, he first forced Batman to move into the real world and therefore to be vulnerable. It is perhaps no coincidence that he is one of the few to know the true (human) identity of Batman. In this connection, Marano stated,

> Ra's's interactions with Batman reflected, albeit in comic book extremes, real international tensions. And yet, as the villain who has most broadly expanded Batman's horizons to include the international and the political, he's also the villain who has dealt with Batman in the most intimate context of all (Marano, 2008: 76).

Despite his Middle Eastern origins, Ra's al-Ghūl has not been the Arab or Muslim superhero created by DC Comics or Marvel after 9/11 (Strömberg, 2011). The history of the character has

its roots in an earlier era, during the Cold War, when it drew
nourishment from the dichotomous, simplistic worldview of those
years: good against evil, West against East etc. Ra's al-Ghūl has
no super-powers and, *at least* in the pre-9/11 series, his conflict
with Batman runs parallel to the conflicts the United States engage
in around the world. After 9/11, everything changes. The war on
terror becomes a global affair and is fought on a religious level
too. As a result, the new enemies of Batman relate to him in a
different perspective. E.g., Batman fights against al-Qaeda in the
much-criticized *Holy Terror* by Frank Miller (2011), where the
superhero "The Fixer" struggles against Islamic terrorists after an
attack on Empire City (Dar, 2010). However, even with *changes*,
the character of Ra's al-Ghul remains in various series of Batman
with more or less unaltered features. The political landscape that
sourrounds these stories is much more complicated, albeit no less
dichotomous than during the Cold War.

"Ra's al-Ghūl's anti-heroic cycle" in the Ghazwat Ra's al-Ghūl

According to narrative strategies that change from one genre
to another, the various episodes related to the life of Ra's al-Ghūl
outline, in epic terms, some sort of "cycle" (or "saga" according
to a definition closer to the comics). The patterns that compose
this cycle vary depending on the genres and the narratives to
which they belong.

Beyond the characterization of the main hero, al-Bakrī's
Ghazwat Ra's al-Ghūl presents a sort of alternative cycle in
which the protagonist is the anti-hero, i.e. Ra's al-Ghūl. The
supposed anti-hero cycle intersects and partly overlaps with that
of the hero, retracing more or less the same stages, from birth to
death, but reversing their function and effect. Consistently with
this perspective, Ra's al-Ghūl's cycle would comprise his rise and
public recognition as villain (I), his anti-heroic service and deeds
(II), his conflict with the hero (III), and his death (IV).

Albeit briefly, the *Ghazwat Ra's al-Ghūl* narrates a number
of episodes that might recall patterns already outlined by Heath

(1996: 67–88) for the heroic cycle of the pre-Islamic Arab knight and poet 'Antar ibn Shaddād in the *Sīrat 'Antar*. The opening sequence of the *Ghazwat Ra's al-Ghūl* recounts the reasons for Ra's al-Ghūl abnormal physical attributes, some episodes of his youth preparatory to his fame as a villain and the killing of his father (al-Bakrī [1970]: 3–13). This part might be connected to the rise of Ra's al-Ghūl as the villain in Yemen. Early in the story, Ra's al-Ghūl is a powerful figure that lives outside the domain of Islam, in some undefined and wild Yemeni setting, leading a confederation of pagan tribes. He worships an idol called Farāsh (or Firāsh) to whom he compulsively addresses himself to ask for advice and help.

Ra's al-Ghūl's anti-Muslim function is established by a massacre he perpetrated against the Yemeni tribe of the Banū Yarbū' because of their conversion to Islam. The *Ghazwat Ra's al-Ghūl* relates this episode as the backstory that leads to the war between Ra's al-Ghūl and the Prophet. The Prophet reacts in shock to the story told by al-Wāfira (daughter of the chief of the Banū Yarbū'), who was victim of an umpteenth abuse by Ra's al-Ghūl who kills her father and exterminates her twelve sons, by decapitating them and hanging their heads on a camel. At first, the Prophet tries to restore order with diplomacy and attempts a peaceful reconciliation with Ra's al-Ghūl. But after his categorical refusal, the Prophet declares war on Ra's al-Ghūl and sends the Muslim troops led by 'Alī to Yemen to overthrow this tyrant (al-Bakrī [1970]: 13–16).

On the narrative level, Ra's al-Ghūl's ferociousness and his apparent aversion to Islam turn him into a sworn enemy who must be eliminated. The episode of the massacre represents the starting point of 'Alī's mission in Yemen. From the moment when it is reported to the Prophet, the action changes perspective by focusing on the Muslim hero and his deeds.

The quest undergone by 'Alī in Yemen is to conquer seven castles, each placed in a different wadi and controlled by one of the Ra's al-Ghūl's sons, and to fight against human and non-human adversaries simply with the help of his sword Dhū l-Faqār. From a comparative perspective, this journey finds parallels

in other works of the legendary *maghāzī* literature, such as al-Bakrī's *Futūḥ al-sab' ḥusūn* (*Conquest of the seven castles*) (al-Bakrī, 1952; Paret, 1930: 99–106; Bellino, 2006: 157), and in the epic Persian poem *Khāwar-nāme* by Ebn Ḥosām (ca. 15th cent.; Calasso, 1979: 421–2), in which 'Alī is again protagonist of the conquest of seven castles, each made of different materials and various precious stones. This story develops the theme of the conquest of a castle made of a precious metal, also present in the story of the City of Copper (or Brass) and in the expedition to the Golden Castle (*Ghazwat Qaṣr al-Dhahab*), into an extended geography that serves as a backdrop for the deeds and religious mission of 'Alī (Basset, 1894: 1–73 Renard, 1979: 174–5; Bellino, 2006: 166–9).

The narration of 'Alī's Yemeni expedition (al-Bakrī [1970]: 16–150) alternates with numerous side events that lead to the conversion of various knights and tribal leaders. Interspersed with these episodes, in which individual duels and battle actions are also described, the *Ghazwat Ra's al-Ghūl* narrates several episodes presenting Ra's al-Ghūl's villainous deeds or, one might say, his anti-heroic service. While "the keynote of Heroic Service is helping others" (Heath, 1996: 79–81), Ra's al-Ghūl constantly impedes and hinders the progressive Muslim action of conquest. In narrative terms, these patterns are situational rather than progressive. Whatever happens, they allow a narrative progression only in the hero's perspective: 'Alī must necessarily overcome Ra's al-Ghūl's obstacles and fight a duel with those who oppose him in order to proceed with his journey.

In this dynamic, the sons of Ra's al-Ghūl move in opposite directions. Some follow their father; while others, especially his daughter al-Ḍalfā', who secretly converted to Islam and fights on the battlefield as a real woman warrior (Kruk 2014: 20), opposes his evil action.

The final duel between 'Alī and Ra's al-Ghūl and Ra's al-Ghūl's death close the cycle, sanctioning the definite death of Ra's al-Ghūl and, at the same time, the victory of 'Alī (al-Bakrī [1970]: 151–159). This last duel represents a topical moment in 'Alī's mission and it is so significant that almost all the covers of

the printed editions reproduce an image that represents the precise moment in which 'Alī kills Ra's al-Ghūl by skewering him with its bifurcated sword Dhū l-Faqār. Unlike other similar scenes, such as those relating to epic heroes like 'Antara or Abū Zayd, 'Alī does not split his opponent, but the scene is no less bloody (Connelly-Massie, 1985: 106, 116–117). This same image, with minor variations, is found in lithographs and Tunisian reverse glass paintings (Fig. 1). In all its variants, it reminds, by stylizing, other well-known duels between a hero and a ghoul such as that of Rostam who kills the white demon with a dagger (Lu'aybī, 2011, 154–156, 174).

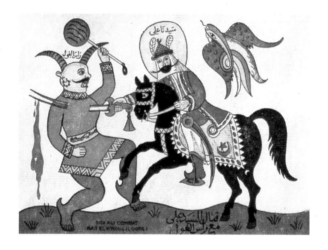

Fig. 1 – Duel between 'Alī and Ra's al-Ghūl (Tunis; the author's private collection)

Differently from the *Sīrat 'Antara ibn Shaddād*, there is no episode where "family and friends avenge the hero's death" (Heath 1996: 85–87). In the legendary *maghāzī* literature, the perspective goes back to that of the Muslim hero: Islam triumphs over paganism, Ra's al-Ghūl's idol is smashed, and his remaining sons, along with his tribe, must convert to Islam (al-Bakrī [1970]: 159–160).

Upturned interpretation of Ras's al-Ghūl in the Islamicate framework

In the 19th-century reworkings of the legendary *maghāzī* literature, the character of Ra's al-Ghūl acquires new significances. A substantial change takes place at some stage in the transmission of the *ghazawāt* in North Africa, and in particular in Algeria, at the beginning of the 19th century. In this context, Ra's al-Ghūl no longer represents an Eastern enemy, pagan and uncivilized, but the new threat to the Arab-Muslim countries, the colonial invader (i.e. France).

In the region of Mitidja, Jean Desparmet documented the circulation of Arabic dialectal *ghazawāt* reworded in verses and recited by local storytellers (*meddāḥ*). The *meddāḥ* used to recite these texts in public squares and markets, not only to entertain their audience, but to awaken the national spirit by proposing them the model of heroism of the first centuries (Desparmet, 1939: 196). After the French invasion of Algeria in 1830, some *ghazawāt* in particular, such as the *Ghazwat Ra's al-Ghūl* and the *Ghazwat Wādī al-Saysabān* (*Expedition in the Wadi al-Saysabān*) or the *Ghazwat al-Ghiṭrīf* (*Expedition against al-Ghiṭrīf*) (Bellino, 2011: 20–1; Būrāyū, 2007: 97–102), stigmatized the French conquest of Algeria (1830-1847), while transposing the facts to a time and space that were certainly far away and almost mythical. On the narrative level, the conqueror-conquered standpoint of the Mamluk version was subverted: "In the Algerian versions of these two romances Ghatrif is equated with the French army and Mukharriq (Ras el-Ġul) curiously, since his citadel is traditionally located in Yemen, with the totality of Western civilization" (Wansbrough, 1969: 478). Even more emphatically, Desparmet (1939: 214) argued that Ra's al-Ghūl personified the bloody regime of the disbelievers. This new interpretation of the *Ghazwat Ra's al-Ghūl* is particularly significant, especially if one reads this production in the dialectic of opposites outlined by Eco (2011) in which the enemy, no matter who he may be, is barbarous and devilish if he is not Muslim. In the legendary *maghāzī* literature, the theme of otherness is developed in a similar way to the epic cycles. "The

Other" is the non-Arab, the Bedouin, the non-Muslim, the Black, or, at least, the ghoul who represents the wildest and uncivilized otherness (Canova, 1998: 137).

In other versions, circulating in Tunisia, Ra's al-Ghūl has Christian origins (Desparmet, 1939: 215). At the end of a Tunisian version of the *Ghazwat Ra's al-Ghūl* summarized by Desparmet, after killing Ra's al-Ghūl, the Prophet teaches the pillars of Islam and advocates the faith and the law of the new religion. He destroys the churches and rebuilds mosques in their place. With his heroic exploits, 'Alī abolishes the abominable tyranny of Christians, restoring order in the region:

> la geste de Ras el-Ghul enveloppe sous forme épique une satire profonde de l'administration des infidèles. Elle illustre, en général, ce lieu commun, cher à la littérature islamique, à savoir que le régime politique établi par Allah est le seul qui soit aussi particulièrement cette prétention affichée par nus d'avoir instauré la paix française dans l'Afrique du Nord; et c'est pourquoi les indigènes prennent plaisir à rappeler l'époque où l'Islam a porté la paix coranique dans les pays chrétiens (Desparmet, 1939: 216).

A further type of change occurred in the process of translation of the *Ghazwat Ra's al-Ghūl* into Swahili and in its transformation in the form of *utenzi* religious text. Within the context of the Islamicate Swahili epic literature, the narrative on Ra's al-Ghūl is projected into a religious discourse of Islamic legends as a model that reminds the believers of their duties and obligations, reasserts their identity, and reinforces their values (Topan, 2001: 107; Knappert, 1985, II: 381–460). From a stylistic point of view, the Swahili text of the *Ghazwat Ra's al-Ghūl* is reformulated in the form of a poem consisting of 4584 verses authored by Mgeni bin Faqihi between 1850 and 1855 in Bagamoyo (northern Zanzibar). The *utenzi* is yet another rewriting of the story, established on basis of the Arabic written version, in which "Yemen was mythologically associated with Eden, defeating Ras al-Ghul was in a sense vanquishing Satan" (Faqihi, 1980: vii).

In the 20th century, the Tunisian writer 'Izz al-Dīn al-Madanī (b. 1938) carries out a further and total transformation of the *Ghazwat*

Ra's al-Ghūl in the collection *Khurāfāt (Fictions)*. The short
story "Futūḥ al-Yaman aw Khurāfat Ra's al-Ghūl" (*The Conquest
of Yemen or the Legend of Ra's-Ghūl*) (al-Madanī, 1968: 8–39)
is, indeed, a foray into the fantastic realm of Borges's *Fictions*
and Barthes' *Mythologies*, but with an Arabic experimentalist
perspective in some way upturned (El-Miskini, 1985; Starkey,
1995). One of the main characters, "the author" (*al-mu'allif*),
claims to have heard from entertaining story-tellers (*meddāḥ* and
rāwī) the story of the 'Alī's expedition in Yemen and his encounter
with Ra's al-Ghūl. Just as in al-Bakrī's *Ghazwat Ra's al-Ghūl*, a
woman came to the prophet Muḥammad to complain of Ra's al-
Ghūl's atrocities, persecutions of Muslims and proclamation of
a false state of religion. Ultimately, the Prophet sent 'Alī to fight
Ra's al-Ghūl but 'Alī died in the encounter. In the last part of the
story, al-Madanī explains that he heard this version when he went
to the popular theatre. On that occasion, the crowd attending the
performance of the storyteller attacked the *meddāḥ*. When the
character of the author began to study Islamic history he realized
that the storyteller's version was nonsensical and he proceeded to
give the historically correct account of the incidents as related by
al-Balādhūrī in his *Futūḥ al-Buldān* (Starkey, 1995: 70).

Al-Madanī reverses the ending of the *ghazwa* and the
victorious Islamic point of view in a subversive critique about the
sense of both history and story-telling. The issues of otherness
and the East-West conflict remain, but are now positioned in the
background. As pointed out by el-Miskini:

> al-Mu'allif makes a prolonged authorial disavowal and claims to be
> surprised by the departure of the story from the historically documented
> triumph of 'Alī against Ra's al-Ghūl. Al-Mu'allif even cites historical
> texts like Al-Balādhūrī's *Futūḥ al-buldān*, to prove that the popular
> version he heard from the oral storyteller was wrong and wonders why
> it was changed. He adds that the readers may be able to figure out why
> (El-Miskini, 1985: 254).

Through this retelling of the story, al-Madanī reflects on the
manipulation of history, "thus merely negotiating the textuality
of the story. It is a negotiation between himself (as the presenter

of "Futūḥ al-Yaman" to society) and the societal forces that
determine the destiny, and status of discourses, including the one
presented by Al-Madanī in the form of the story" (255).

Endless "Ra's al-Ghul's anti-heroic cycle" in the DC comics

While al-Bakrī's *Ghazwat Ra's al-Ghūl* is characterized by a
rather linear progression, the DC comics do not follow the direct
causality pattern of the events featured. The various series and
graphic novels on the American Ra's al-Ghul contain episodes
that may be clustered into patterns of his supposed cycle. These
episodes are in the main inserted into the long and complex
(ongoing) story of Batman, which is developed starting from
its origins in 1939, through the successive ages until the present
time. The story of Ra's al-Ghūl is scattered in many series which
do not linearly follow his life and do not retrace the sequences
in the order in which they were outlined above, but which, taken
together, allow the detection of an anti-heroic cycle too.

The first two series of the seventies in which Ra's al-Ghul
appears (respectively *Batman#232*, June 1971 to *Batman#244*,
Sept. 1972 and the "Bat-Murderer"'s series, *Detective
Comics#444-448*, Dec. 1974 to June 1975) (*Showcase Presents
Batman*, 2015) serve as a prelude to Ra's al-Ghūl's saga (Fig. 2)
and delineate his personality and agenda. In the earlier episodes,
the main protagonist is not even Ra's al-Ghul, but Talia, one
of his daughters, who is kidnapped while studying medicine
at Cairo University. Immediately, a long manhunt is started in
the East (involving Egypt, Tibet and India) that forces Ra's al-
Ghul (founder and leader of the League of Assassins) to ally
with Batman. The scenarios seem inspired by those of James
Bond films, including the love relationship that slowly develops
between Talia and Batman (Eco, 2011: 160–2).

In this context, the origins of Batman and Robin are recalled and
it turns out that Ra's al-Ghūl knows the true identity of Batman
(i.e. Bruce Wayne). Soon, however, Batman is fooled into helping
Talia, but he is betrayed and so discovers the true inhuman,

mad, insane personality of her father Ra's al-Ghul. At this point, Batman prepares to make war on Ra's al-Ghul by staging Bruce Wayne's death. Batman defeats Ubu (Ra's bodyguard) at the entrance of Ra's al-Ghul's headquarters and discovers from Talia that her father is dead. To help her father, Talia secretly activates the Lazarus pit lowering him into a chemical bath which returns him to life. When Ra's al-Ghul awakens from it, he is seized by a fit of madness and the strength of ten men. Using his detective skills, Batman finds Ra's al-Ghul and the conflict culminates in a long sword duel in the Arabian Desert. In the last sequences, in love with Batman, Talia choose to help Batman to survive the bite of a poisonous scorpion and Ra's al-Ghul is captured. In the end, Batman manages to return to Gotham, where he discovers the enormous intrigue behind the Bruce Wayne murder case.

This first set of narratives retraces some fundamental stages, in which for the first time Batman comes out of Gotham to fight Ra's al-Ghul in scenarios reminiscent of the Middle and Far East. At the same time, Batman's journey in search of Ra's al-Ghul follows all the stages of the hero's journey: departure, deeds and transformation, duel and return. As to Ra's al-Ghul, these early series give him the role of Batman's deadliest enemy (Eury-Kronenberg, 2009: 173) and visibly show his ambiguous anti-heroic service that makes use of all necessary means to achieve the goal of bending Batman to his will, if not eliminating him. The role of his daughter Talia is comparable to that of al-Dalfā' in the *Ghazwat Ra's al-Ghūl* to the extent that she is a character connecting Batman and 'Alī and his father Ra's al-Ghul. As typical of modern storytelling (as James Bond teaches), this connection is made through a woman and an ambivalent love affair (Eco, 2011: 161).

The following narratives on Ra's al-Ghul, published originally as individual series and then as graphic novels, develop the character in detail. Some series focus on crucial episodes of his close relatives' lives, while others on the most acute phases of the Ra's al-Ghul-Batman conflict, in an ongoing regeneration or variation of themes and clusters of the cycle as a result of the evolution of the Batman character in the DC universe.

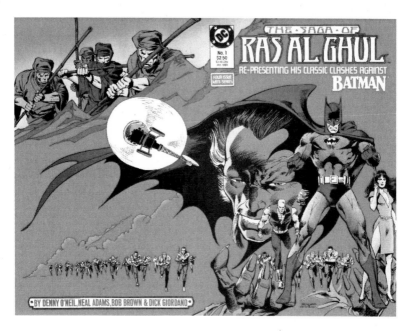

Fig. 2 – Cover of The Saga of Ras al-Ghul by O'Neil (1971)

One of the most intriguing "post-crisis" graphic novels, the *Birth of the Demon* (1992) by Dennis O'Neil, covers the entire first phase of the Ra's al-Ghul cycle and narrates his birth as the Demon. The first sequences retrace the major events of Ra's al-Ghul's lifetime in the Arabian Desert, as well as his interest in the sciences and his training as a physicist. Just in the desert, Ra's al-Ghul discovers both the secret of the Lazarus pit placed next to a sort of powerful idol, which he destroys, and even the germ theory of disease. His new powers lead him to kill the Sultan of his time, along with his son and tribe as well as the whole city – drawn in a perfect *Arabian Nights* style – thereby showing Ra's al-Ghul's cruelty. At this point, his transformation into the Demon's Head definitely takes place. Using the Lazarus Pit to extend his life, he spends the following several centuries journeying the world. Over time, he becomes a master of many forms of combat, in particular fencing. He even creates the League of Assassins, resulting from the Crusader Order of the Assassins.

Greg Rucka's *Death and the Maidens* (2004) represents another turning phase of the anti-hero cycle of Ra's al-Ghul. By jumping through time, this graphic novel overlaps several inner stories dealing with the wider conflict between Batman, Superman, Ra's al-Ghūl and his daughters Talia and Nyssa Raatko. The events narrated start from the Nazi era, during which Nyssa is abandoned by her father in a concentration camp, but then move compulsively in space and time in contaminated and truly disturbing dystopian settings. While Batman manages to stop Nyssa from killing Superman, Ra's al-Ghul appears to meet his fate and die. An old and dying Ra's al-Ghul reveals his greater plans. At this point, the daughters decide to take over the leadership of the League of Assassins, declaring war on Batman. Nyssa kills her father and Batman oversees his nemesis' cremation.

But the physical death of Ra's al-Ghul does not mark the end of this character. Nyssa is killed in the next *Year One: Batman-Ra's al-Ghul* (2005) by Kalile Devin Grayson, which takes place a year after Ra's al-Ghūl's death. In this graphic novel, the phantasmagoric presence of Ra's al-Ghul is persuasively hinting at a sequel. Batman must uncover his secrets to regain order in a Gotham City devastated by violence. This "iconography of terror" is reflected in Christopher Nolan's *Batman Begins* (2005), a film reinterpreting the origin of the Bat and the beginning of the conflict between Batman and Ra's al-Ghul. Ra's al-Ghul is modeled on the twenty-first century's terrorists. He is led by fury and obsessed by the decadence of Gotham. He clashes with the more puritan Batman in a war that recalls the one against fanaticisms and terrorisms of various kinds which leads the US government since the post 9/11 (DiPaolo, 2011: 49–55; Kavadlo, 2015: 164–9).

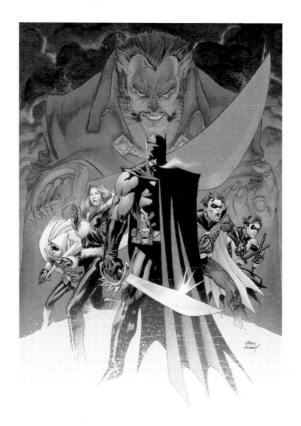

Fig. 3 – Cover of *Resurrection of Ra's al-Ghul* by Morrison (2008)

The final return of Ra's al-Ghul occurs in *The Resurrection of Ra's al-Ghul* (2008) by Grant Morrison. This graphic novel is a cornerstone in Ra's al-Ghul's biography as it narrates his resurrection and the final transformation into a liminal figure between the world of a living and that of the dead. *The Resurrection of Ra's al-Ghul* (Fig. 3) moves from a rather complicated sequence, set in the Chinese city, in which an albino named White Ghost (also referred in Ar. as al-Shabḥ al-Abyaḍ, "The White Ghost") plans to use Damian Wayne (Batman and Talia's son) as a shell for the soul of Ra's al-Ghul to return to

Earth. Realizing that this process would kill Damian, Talia saves her son from his fate at the last minute. However, the essence of Ra's al-Ghul is still able to return to our plane of existence as a living corpse, still needing Damian to stabilize his form. After a tough fight between Batman and White Ghost, Ra's al-Ghul succeeds in returning having evaded death by transferring his consciousness into the body of another. Because his host body is decaying from radiation poisoning, he needs to transfer his mind into another host body. Therefore, Ra's al-Ghul performs a series of transfers of souls into different bodies, first a Nanda Parbat monk and then his son Dusan (who turns out to be just White Ghost), so as to succeed in his evil enterprise. In this context, it is revealed that Ra's al-Ghul has access to a Fountain of Essence, which has similar abilities to the Lazarus Pit but does not appear to confer insanity on the user. Having returned to life in a crumbling body, Ra's al-Ghul seeks a permanent young one to take as host. After a fight with the Sensei, who claims to be Ra's al-Ghul's father, Batman is stabbed with a cane in the chest and pulls the Sensei down into the pit with him. Because the Sensei is healthy, he is killed by the chemicals in the Pit, but Batman is fully healed and rejuvenated. Following his resurrection, Ra's al-Ghul, in his new body, moves his base of operations to Gotham City where it is revealed that a remnant of his son Dusan's consciousness still remains within him. Since the White Ghost was his son, Ra's al-Ghul was able to use the resemblance between them to modify his new body's appearance to be more like his own. A final sword duel between a spirited and cadaveric Ra's al-Ghul and Batman, which takes place in Arkham City, a huge new super-prison enclosing the decaying urban slums of fictional Gotham City, marks the albeit temporary victory of the latter.

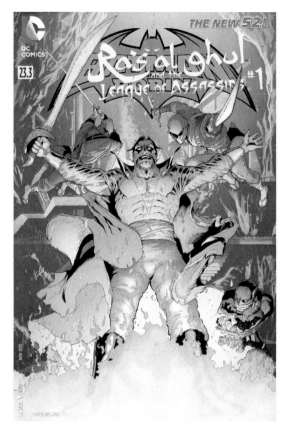

Fig. 4 – Cover of *Ra's al ghul and the League of Assassins* (2013)

In more recent DC series (Fig. 4), Ra's al-Ghul is physically a protagonist of the storylines both through his various incarnations and his relatives who are increasingly intermarried and interconnected with Batman (Brooker, 2012: 61–4). In a profound iconographic modification of the character, he seems to have returned to the demonic world from which he comes, losing the political significance that he embodied in the previous series. Ra's al-Ghūl has now taken the fluorescent color of the chemical substance of the Lazarus pit. However, his contagion weapons have permanently contaminated the world or, rather, the new

worlds and universes of Batman. The post 9/11 world, no longer dichotomist like to the cold war one, is infected by forms of global and internal terrorism. It finds a perfect coincidence with the evolution of the character of Ra's al-Ghul who moves with his deep crisis like a real ghoul in apocalyptical and dystopian scenarios.

Concluding remarks

The similarities and the parallels between the two Ra's al-Ghūl and between the various narratives that have coagulated around this character in real cycles are so striking to the point that the question arises if the American Ra's al Ghul derive his roots from the Arabic one. Textual evidence is compelling and shows the connection between the two complex narrative constructions. The Arabic origin is explicitly mentioned in the American stories. An editorial note of the first episode in which Ra's al-Ghul is mentioned (May 1971) says that in Arabic this name means "'The Demon's Head'! Literally, Al Ghul signifies a mischief-maker, and appears as the Ghoul of the *Arabian Nights*!'". In another episode (1998), it is said that "Ra's al Ghul's true name is lost in the sands of time. Of all the Dark Knight's foes, 'The Ghoul's Head', as his name translates from Arabic, is perhaps the most dangerous". In the most recent *Demon Star* (2013), Grant Morrison explicitly evokes the question of the star Algol in the constellation Perseus. In an episode of the story, a fortune teller shows Talia the constellation of Perseus and especially the fact that the hero holds the severed head of the Gordon, Medusa, by telling her: "That bright star is Beta Persei, the Demon star, the deadly winking eye of Gordon, Algol".

The first authors such as Denny O'Neil, Neal Adams and Dick Giordano have never provided precise evidence of Ra's al-Ghūl's name and he origin of their inspiration, recalling conversely quite a resemblance with Sax Rohmer's Fu Manchu and some villains from James Bond films (Eury-Kronenberg, 2009: 169; Adams, 2004). But it is especially the iconography of the earlier Ra's al-Ghul that emphasizes his unquestionable Middle Eastern look. In

particular, the image of the sword duel between Ra's al-Ghul and Batman both armed with semi-oriental swords, notwithstanding it has been re-modernized several times, seems to gloss the epic significance of the earlier duel between Ra's al-Ghūl (armed with a mace) and 'Alī (armed with his Dhū l-Faqār). Possibly, but how?, Arab informants aware of the fame of this work in Islamicate literatures have given some hints that were cleverly transformed by comic writers into a modern characterization of the evil. Certainly, the iconic and narrative intensity that Ra's al-Ghūl/Ra's al-Ghul embodies has inspired numerous storytellers over the centuries, from the narratives of the post-Crusader period up to the contemporary fictional mythologies in which a Caped Crusader seeks to restore order and peace by defending Gotham City, including the earth, parallel worlds and his post-Crisis universes, from ghouls of all types who threaten them with their terrorist attacks and their barbarity.

Primary Sources

Showcase Presents Batman. Volume 6 (New York: DC Comics, 2015).

Adams, Neal, and Dick Giordano, 'Daughter of the Demon', *Batman* #232, June 1971.

— 'The Lazarus Pit!', *Batman* #243, August 1972.

—, 'The Demon Lives Again!', *Batman* #244, September 1972.

—, *Batman Illustrated by Neal Adams* (New York: DC Comics, 2004).

Al-Bakrī, Abū al-Ḥasan, *Qiṣṣat al-Imām 'Alī ibn Abī Ṭālib wa-fatḥuhu al-sab'a ḥuṣūn wa-muḥāribatuhu al-Ḥaddām ibn al-Hajjāf ibn 'Awn ibn Ghānim al-Bāhilī* (Cairo: Muṣṭafā al-Bābī al-Ḥalabī, 1952).

—, *Qiṣṣat Futūḥ al-Yaman al-kubrā al-shahīra bi-Ghazwat Ra's al-Ghūl* (Cairo: Maktabat al-Jumhūriyya al-'arabiyya, [1970]).

Barr, Mike W., and Jerry Bingham, *The Son of the Demon* (New York: DC Comics, 1987).

Faqihi, Mgeni bin, *Rasi lGhuli*, Ed. by Leo van Kessel (Dar es Salaam: Tantania Publishing House, 1980).

Grayson, David K., and Paul Gulacy, *Year One: Batman-Ra's al-Ghul* (New York: DC Comics, 2005).

Al-Madanī, 'Izz al-Dīn, 'Futūḥ al-Yaman', in *Khurāfāt* (Tunis: al-Dār al-Tūnisiyya li-l-nashr, 1968), pp. 8–39.

Loeb, Jeph, Jim Lee, and Scott Williams, *Batman: Hush* (New York: DC Comics, 2009).

Morrison, Grant, and Paul Dini, *The Resurrection of Ra's al-Ghul* (New York: DC Comics, 2008).

—, J.G. Jone, and Doug Mahnke, *Final Crisis* (New York: DC Comics, 2008).

—, Chris Burnham, and Frazer Irving, *Batman Incorporated*, Volume 1: *Demon Star* (New York: DC Comics, 2010).

Nolan, Christopher, *Batman Begins*, 2005, Film.

O'Neil, Dennis, and Neal Adams, *Tales of the Demon* (New York: DC Comics, 1991).

—, and Norm Breyfogle, *Birth of the Demon* (New York: DC Comics, 1992).

—, and Mike W. Barr, *La Saga de Ra's Al Ghul* (New York: DC Comics, 2014).

Rucka, Greg, and Klaus Janson, *Batman: Death and the Maidens* (New York: DC Comics, 2004).

Waid, Mark, and Howard Porter, *JLA Vol. 7: Tower Of Babel* (New York: DC Comics, 2001).

Wen, Len, 'Bat-Murderer' series. *Detective Comics* #444-448, Dec. 1974–June 1975.

Works Cited

Basset, René, 'L'expédition du Château d'or et le combat de 'Ali contre le dragon', *Giornale della Società Asiatica Italiana*, 7 (1893), 1–81.

Bellino, Francesca, "'Alī contro geni, demoni e dragoni nella letteratura delle *maġāzī* leggendarie", *Quaderni di Studi Arabi*, n.s. 1 (2006), 155–70.

—, 'La letteratura delle *maghāzī* leggendarie: la conquista dello Yemen tra storia e leggenda', in *Medioevo Romanzo e Orientale. Temi e motivi epico-cavallereschi fra Oriente e Occidente*, Ed. by Antonio Pioletti and Gaetano Lalomia (Soveria Mannelli: Rubbettino, 2010), pp. 5–25.

—, 'Manoscritti e testimonianze orali del nord Africa: La spedizione di 'Alī b. Abī Ṭālib contro il re al-Ġīṭrīf nel wādī al-Saysabān', *Annali dell'Università degli Studi di Napoli "L'Orientale"*, 71 (2011), 1–39.

Brooker, Will, *Hunting the Dark Knight: Twenty-First Century Batman* (London-New York: I.B. Tauris, 2012).

Būrāyū, 'Abd al-Ḥamīd, *Al-Adab al-sha'bī al-Jazā'irī: dirāsa li-ashkāl al-adā' fī al-funūn al-ta'bīriyya al-sha'biyya fī al-Jazā'ir* (Al-Jazā'ir: Dār al-Qasābah li-l-Nashr, 2007).

Calasso, Giovanna, 'Un'epopea musulmana di epoca timuride: il *Xāvar-Nāmè* di Ebn Ḥosām', *Atti della Accademia Nazionale dei Lincei, Classe di Scienze morali, storiche e filologiche* ser. 8, vol. 23, fasc. 5 (1979), 383–539.

Canova, Giovanni, 'Une analyse de l'altérité dans la tradition épique arabe', in *Philosophy and Arts in the Islamic World. Proceedings of the Eighteenth Congress of the Union Européenne des Arabisants et Islamisants held at the Katholieke Universiteit Leuven (September 3-9, 1996)*, Ed. by U. Vermeulen and D. De Smet (Leuven: Peeters, 1998), pp. 135–146.

—, 'Critical attitudes toward Arabic Folk Epics', *Eurasian Studies*, 4.1 (2005), 29–40.

Chraïbi, Aboubakr (Ed.), *Arabic Manuscripts of the Thousand and One Nights. Presentation and Critical Editions of Four Noteworthy Texts. Observations on Some Osmanli Translations* (Paris: Espaces&Signes, 2016).

Connely, Bridge, and Henry Massie, 'Epic Splitting: An Arab Folk Gloss on the Meaning of the Hero Pattern', *Oral Tradition*, 4, 1–2 (1989), 101–124.

Coogan, Peter, *Superhero. The Secret Origin of a Genre* (Austin: Monkey Brain Books, 2006).

Dar, Jehanzeb, 'Holy Islamophobia, Batman! Demonization of Muslims and Arabs in Mainstream American Comic Books', *Counterpoints*, 346, *Teaching Against Islamophobia* (2010), 99–110.

Desparmet, Joseph, 'Les *Chansons* de Geste de 1830 à 1914 dans la Mitidja', *Revue Africaine*, 379 (1939), 192–226.

DiPaolo, Marc, *War, Politics and Superheroes. Ethics and Propaganda in Comics and Film* (Jefferson: McFarland, 2011).

Douglas, Allen, and Fedwa Malti-Douglas, *Arab Comic Strips. Politics of an Emerging Mass Culture* (Bloomington and Indianapolis: Indiana University Press, 1994).

Eco, Umberto, *Il superuomo di massa. Retorica e ideologia nel romanzo popolare*, Reprint (Milano: Bompiani, 2001).

—, 'Il mito di Superman', in *Apocalittici e integrati. Comunicazioni di massa e teorie della cultura di massa*, Reprint (Milano: Bompiani, 2003), 219–261.

El-Miskin, Tijani, 'Disclaiming Authorial Originality: The Negotiation of

Textuality in Two African Texts', *Comparative Literature Studies*, 22, 2 (1985), 252–264.

Eury, Michael, and Kronenberg, Michael, *The Batcave Companion. An Examination of the "New Look" (1964-1969) and Bronze Age (1970-1979)* Batman *and* Detective Comics (Raleigh: TwoMorrows Publishing, 2009).

Greenberger, Robert, *The Essential Batman Encyclopedia* (New York: Del Rey/DC Ballantine Books, 2008).

Guillaume, Jean-Patrick, 'Y a-t-il une littérature épique en arabe?', *Littérales*, 19 (1996), 91–107.

Knappert, Jan, *Islamic Legends. Histories of the Heroes, Saints and Prophets of Islam* (Leiden: Brill, 1985).

Kruk, Remke, *The Warrior Women of Islam. Female Empowerment in Arabic Popular Literature* (London: I.B. Tauris, 2014).

Kavadlo, Jesse, *American Popular Culture in the Era of Terror. Falling Skies, Dark Knights Rising, and Collapsing Cultures* (Santa Barbara–Denver: ABC-CLIO, 2015).

Lu'aybī, Shākir, *Taṣāwīr al-Imām 'Alī: marāji'uhā wa-dalālātuhā al-tashkīliyya* (Beirut: Riyāḍ al-Rayyis li-l-Kutub wa-al-Nashr, 2011).

Marano, Michael, 'Ra's al Ghul: father figure as terrorist', in *Batman unauthorized. Vigilantes, Jokers, and Heroes in Gotham City*, Ed. by O'Neil, Dennis with Leah Wilson (Dallas: BenBella Books, 2008), 69–84.

Norris, Harry T., 'The *Futūḥ al-Bahnasā* and Its Relation to Pseudo-*Maghāzī* and *Futūḥ* literature, Arabic Siyar and Western Chanson de Geste in Middle Ages', *Quaderni di Studi Arabi*, 4 (1986), 71–86.

—, 'Arabic Folk Epic and Western *Chanson de Geste*', *Oral Tradition*, 4.1-2 (1989), 125–50.

Paret, Rudi, *Die legendäre Maghāzī-Literatur. Arabische Dichtungen über die muslimischen Kriegszüge zu Mohammeds Zeit* (Tübingen: J.C.B. Mohr, 1930).

Pearson, Roberta E., and Uricchio, William (eds.), *The Many Lives of the Batman: Critical Approaches to a Superhero and His Media* (London: Routledge, 1991).

Al-Rawi, Ahmed, 'The Arabic Ghoul and its Western Transformation', *Folklore*, 120 (2009), 291–306.

Renard, John, *Islam and the Heroic Image. Themes in Literature and the Visual Arts* (Macon: Mercer University Press, 1979).

Shoshan, Boaz, *Popular culture in medieval Cairo* (Cambridge: Cambridge University Press, 1993).

Starkey, Paul, 'Quest for Freedom: The case of 'Izz al-Dīn al-Madanī', *Journal of Arabic Literature*, 26.1-2, The Quest for Freedom in Modern Arabic Literature (1995), 67–79.

Strömberg, Fredrik, '"Yo, rag-head!": Arab and Muslim Superheroes in American Comic Books after 9/11', *American Studies*, 56, 4, American Comic Books and Graphic Novels (2011), 573–601.

Topan, Farouk, 'Projecting Islam: Narrative in Swahili Poetry', *Journal of*

African Cultural Studies, 14.1, Islamic Religious Poetry in Africa (2001), 107–19.

Wansbrough, John, 'Theme, Convention, and Prosody in the Vernacular Poetry of North Africa', *Bulletin of the School of Oriental and African Studies*, 32.3 (1969), 477–495.

Wellesz, Emmy, 'An Early al-Ṣūfī Manuscript in the Bodleian Library in Oxford: A Study in Islamic Constellation Images', *Ars Orientalis*, 3 (1959), 1–26.

MIMESIS GROUP
www.mimesis-group.com

MIMESIS INTERNATIONAL
www.mimesisinternational.com
info@mimesisinternational.com

MIMESIS EDIZIONI
www.mimesisedizioni.it
mimesis@mimesisedizioni.it

ÉDITIONS MIMÉSIS
www.editionsmimesis.fr
info@editionsmimesis.fr

MIMESIS COMMUNICATION
www.mim-c.net

MIMESIS EU
www.mim-eu.com

Printed by Booksfactory – Szczecin (Poland) in July 2017